Selections from
The Art Institute
of Chicago

African
Americans
in Art

THE ART INSTITUTE OF CHICAGO

in association with

UNIVERSITY OF WASHINGTON PRESS

Published by The Art Institute of Chicago in association with the University of Washington Press, P. O. Box 50096, Seatlle, WA 98145-5096.

ISBN 0-295-97833-3

Editor: Susan F. Rossen, Executive Director of Publications; Assistant Editor: Laura J. Kozitka; Photo Editor: Martin Fox; Designer: Ann M. Wassmann; Production: Sarah E. Guernsey; Subscription and Circulation Manager: Bryan D. Miller.

Unless otherwise noted, all works in the Art Institute's collection were photographed by the Department of Imaging, Alan Newman, Executive Director.

Permission to reproduce the works of art in this volume has been provided in most cases by their owners or custodians. The following credits apply to all images for which separate acknowledgment is due. They are arranged alphabetically by artist and are keyed to page numbers: Bearden, Romare, © Romare Bearden Foundation/ Licensed by VAGA, New York, N.Y. (p. 78); Brown, Hilda Wilkinson, © Lilian Thomas Burwell (p. 62); Catlett, Elizabeth, © Elizabeth Catlett/Licensed by VAGA, New York, N.Y. (pp. 70, 89); Covarrubias, Miguel, from *Negro Drawings* by Miguel Covarrubias, © 1927 by Alfred A. Knopf Inc. and renewed 1955 by Miguel Covarrubias, reprinted by permission of the publisher (p. 38); DeCarava, Roy, © Roy DeCarava 1996 (p. 69); Lawrence, Jacob, courtesy of the artist (pp. 66, 44); Motley, Archibald J., Jr., ©Archie Motley (pp. 26, 31, 32, 33, 34, 36, 37, 39, 40, 41); Simpson, Lorna, courtesy Rhona Hoffman Gallery, Chicago (pp. 114, 117); Smith, Vincent, courtesy of the artist & G. W. Einstein Company, Inc. (p. 74); Weems, Carrie Mae, courtesy Rhona Hoffman Gallery, Chicago (pp. 108, 118); White, Charles, courtesy Heritage Gallery, Los Angeles (cover and p. 70).

Typeset in Stempel Garamond by Z...Art & Graphics, Chicago, with the assistance of Cris Ligenza, The Art Institute of Chicago. Printed by Litho Inc., St. Paul, Minnesota. Bound by Midwest Editions, Minneapolis.

Front cover: Charles White (American; 1918-1979), *Harvest Talk* (detail), 1953 (Portfolio, no. 17). Back cover: Beauford Delaney (American; 1901-1979), *Self-Portrait*, 1944 (Portfolio, no. 12). *African Americans in Art: Selections from The Art Institute of Chicago* originally appeared as volume 24, no. 2 of *The Art Institute of Chicago Museum Studies*, ISBN 0-86559-154-7. The publication has been supported, in part, by generous grants from the Lila Wallace-Reader's Digest Fund Museum Collections Accessibility Initiative and by a grant for scholarly catalogues and publications from The Andrew W. Mellon Foundation.

Table of Contents

African Americans in Art: Selections from The Art Institute of Chicago

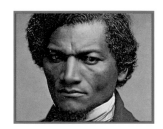

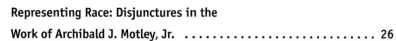

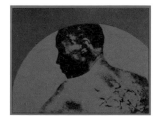

Introduction

This issue of *The Art Institute of Chicago Museum Studies*, "African Americans in Art: Selections from The Art Institute of Chicago," has been organized in recognition of the significant expansion of our holdings of works by African Americans, as well as of examples by other artists in which African Americans are the subjects. It provides as well an occasion to look back at the institution's relationship to this aspect of American culture.

In the early years of their existence, the Art Institute's museum and school—being relatively small in scope—operated as one entity. Nonetheless, the school's pedagogical efforts and the museum's program of acquisitions and exhibitions did not always move in the same direction or at the same speed. At the turn of the twentieth century, the School of the Art Institute was far ahead of the museum in its commitment to art by African Americans. It was one of the few art academies in the United States in which blacks could enroll. While their numbers were relatively low in the early decades, it is significant that so many who studied at the School—among them, Richmond Barthé, Margaret Taylor Goss Burroughs, Elizabeth Catlett, Eldzier Cortor, Walter Ellison, Charles White (see Portfolio, nos. 11, 15, 18, 8, 5, and 17, respectively), and Archibald J. Motley, Jr. (see Mooney essay)—enjoyed full and active careers, working in Chicago, New York, and/or Europe and participating in such important cultural forces as the Harlem Renaissance and later in the Federal Art Project of the Works Progress Administration (WPA). These pioneers understood that they needed to assist one another by organizing support groups such as the Chicago Art League, which was founded in 1923 to organize exhibitions and programs focused on black artists and their work, and the South Side Community Art Center. Opened in 1941 to provide training in the arts and exhibition opportunities for the residents —primarily African American—of this neighborhood, the SSCAC is one of the few WPA-sponsored art centers still in existence.

After World War II, the G.I. Bill helped more blacks to enroll at the School; many trained to be teachers as well as artists. They were encouraged by a number of instructors, but most especially the artist and art historian Kathleen Blackshear and the art historian Whitney Halstead. Blackshear initially served as assistant to Helen Gardner, whose *Art Through the Ages* (first published in New York about 1926), was the standard college textbook for many decades. Gardner's embrace of art from many non-Western cultures—including Africa—was far ahead of its time. Blackshear, who helped African American students in a number of ways, including financially, regularly took her classes to see the extensive collections of African, South Pacific, and Amerindian art at the Field Museum.[1] Courses on African art were introduced by Halstead in the 1950s; he was particularly supportive of African American artists, as well as of Outsider artists, including Joseph Yoakum (see Portfolio, no. 23), whose work he acquired in great depth. When written, the history of African Americans at the School of the Art Institute will undoubtedly prove enlightening.[2]

Several museum staff members also emerged as significant supporters of African American artists. Robert Harshe, the Art Institute's director from 1921 to 1938, became particularly interested in the work of Archibald J. Motley, Jr., regularly critiquing his work and helping to arrange his first solo gallery exhibition, in New York City

in 1927 (see Mooney essay). Harshe cooperated with the Chicago Art League and the Chicago Women's Club in organizing a one-week exhibition, "Negro in Art Week," held at the museum in 1927. The event featured the work of local and national African American artists; a showing of the Blondiau Collection from what was then the Belgian Congo; as well as a number of lectures, dinners, and concerts.[3] The next exhibition to showcase the work of African Americans did not occur until the summer of 1943, when the museum staged "Negro Artists of Chicago."[4] After World War II, two Art Institute staff members—publicist Peter Pollack and curator Katharine Kuh—worked enthusiastically on behalf of African American artists. Pollack, who "discovered" the work of Marion Perkins (see Schulman essay), was instrumental in the founding of the South Side Community Art Center; Daniel Catton Rich, director of the Art Institute from 1939 to 1958, served on its board. Kuh introduced the work of Richard Hunt (see Portfolio, no. 19) to prospective collectors.

This said, it must be acknowledged that, until the late 1980s, the museum had what can only be termed an inconsistent history of dedication to collecting and exhibiting African American art, with moments of vision and leadership in supporting black artists alternating with periods of inactivity or lack of interest. The first work by an African American to enter the Art Institute's collection was Henry Ossawa Tanner's *Two Disciples at the Tomb* (Portfolio, no. 2), which won a purchase prize at the 1906 "Annual Exhibition of American Art." A second work by Tanner, *The Three Marys,* was acquired in 1913 but was deaccessioned in 1950 when it was presented to Fisk University, Nashville, Tennessee.[5] It took over thirty years for the next such acquisition: Richmond Barthé's *The Boxer* (Portfolio, no. 11) came to the museum in 1948. Perkins's *Man of Sorrows* (see Schulman essay, figs. 1, 21) earned a purchase prize in the museum's 1951 "Chicago and Vicinity" exhibition. In the 1950s, works by Norman Lewis (Portfolio, no. 14) and Richard Hunt (Portfolio, no. 19) entered the collection. Among the pieces acquired in the 1970s were Sam Gilliam's *"A" and the Carpenter* and Romare Bearden's *Return of Odysseus* (Portfolio, no. 25). At the end of the decade, the museum received Whitney Halstead's bequest, which made it the greatest single repository of works by Joseph Yoakum. In 1982 the museum acquired Martin Puryear's *Sanctuary* and in 1991 organized a traveling, mid-career exhibition and catalogue for this important sculptor.[6]

The tenure of Charles F. Stuckey as Curator of Twentieth-Century Painting and Sculpture, from 1987 to 1995, marked a turning-point for the representation in the Art Institute's permanent collection of African American artists. Stuckey's determination to build a significant concentration of such work resulted in an impressive group of acquisitions. In fact, he purchased six of the seven paintings featured in the Portfolio section of this issue. The department continues to actively pursue the course that Stuckey initiated. The Department of Prints and Drawings has also made significant additions in the last decade, as attested to here by the inclusion of eleven such acquisitions in the Portfolio section. So too the Department of Photography has expanded its holdings of works by African Americans (see Portfolio, nos. 7, 16, 27, and Smith essay). Recent purchases in the Department of American

Arts include a double portrait by the early nineteenth-century Baltimore artist Joshua Johnson (Portfolio, no. 1).

While the Art Institute is devoted to representing cultures worldwide, a mission that precludes exclusive focus on the region that surrounds it, a significant number of African American artists with works in the collection have been or are associated with Chicago. In addition to the artists connected to the School of the Art Institute mentioned above (Barthé, Burroughs, Catlett, Cortor, Ellison, Motley, and White), Kerry Coppin (see Portfolio, no. 27), Perkins, and Yoakum lived and worked in the city; Hunt and Kerry James Marshall (see Portfolio, no. 28) continue to reside here. This is not surprising, for Chicago and its legendary South Side can legitimately claim to rival, if not to equal, such centers as New York and New Orleans in the significance of their contributions to the nation's musical, literary, and artistic life.

For reasons of space, we decided, with one exception (see below), to limit our choices to works by African Americans, although the issue's title, "African Americans in Art," conveys our intent to show some of the ways in which blacks have contributed to this nation's visual culture as its subjects as well as its makers. Thus, we had to exclude such arresting works as *The Freedman* by the nineteenth-century sculptor John Quincy Adams Ward; an 1893 portrait of Henry Ossawa Tanner by Herman Dudley Murphy; and *Roll, Jordan, Roll,* a 1933 book of ninety-one photogravures by Doris Ulmann.

While it is by no means a record of every object by or about African Americans in the collection, the issue demonstrates the institution's commitment to acquiring important works by the nation's black artists, as well as our desire to research and showcase these acquisitions, not only so that their significant contributions will be recognized, but also to provide a fuller and more accurate picture of the multifaceted nature of American culture.

The only work featured in this issue that is not by an African American is the arresting daguerreotype, by Samuel J. Miller, an obscure Ohio-based daguerreotypist, of the former slave and Abolitionist leader Frederick Douglass. In his absorbing study of this work, Colin L. Westerbeck argues convincingly that Douglass was as responsible, if not more so, as the man behind the camera for creating the strong, stern image of this Emersonian "self-made" man and hero. Amy M. Mooney's essay on the representation of African Americans by Archibald J. Motley, Jr., as reflected in an early self-portrait and a later genre scene, explores the stresses and resulting complexities that black artists could experience in trying to create honest and evocative images of life in the urban north of the United States.

The Portfolio section features full-color reproductions of twenty-nine works, along with brief commentaries prepared by a number of authors (see list, page 52). As stated above, this is by no means a comprehensive representation of the collections, both because of the number of artists and works from which we made our selections and also in order to respect the desire of some individuals with pieces in the Art Institute who do not wish their art to be considered in such a framework. This section is introduced by Andrea D. Barnwell and Kirsten P. Buick, who articulate for us the advantages and pitfalls of discussing art by African Americans apart from works by other Americans. They set forth a nexus of questions and concerns about

concepts of race that we must keep in mind as we read not only the Portfolio entries but also the articles that precede and follow this section.

Daniel Schulman has assiduously examined primary documentary materials and has interviewed a number of the family and colleagues of Chicago sculptor Marion Perkins. This has resulted in the most complete picture of this artist's career to date and provides a context for pieces by him in the museum's permanent collection. Finally, Cherise Smith considers the works of contemporary artists Lorna Simpson, Carrie Mae Weems, and Willie Robert Middlebrook, each of whom began as a documentary photographer. While their oeuvres differ significantly from one another, each artist combines photography with other media and/or text in order to examine issues of photographic veracity and to address such key societal issues as race, history, and gender.

"African Americans in Art: Selections from The Art Institute of Chicago" represents a labor of love on the part of many. I am particularly grateful to all of the authors mentioned above, as well as those who contributed entries to the Portfolio section, for their devotion to the project and for their fine work. I wish to thank the Lila Wallace-Reader's Digest Fund Museum Collections Accessibility Initiative for its support not only of this issue but also of a number of programs at the Art Institute that further knowledge and understanding of African American culture. Also instrumental in the publication's realization was the support of the Art Institute's Deputy Director, Teri J. Edelstein, for whose counsel I am grateful. I would also like to thank Daniel Schulman and Andrea D. Barnwell for their enthusiasm and help with a myriad of issues.

Ronne Hartfield, Jeremy Strick, David Travis, and Sylvia Wolf provided useful advice. Kymberly N. Pinder is to be acknowledged for her research on the history of black Americans at the School of the Art Institute. The issue's sensitive layout is the work of the Art Institute's designer Ann M. Wassmann; Toby Zallman, of Z...Art & Graphics, patiently typeset the issue, assisted by Publications Department secretary Cris Ligenza. I also wish to acknowledge the wise suggestions of freelance editor Terry Ann R. Neff and Associate Editor Margherita Andreotti; and the hard, good work of Publications Department interns Laura Kozitka and Martin Fox and Associate Manager of Production, Sarah E. Guernsey.

Last, but not least, I wish to thank our former Associate Editor Michael Sittenfeld, who conceived the issue and who worked initially with the departments and many of the authors involved. But more than this, for seven years, Michael lovingly managed and edited this journal, helping to maintain its high scholarly standards and to extend its appeal and accessibility to general audiences. We are very grateful to him.

SUSAN F. ROSSEN
Executive Director of Publications

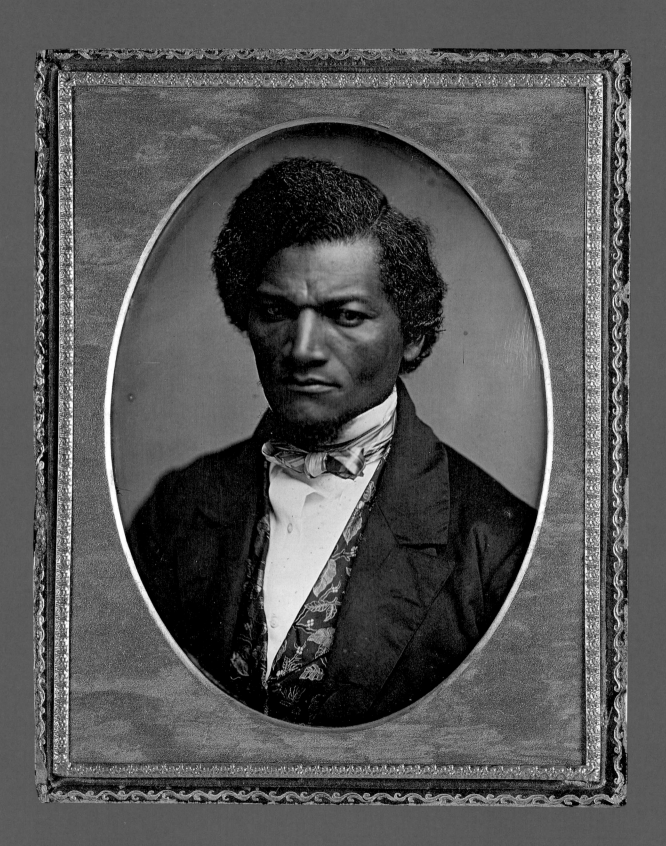

Frederick Douglass
Chooses His Moment

COLIN L. WESTERBECK
Associate Curator of Photography

The centerpiece of the 1997 exhibition "In Their Own Right: Images of African Americans from The Art Institute of Chicago" was a pre-Civil War daguerreotype of the Abolitionist leader Frederick Douglass (fig. 1) that the museum had recently acquired.[1] This was not the first time that Douglass had been seen in the museum. His previous appearance had been in person over a century earlier in the Art Institute's original building, only a few feet from where the daguerreotype would one day be installed. At that time, Douglass was attending the 1893 World's Columbian Exposition as the Commissioner of the Haitian Pavilion. He had been invited to serve in this capacity by the government of Haiti because he had just finished a term as the American minister to that country.

This honor came toward the end of a long and eventful life that had made Douglass the most important African American spokesman of the nineteenth century. His rise to prominence ran parallel with the rise to popularity of the daguerreotype as a medium for portraiture. A small, copper plate with a coating of silver that has been made photosensitive, the daguerreotype was invented in France in 1839, the year after Douglass escaped from slavery. A mulatto born on a Maryland plantation in February 1818, Douglass had made a break for freedom at the age of twenty via the Underground Railroad. Finding his way to New England, he began the speaking career for which the presence of mind we see in the Art Institute's portrait gave him a natural talent.

Douglass had initially attracted national attention in 1845 as the author of *Narrative of the Life of Frederick Douglass, an American Slave, Written by Himself,* the first of three autobiographies.[2] Since he was subject to arrest under the Fugitive Slave Act once this book had revealed his identity, he fled to Great Britain until Quaker Abolitionists there raised the money to buy his freedom from his former master. In 1847 he returned to North America free at last from all the constraints of slavery except, of course, prejudice, which he would have to continue fighting the rest of his life. At the end of 1847, he began publishing an influential newspaper[3] that was to promote the Abolitionist cause to every Northern leader right up to President Abraham Lincoln, who met with him twice at the White House before issuing the Emancipation Proclamation. After the Civil War, Douglass used his many official honors, including his appointment at the 1893 exposition, to combat the oppression of his race.[4]

During the exposition, the building that would become The Art Institute of Chicago

FIGURE 1

Samuel J. Miller (American; ?–1888). *Frederick Douglass,* 1847/52. Daguerreotype; 14 x 10.6 cm (5½ x 4⅛ in.). The Art Institute of Chicago, Major Acquisitions Centennial Endowment (1996.433).

Frederick Douglass would have concurred with Ralph Waldo Emerson that each person must be his or her own portraitist, that one's portrait must be self-made.

was used for a series of international cultural exchanges, the most important being the World Parliament of Religions. The purpose of the parliament, according to opening remarks, was to explore the "grounds for fraternal union in the religions of different people."[5] Since Douglass had spent his life trying to establish among the races what the parliament was seeking among religions, he accepted an invitation to speak. But the parliament did not prove a satisfactory forum for issues of race, nor did the exposition.

Douglass' experiences at the Chicago fair reveal much about the man pictured in the daguerreotype made over forty years earlier. His involvement with the Haitian pavilion gave him a perspective on the proceedings that sadly disappointed and ultimately angered him, for he saw that a conception of human progress he despised and had denounced at every turn persisted still. This was apparent in the very layout of the Midway, for the sequence of exhibits was supposed to demonstrate the advance of civilization from so-called primitive cultures, such as those in Africa, to the supposedly higher stages represented by Europe and North America. Although this neat scheme became rather jumbled in execution, the idea remained clear in displays such as the Dahomey village, for which African Americans were hired to pose as African natives in jungle costumes. Douglass observed that, "as if to shame the Negro, the Dahomians … exhibit the Negro as a repulsive savage."[6]

The man in charge of the Columbian Exposition's ethnological displays was F. W. Putnam, who published after the fair closed a souvenir volume entitled *Oriental and Occidental Northern and Southern Portrait Types of the Midway Plaisance.*[7] This book was intended as an illustration of the idea of progress from race to race that Putnam had wanted his plan for the Midway to embody. A Harvard pro-

fessor, Putnam was heir to the legacy of the naturalist Louis Agassiz, who had taught at the university earlier in the century. Agassiz believed in the practice of body typing and in comparing the measurements of skulls as a way to rank the races. As Agassiz was a mentor to Putnam, so was a group of daguerreotypes that Agassiz had commissioned in 1850 the precedent for Putnam's *Portrait Types.* Inspired by an earlier comparative anatomy text, Dr. Samuel Morton's *Crania Americana,* Agassiz toured plantations in the vicinity of Columbia, South Carolina, and selected five male and two female slaves to pose nude for a sequence of daguerrean plates (see figs. 2–3).[8]

Taking these images into consideration may help us to feel more fully the historical impact of Douglass' portrait. According to the census taken the year Agassiz had his daguerreotypes made, the population of South Carolina's Tidewater parishes numbered over one hundred twenty-six thousand slaves but only forty thousand free whites. In some districts, there was only one free white for every ten enslaved blacks.[9] In the antebellum South, tensions ran high as the Abolitionist movement, gaining momentum in the North, raised the specter of what would happen should the sort of slaves humiliated in the Agassiz documentation ever be in a position to turn their rage on their white masters. The Douglass daguerreotype may even have been made the same year as the Agassiz pictures. Imagine how his portrait would have looked to white residents of Columbia that year, or how it would have looked to the slaves in Agassiz's daguerreotypes!

Although Douglass was unlikely to have known about Agassiz's documentation, at the time it was done he was certainly aware of the racist pseudoscience it represented. He devoted part of a commencement address delivered in 1854 at Western Reserve College,

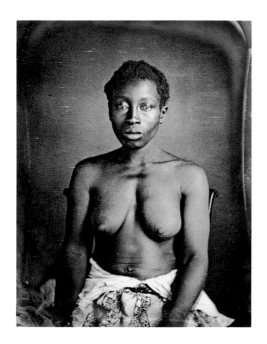 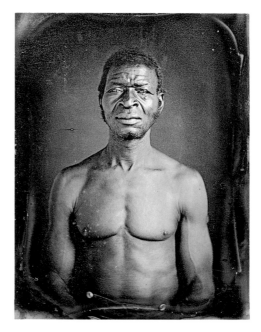

FIGURE 2

J. T. Zealy (American; act. 1850s). *Delia*, 1850. Daguerreotype; 8.9 x 6.4 cm (3½ x 2½ in.). Peabody Museum, Harvard University, Cambridge, Mass. Photo: Hillel Burger.

FIGURE 3

J. T. Zealy. *Jack*, 1850. Daguerreotype; 8.9 x 6.4 cm (3½ x 2½ in.). Peabody Museum, Harvard University, Cambridge, Mass. Photo: Hillel Burger.

"The Claims of the Negro Ethnologically Considered," to an attack on *Crania Americana,* the book on which Agassiz had relied.[10] Almost four decades later, at the Columbian Exposition, the influence of the ideas Douglass had attacked continued to be seen in Putnam's design for the fairgrounds, as well as in the updating that Putnam's *Portrait Types* gave to *Crania Americana* and the Agassiz daguerreotypes.

The fair's only official recognition of African Americans—"Colored People's Day," held August 25, 1893—provided Douglass with an occasion on which to express his disgust at these stereotypes. On this one day, blacks were welcomed to the grounds (while whites, presumably, were to stay away).[11] Despite the opposition to the event of the young black firebrand Ida B. Wells, whom he greatly respected, Douglass decided not only to attend, but to give an address. How else was he to reach his own people? Precisely because the day symbolized all of the exposition's failings, it presented him with an appropriate opportunity to speak out on the issues.

Yet when Douglass arrived to find that the exposition had a huge supply of watermelons on hand, he began to lose heart. Some whites had shown up after all, in order to heckle, and they unnerved him as he began the speech he had prepared, "The Race Problem in America." According to a newspaper account of him dating from the very beginning of his career, a Douglass performance at the podium entailed more than just "oratory, or eloquence. It was sterner, darker, deeper than these." The writer likened Douglass, "as he stalked to and fro upon the platform," to "the Numidian lion."[12] But that had been nearly fifty years before.

Now Douglass, who was in his mid-seventies, appeared to falter as his age, the heat, the distraction of the heckling, and perhaps the dubiousness of the occasion itself all got the better of him. Then he decided to set aside his text, lay his glasses down on top of it, and continue extempore. "There is no Negro problem," he proclaimed. "The problem is whether the American people have loyalty enough, honor enough, patriotism enough,

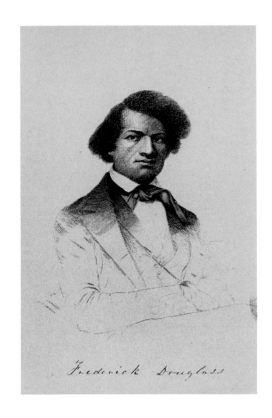

his second autobiography, *My Bondage and My Freedom* (1855). Engravings done from daguerreotypes were unavoidably interpretations of their source; as a rule, the process of translation softened the impression made by the original. The frontispiece portrait for Douglass' 1845 *Narrative* (fig. 4) could have been based on a daguerreotype that is also now lost. An oil painting from the early 1840s is very like his *Narrative*'s frontispiece, and it would not have been unusual had both of them been done from a daguerreotype.[14] All that is certain is Douglass' unhappiness with the engraving. "I am displeased with it not because I wish to be," he wrote to his Glasgow publisher, "but because I cannot help it. I am certain the engraving is as good as the original portrait. I do not like it."[15]

Of the six daguerreotypes of Douglass known to have survived, only one besides the Art Institute's has had its daguerreotypist identified. This image (fig. 5) by Ezra Greenleaf Weld is unique because, rather than a studio portrait, it is a group shot at an outdoor meeting that Douglass attended. Daguerreotypes were seldom attempted under these circumstances because the long exposure time required made it difficult to get a satisfactory result. This is the only daguerreotype of Douglass whose date is known with certainty, since there is a record of the Abolitionist meeting in Cazenovia, New York, that the image documents. This daguerreotype is also unique in the paradoxical sense that it is the only one known to have been copied. The second plate is in the J. Paul Getty Museum, Los Angeles (for more on copying, see pp. 15–16).[16]

Neither the makers nor the places of origin of the four remaining daguerreotypes are known, and the dates usually given for them are only approximate. Trying to establish a chronological order for these images of Douglass is an intriguing but highly conjectural process.

to live up to their own Constitution."[13] By all accounts, the talk Douglass delivered that day ranked among the greatest of his life. It was also his last major public utterance. The "Numidian lion" ended his speaking career as the lion in winter he had become.

* * *

Unlike Frederick Douglass himself, the Art Institute's daguerreotype of him is undocumented. He has a vivid immediacy in it, but it is an obscure historical object. Still, because the velvet lining inside the cover of the daguerreotype's case bears the name of its maker and the city where he was in business—Samuel J. Miller of Akron, Ohio—we have more information about this daguerreotype than about most others of Douglass (or of anyone, for that matter).

Douglass sat for a number of daguerrean portraits. At least one is now lost, that on which the engraved frontispiece was based in

The only one that can be clearly sequenced with the Art Institute's, based on internal evidence, is the portrait (fig. 6) recently acquired by The Metropolitan Museum of Art, New York, from the William Rubel Collection. In this likeness, unmistakable streaks of gray have emerged in Douglass' hair and imply that he was older than in the Chicago portrait. The Metropolitan's daguerreotype is usually dated circa 1855 or 1850/55, but whenever it was made, the Art Institute's has to have preceded it. The question is, by how much?

Two other daguerrean portraits are key to any sequence that might be proposed. One (fig. 7) is thought to be a copy done in 1850 of a plate made in 1847, just after Douglass returned from Great Britain, or in 1845, just before he left.[17] Judging from his appearance in this work, the earlier date seems the more likely. In an enlightening essay written from a psychiatric point of view, Allison Davis suggested that this picture was taken of Douglass at a time "when he felt and looked like a hunted animal."[18] That would have been 1845, when he had to flee the country for fear of being captured and returned South by bounty hunters, rather than 1847, when he returned to the United States in triumph. Although Davis's characterization seems extreme, Douglass does here appear crestfallen, bewildered, lost. At the very least, he looks younger and more unformed than in the Chicago and New York daguerreotypes.

The same could be said of the other early daguerreotype of Douglass that must be taken into account. This portrait (fig. 8) is in the Chester County Historical Society in West Chester, Pennsylvania. Here again Douglass looks away from the camera in a fashion that seems tentative and suggests an uncertainty that he had overcome by the time of the Art Institute's daguerreotype. In the Chester County picture, the knotting of Douglass'

brows just above the bridge of his nose, which is so conspicuous in the Art Institute portrait and was to characterize his portraits throughout the rest of his life, had not yet appeared. This daguerreotype in Chester County has been dated circa 1848. It was definitely not made after that time, in my opinion, and it seems likely to have been taken even earlier. The Art Institute's portrait, on the other hand, was almost certainly made no earlier than 1847, and circumstantial evidence suggests that the date may have been as late as 1852.

While Frederick Douglass traveled far in life, the Art Institute's daguerreotype of him did not. Since the daguerreotype came to light over 140 years after being made in Akron, Ohio, but less than one hundred miles away,

FIGURE 5

Ezra Greenleaf Weld (American; act. 1845–69). *Frederick Douglass at an Outdoor Abolitionist Meeting, Cazenovia, New York,* 1850. Daguerreotype; 14 x 11.4 cm (5½ x 4½ in.). Madison County Historical Society, Oneida, New York.

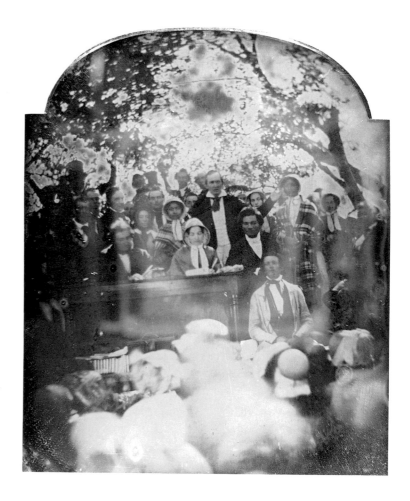

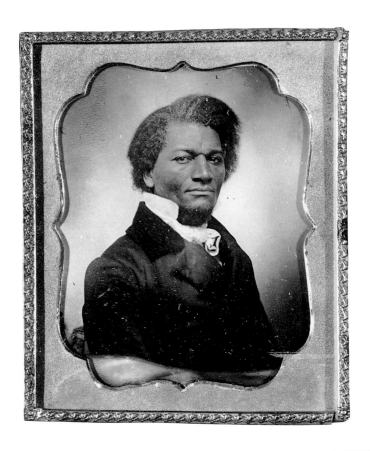

FIGURE 7

Anonymous.
Frederick Douglass,
c. 1850 (copy after
plate made in the mid-
1840s). Daguerreo-
type; 8 x 6.9 cm (3⅛ x
2¾ in.). National
Portrait Gallery,
Smithsonian Institu-
tion, Washington,
D.C. (NPG.80.21).

FIGURE 6

Anonymous.
Frederick Douglass,
c. 1855. Daguerreotype;
7 x 4.6 cm (2¾ x
1¹³⁄₁₆ in.). The Metro-
politan Museum
of Art, New York,
The Rubel Collection,
promised gift of
William Rubel, 1997
(1997.84.8).

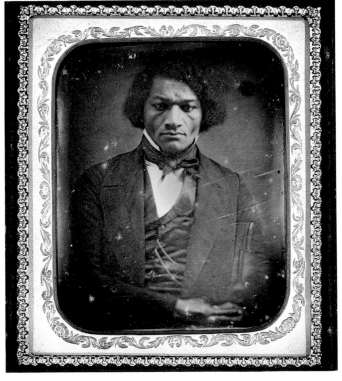

in Pittsburgh, chances are that it never left the area. Its whereabouts in the interim are unknown; it and three other daguerreotypes were found in a shoebox whose contents were offered at the conclusion of a gun sale at a regional auction house.[19] Had the daguerreotype gone with Douglass back to Rochester, where he settled in the late 1840s and early 1850s, either it would have perished in the fire that destroyed his house there or it would have re-emerged at his later home in Cedar Hill, Maryland.

Despite being of him, the portrait may not have been made for him. It may have been a gift for a friend or a supporter of Douglass' cause. Reporting from Columbus, Ohio, in an 1848 issue of *North Star*, Douglass' partner in the newspaper, Martin R. Delany, described the parlor of the man in whose house he was staying at nearby Leesburg, which he declared to be the "most Abolitionized" town he had been to in the West. The "ornaments around the walls" consisted of ten portraits of Abolitionist leaders, Douglass included.[20] Although he did not say so, these were probably daguerreotypes, or lithographic reproductions of daguerreotypes. If they were daguerreotypes, it is conceivable that the image of Douglass was the one now in the Art Institute.

Leesburg, however, is far from Akron, on the opposite side of Ohio. It makes more sense to wonder whether this daguerreotype ever left the studio of its maker, Samuel J. Miller. A common practice of successful daguerrean establishments was to have salons or waiting rooms that functioned as galleries for the exhibition of the owner's handiwork. These places were socially fashionable in the way a trendy art gallery might be today. The public went to them to see and be seen. Mathew Brady's daguerrean gallery on Broadway in New York (fig. 9) set the style, which was soon imitated in every city that had a potential market large

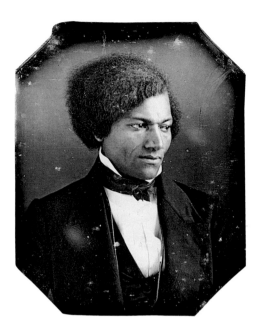

FIGURE 8

Anonymous. *Frederick A. Douglass,* c. mid-1840s. Daguerreotype; 8 x 7 cm (3⅛ x 2¾ in.). Collection of Chester County Historical Society, West Chester, Penn.

enough to support such a venture. Miller's obituary in an Akron newspaper recalls his gallery as having been "a model of elegance and good taste."[21]

Most of the portraits on the walls of these studios were of the local clientele, but also present, often, were public figures famous enough that visitors would be fascinated by their images and might even want to buy a copy. The portrait of Douglass that Delany mentioned in Leesburg could have been a daguerreotype copy purchased from a gallery—if not one in far-off Akron, then maybe closer to home in Cincinnati at J. P. Ball's Daguerrean Gallery of the West, which Douglass featured in his newspaper on two occasions.[22] Daguerreotypists frequently acquired plates of popular subjects from one another and, just as often, took credit for the image. This can make it difficult to figure out who actually took a portrait.

Since a daguerreotype was a direct positive on a silver-coated copper plate, no negative existed from which multiple prints could be made. Copying daguerreotypes was a tricky

FIGURE 9

A. Berghaus
(nineteenth century).
*M. B. Brady's New
Photographic Studio,*
c. 1860. Wood
engraving from *Frank
Leslie's Illustrated
Newspaper,* Jan. 5, 1861;
Library of Congress,
Washington, D.C.
(LC-USZ62–114481).

business. The most reliable way was to reda-guerreotype the original on a second plate, or a third or a fourth, depending on how many copies were wanted. The copies were seldom as sharp as the originals; and because the original was a mirror image, the copy righted the subject again so that it corresponded to reality. Thus the side on which the subjects' hair is parted or their clothes are buttoned can flip around in these early nineteenth-century documents in a most confusing way. The Art Institute's daguerreotype of Douglass, with its clarity, its precision, and its shirt that buttons right over left (i.e., backward), is unquestionably an original.[23]

While Frederick Douglass makes a great impression on us in this portrait, the man who made it has left only a faint trace on the history of photography. We know that this is

his work because it has come down to us in its original case (fig. 10). Although cases can be notoriously unreliable ways to identify daguerreotypes, since they were often inter-changed, in this instance there cannot be much doubt about its authenticity. The plate when acquired was still in its original preserver; that is, it, the glass, the brass mat, and the binding in which the whole package was sealed had never been opened or replaced.[24] The plate in its preserver, the back of the case, and the cover all fit each other snugly, and on the inside of the cover embossed on the velvet lining is "Samuel J. Miller, Akron, O."

As handsome and provocative an example of Miller's work as this is, today he is all but forgotten. The standard references on daguerrean operators give him only the briefest of mentions.[25] We know that he had a studio

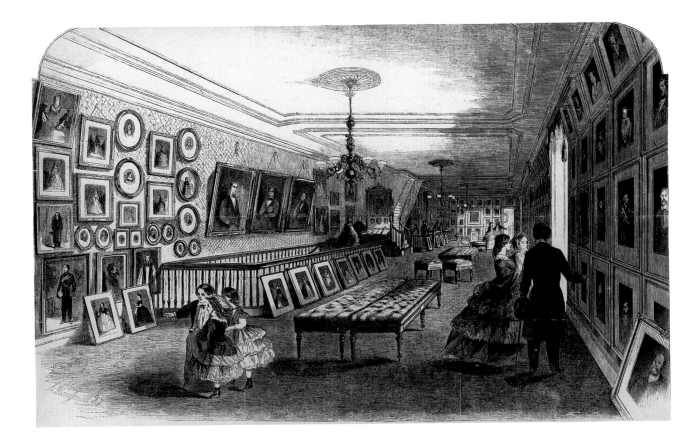

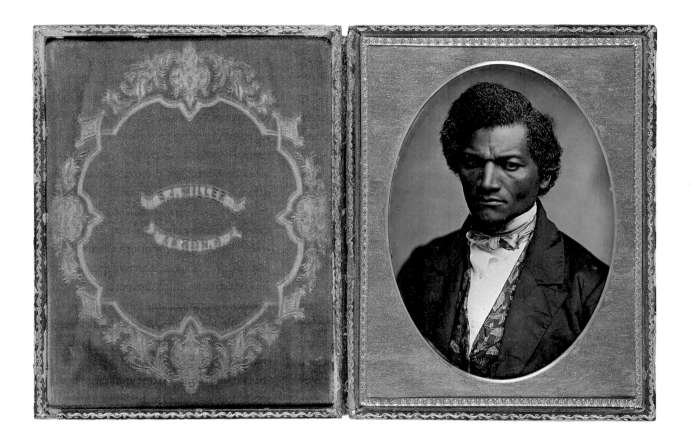

FIGURE 10
Samuel J. Miller.
Frederick Douglass
(see fig. 1), with case.

in Akron from the late 1840s until the late 1850s and spent a time thereafter in New York working for J. Gurney and Son, an important daguerrean firm. An Akron newspaper praised Miller for his skill in "fixing the posture and position of the person being typed,"[26] and at Gurney's his job was that of a "poser" or "posturer."[27] This may suggest Miller was adroit at that momentary rapport with the client assumed necessary to get a good likeness. At the same time, too much should not be made of his position at Gurney's. Big firms such as this one were production lines set up for efficiency and speed. That Miller's job was to pose subjects does not mean that it was more than perfunctory and certainly not that he was a virtuoso portraitist. At the time of his death in 1888, he was a church janitor back in Akron.

The question of how much talent Miller may have had, beyond the technical proficiency that the Douglass plate displays, is impossible to answer without more examples of his work. Unfortunately, none is known at this time. Can we, then, regard Douglass' portrait as a work of art? The fact that it is now in the possession of an art museum does not make it such. (In recent years, museums have been much criticized for just the sort of appropriation and recontextualization of historical artifacts that the acquisition of this daguerreotype represents.) In art the maker is customarily thought of today as the most important element. The modern notion is that his or her signature style or unique genius qualifies the piece to be a work of art.

But this standard is questionable when applied to the daguerreotype. Even more than

with medieval workshops or Renaissance schools of painting, with the most prominent daguerrean firms, such as Brady's and Gurney's, it is often impossible to determine who actually took a particular portrait. While invented in France, the daguerreotype achieved its greatest popularity in the United States because, in part, it came into being at a time when there had been a severe economic depression. Young men were looking for a promising way to make a living that did not require much investment to get started,[28] and the daguerreotype lent itself to this distinctly American spirit of free enterprise. Such opportunism, more than an artistic ideal, was what Brady represented.

Equally important in any consideration of the daguerreotype as an art form is acknowl-edgment of the role that the subject inevitably played. If a subject threw a pout while sitting for a portrait painter, or had a wart on his nose, a painter could subtly change all that in the finished painting, which was often made after the subject had left the studio, or even died. But there was very little a daguerreotypist could do to alter the basic facts of the sitter's looks and attitude. Sitters were vulnerable to the camera, but they could also exert a kind of control that they would never have in a hand-rendered portrait. It is not mere coincidence that the history of the daguerreotype should have been bound up with the history of the two great republics of the era in which it was invented. Ralph Waldo Emerson loved the daguerreotype, calling it "the true Republican style of painting," because, he explained, "the artist stands aside and lets you paint yourself."[29] This is an insight, I believe, into all photographic portraits, but most particularly into the Art Institute's daguerreotype of Douglass.

The daguerreotype was highly regarded in its own day as a kind of democratization of art, for it permitted those who had neither the time nor the money for painted portraits to obtain a likeness nonetheless. But Emerson went beyond that. He proposed a democracy in which portraiture was both an opportunity and a responsibility, like other manifestations of citizenship. "If you make an ill head," Emerson felt, "not [the daguerreotypist] but yourself are responsible."[30] Each person must be his own portraitist. It was a point of view in which I suspect Douglass would have concurred. One of Douglass' most often-repeated talks was entitled "Self-Made Men,"[31] by which he meant those capable of Horatio Alger success stories but also of a more transcendental vision of individual freedom such as that described in Emerson's famous 1841 essay "Self-Reliance." It would follow from Douglass' views that one's portrait, too, must be self-made.

FIGURE 11

J. P. Ball (American; 1825–1904). *Alexander Thorn, Photographer, Wearing Vest, Bow Tie, and Jacket*, c. 1850s. Daguerreotype; 7.6 x 8.9 cm (3 x 3½ in.). Cincinnati Historical Society.

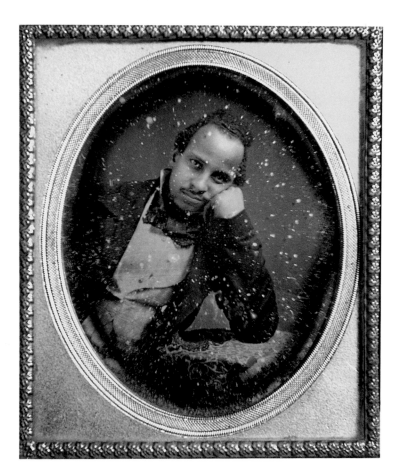

Douglass' comments on portraiture make clear that he would have preferred an African American daguerreotypist to Samuel J. Miller. One reason that articles in his newspaper singled out the daguerreotypist J. P. Ball of Cincinnati was that Ball was an African American.[32] It was rare for members of Douglass' own race to practice this trade. The sentiments expressed in the two Douglass pieces that praised Ball were in line with more critical views Douglass had on white portraitists. He did not trust them to make images of blacks. "Negroes can never have impartial portraits, at the hands of white artists," he said. "It seems to us next to impossible for white men to take likenesses of black men, without grossly exaggerating their distinctive features."[33]

Perhaps. But Ball's own portraiture does not corroborate Douglass' opinion that an African American daguerreotypist would have a unique vision of members of his own race. Ball's subjects typically assumed clichéd poses of gentility found in the daguerreotypes that white operators made of white subjects. In some instances, a posture intended to suggest a life of leisure gives a subject a curiously passive air (see fig. 11). Whether the fault lay with Ball or with his subjects, the effect was the same: the sitters do not appear to have asserted themselves in any discernible way either as African Americans or as individuals. The portraits can be praised only on the paradoxical ground that, by making an African American subject indistinguishable in attitude from a white one, these images aspire to an integrated society. It is conceivable that Douglass would have admired Ball for envisioning such a possibility, since Douglass had the same aspiration himself.

Conversely, Douglass would have seized upon the Agassiz daguerreotypes of slaves to illustrate his point about the inappropriateness of white men's photographs of African Americans. Yet in some of these documents, the subjects do seem to express personal feelings despite, or perhaps even because of, the oppressive conditions under which the images were made. It is true that these portraits are not "impartial." Still, the subjects do not strike us as pathetic. Notwithstanding the absolute domain over them that the slave owners, Agassiz, and the daguerreotypist had, these people impress us with their humanity. A purse of the lips or narrowing of the eyes at the moment the plate was exposed betray the rage that they had to suppress under the circumstances.

Confronted with Miller, and having little faith in white portraitists in any event, Douglass would have done all in his considerable powers to be sure he kept control of the results. More than the story of who took the Art Institute's portrait, the significance in its subject's life of where and when it was taken can help us understand its greatness. The time and place in which it was made were crucial for Douglass. It was the most important period of transition in his life outside of the escape from slavery itself, and Ohio was the scene, or at least the background, of key events.

* * *

Ohio was fertile ground for Douglass, and he went there repeatedly on speaking tours. In 1843 he gave a talk in New Lisbon, Ohio, where the Ohio Anti-Slavery Society proffered him a one-year contract to remain and continue lecturing in the area (he declined). He was back in 1847 with his mentor William Lloyd Garrison (fig. 12), the country's leading white Abolitionist, on a triumphal tour that took them to New Lyme, Elyria, Painesville, Munson, Twinsburg, Richfield, Oberlin, Medina, Massillon, Leesburg, Salem, and Cleveland. In 1848 Douglass was in Cincinnati, Columbus, and (again) Leesburg, from which Delany filed the glowing reports discussed above; that same

FIGURE 12

Anonymous. *William
Lloyd Garrison,*
c. 1855. Oil on canvas;
76.2 x 63.5 cm (30 x
25 in.). National
Portrait Gallery,
Smithsonian Institution,
Washington, D.C.,
gift of Marlies R. and
Sylvester G. March
(NPG.84.205).

FIGURE 13

Map of Western
Reserve area.
Photo: Walter C.
Kidney, *Historic
Buildings of Ohio*
(Pittsburgh,
1972), p. 2.

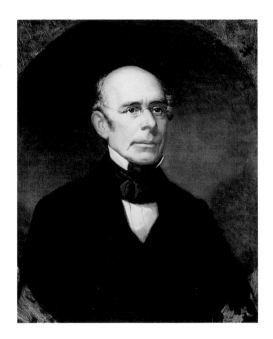

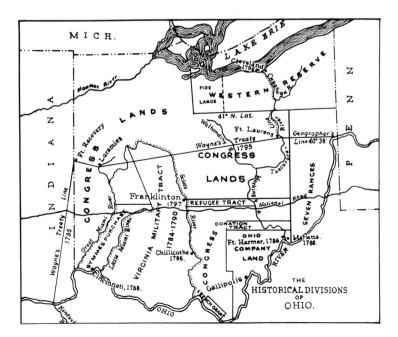

year, he returned to Cleveland to preside over
the National Convention of Colored Freemen.
In 1850 he was once more in Salem, and in 1852
he traveled yet again to Salem and Cincinnati,
and visited Harveysburg, Ohio, and Pittsburgh,
Pennsylvania, as well.

In 1854, at Western Reserve College in
Hudson, Ohio, Douglass delivered the lec-
ture in which he attacked *Crania Americana.*
The Western Reserve (fig. 13), which included
Salem, Oberlin, Massillon, New Lyme, Elyria,
Cleveland, and Akron, was a hotbed of Aboli-
tionism. The original settlers of this northeast-
ern section of the state had come from Con-
necticut, which had continued to lay claim
to the area until 1800. (This is why there is
a sister-city resonance to some town names
like New Lyme, as opposed to Old Lyme,
Connecticut.) In the early nineteenth cent-
ury, the Western Reserve was "still a little New
England," according to one historian of the
Abolitionist movement.[34]

The region was imbued with the liberal
politics and spirit of reform characteristic of
New England. Like the northeastern United
States, northeastern Ohio could be counted
on for many staunch, even radical supporters
of the Abolitionist cause. John Brown was
born in Connecticut but went at an early age
to Hudson, Ohio, where Western Reserve
College was founded in 1825. The shoebox
from which the Art Institute's daguerreotype
was recovered was a veritable time capsule
of the Abolitionist movement in the area. In
addition to daguerrean portraits of Douglass
and George Lippard, a now largely forgotten
Abolitionist writer, the box also contained a
daguerreotype of John Brown clutching the
American flag with one hand while swearing
an oath with the other (fig. 14).

There is no record of Douglass' having
spoken at Akron, but the city is between Cleve-
land and Salem, right in the middle of the

network of towns he was visiting. He must have passed through it more than once. In a letter written during the 1847 lecture tour, he enthused, "The whole Western Reserve is now in a healthy state of Anti-Slavery agitation. . . . The West is decidedly the best Anti-Slavery field in the country."[35] Knowing he was among friends, he would have felt free to assume an appropriately fierce expression when his picture was taken. More than that, had he been aware that the portrait was intended for public display, he no doubt would have played to his audience.

Douglass was not above grandstanding, or what we call image-making today. Limited as the circulation of daguerreotypes was, they were the beginnings of mass media, and the astute public figure of the time recognized the potential for manipulating public opinion.[36] Some of Douglass' wisdom about how to take the right pose in front of a camera may have come from a book of famous speeches he bought when he was only twelve. Having been taught to read by his owner's wife, he scrounged together fifty cents to buy the late eighteenth-century classic *The Columbian Orator*.[37] He cherished this book all his life, and among the pointers he took from it was how to look while delivering an oration, how to project one's image as well as one's voice. The attitudes that Douglass had practiced striking on the podium he undoubtedly knew enough to assume when giving the mute speech that a portrait was.

"I am hardly black enough for the British taste," Douglass reported from England when he was touring and speaking there while money was being raised to buy his freedom, "but by keeping my hair as wooly as possible— I make out to pass for at least half a negro."[38] The remark shows that, up to a point, Douglass had a sense of humor about the need to exploit how he looked. The case was put more soberly by Boston Brahmin James Russell Lowell when

he wrote in 1845, "The very look and bearing of Douglass are an irresistible logic against the oppression of his race."[39] Unlike Garrison or Brown, Douglass was the embodiment of his cause, as he well knew.

Whether or not Douglass was posturing for the camera, we cannot help being impressed by the sheer physical presence of the virile figure we see in the portrait. The struggle in which he was engaged, both before and after his escape from slavery, was profoundly physical in a way that we have to understand in order to appreciate this daguerreotype. When he was a boy, Douglass had been in a scrape during which a cinder fused with iron from a forge had hit him on the forehead and left a scar in the shape of a cross that he carried the rest of his life. This was but the first of a number of fights in which he engaged that seemed to have biblical proportions for him. The most audacious was one in which he struck back at a slave-breaker under whose lash he had been placed in his teens. Risking death for such

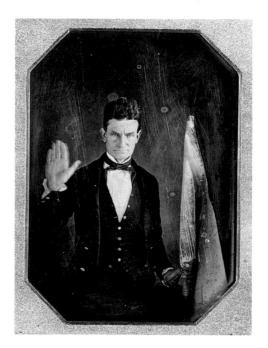

FIGURE 14

Augustus Washington (American [born in Liberia]; 1820/21–?). *John Brown*, c. 1847. Daguerreotype; 10.2 x 8.3 cm (4 x 3¼ in.). National Portrait Gallery, Smithsonian Institution, Washington, D.C., purchased with major acquisition funds and with funds donated by Betty Adler Schermer in honor of her great-grandfather August M. Dondi, who joined Brown's band of "Free Staters" in their struggle with pro-slavery raiders in the Kansas Territory from 1856 to 1858 (NPG.96.123).

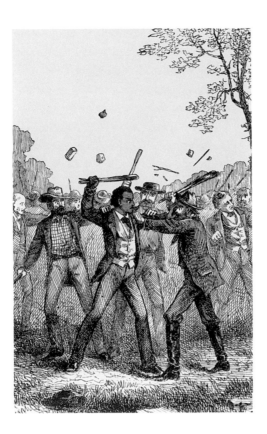

rebellion, Douglass fought the man for hours, much as Jacob wrestles the Angel of the Lord sent to test him in the Book of Genesis.[40] Douglass, too, was struggling to shape his own soul as much as to best an adversary. He would have to carry on the fight throughout his career as an Abolitionist whenever pro-slavery sympathizers would disrupt one of his talks by storming the podium (see fig. 15). Having literally to grapple with his life gave Douglass the sense of himself as a physical being in the world that his portrait conveys with great force.

Physical courage of the sort Douglass displayed when assaulted in public was integral to notions of manhood in nineteenth-century America, especially in the South where he had been raised. But showing himself to be a man in this and every other sense had for Douglass a significance it did not have for the white

men of his day, including those who would ride off gallantly into the slaughter of the Civil War. For under law, Douglass had not been born a man, nor any other sort of human being: he had been born chattel, a piece of property. Being taken for an ordinary man meant something more elemental to him than to any white American. It was an acknowledgment that he was human. "I was *nothing* before," he reflected on the fight in which he bested the slave-breaker. "I WAS A MAN NOW."[41] The significance of the enormous self-possession with which the Chicago portrait of Douglass strikes the viewer lies in the fact that the subject had originally been someone else's possession.

The question of whether Douglass was a man or just valuable property infected even his relationship with his white mentor in the Abolitionist movement, William Lloyd Garrison. The issue came to a head during the period in the late 1840s and the early 1850s that we have been examining, but it had begun almost as soon as Douglass met Garrison in 1841. Invited to tell his story to an Abolitionist convention in Nantucket, Massachusetts, Douglass so moved those assembled that Garrison recruited him to go on the lecture circuit that the American Anti-Slavery Society was establishing in New England. But Douglass quickly realized that he was being taken as a "text" from which Garrison and his followers could draw the moral they wanted to promulgate. As Douglass' powers of articulation increased, Garrison's associates tried to curb him. "Give us the facts," said one. "We will take care of the philosophy." "Better to have a *little* of the plantation manner of speech," advised another. "'Tis not best that you seem too learned."[42]

Because of this sort of treatment, Douglass came to feel that at Abolitionist meetings he was being, as he wrote later, "generally introduced as . . . a '*thing*'—a piece of southern

FREDERICK DOUGLASS CHOOSES HIS MOMENT WESTERBECK

'property.'"[43] The Garrisonians wanted him to go on being a slave even though he was now free. The historian Eric J. Sundquist believed that eventually this made "the lecture platform . . . too much like the auction block"[44]; indeed, the terminology of slaving crept into Douglass' own comments on his situation when he chastised a member of Garrison's inner circle, who was having Douglass' activities in England monitored, not to try to "put me under overseership."[45] Reluctantly, Douglass concluded that "the settling of one difficulty only opened the way for another; . . . and though I had reached a free state, and had attained a position of public usefulness, I was still tormented with the liability of losing my liberty."[46]

Back in Maryland, Douglass' owner, Thomas Auld, had scolded his wife severly when she taught little Frederick how to read. Doing so with any slave was deemed a mistake, and it was against the law in most southern states. Douglass now found that his literacy was putting him in an uncomfortably similar position in the North. His Abolitionist handlers wanted him to play the "darkie" so that members of the public would not develop doubts about his having been a slave. He addressed their incredulity by displaying his learning, rather than hiding it, when he wrote his first autobiography. Because its publication forced him to flee for his life, it left no room for doubt about his having been the slave he said he was.

By the time that the Art Institute's daguerreotype was made, Douglass had already written that first autobiography in order to make clear how he came to be the person whom we see in his portrait. He was still to write two more. Anyone whose self-awareness was that acute has to have realized, as he sat down before the camera, that his daguerreotype could be yet another autobiography. If his portrait was an address delivered without speak-

ing, as is suggested above, so was it his story published without writing.

Despite Garrison's displeasure at the independence Douglass had shown in publishing his autobiography, the two men embarked on their 1847 speaking tour of Ohio shortly after Douglass returned from England. But the trip ended badly when Garrison fell ill and afterward thought, unjustly, that Douglass had gone off and left him without concern. Thereafter, the rift widened. Not only had Douglass written his autobiography, but he declared his plan to start his own newspaper. He intended to do this, he said, expressly to show Garrison and other Abolitionists that "the Negro was too much of a man to be held a chattel."[47] With the founding of *North Star*, Douglass stopped writing for Garrison's journal, *The Liberator*, and, worse still from Garrison's point of view, began taking an independent political stand. Garrison abhorred politics. Regarding the United States Constitution as a corrupt document, he forbade his followers from using either legal action or the election process to further their cause. He believed that only moral suasion—convincing people that slavery was wrong in principle—could bring about abolition.

Most alarming to Garrison was that Douglass might be drifting away from the strict non-violence that Garrison insisted upon. In a speech at Salem, Ohio, late in the 1847 speaking tour, Douglass appalled many in the movement by suggesting that "slavery could only be destroyed by bloodshed."[48] The following year, he met John Brown for the first time, and he eventually became so drawn into Brown's schemes of insurrection that he had to flee to Canada after Brown's disastrous 1859 raid on Harper's Ferry because incriminating notes from him to Brown were uncovered. After all the physical attacks to which Douglass had been subjected, Brown

must have offered a tempting outlet for the pent-up anger Douglass felt. Working with Brown, Douglass might have been able to turn the tables on all the white oppressors who had savaged him over the years.

Brown's old stomping ground in the Western Reserve of Ohio was where his violent tendencies received some of their most fervent encouragement. In 1854, on his way to "bloody Kansas" after the passage of the Kansas-Nebraska Act left the slavery question unresolved in the territories and thereby ignited guerrilla warfare, Brown stopped over in Akron. A public outpouring of support there supplied him with everything he needed for his campaign against slavery in the territories. This included weapons of all description, among them swords presented to him by a former mayor of Akron. These Brown would use in Kansas to hack to death the sons of a man he had shot in a reprisal killing.

But Douglass would eventually reject the terrible, swift sword of vengeance that Brown held out to him. Upon first hearing Douglass speak in the early 1840s, the feminist Elizabeth Cady Stanton described him as "majestic in his wrath."[49] In the glowering visage Douglass presented us in his portrait, the wrath is visible still. But the most frequently given of all his talks, "Self-Made Men," reminds us that Douglass was at his core not an insurrectionist like Brown. He was an assimilationist. Douglass was playing with the phrase "self-made man," adapting it to the challenge he issued to all African American males to make men of themselves by refusing to be mere property, as he had. But he also intended the phrase in the popular sense in which boosters used it to encourage young men to believe that anyone could make his fortune in America.

If Douglass put himself forward as a man in the common terms of his day, including at times a certain reckless bravado, it was because he wanted to take his rightful place as a man in the society of that day. In 1846 he wrote to Garrison, "I am not only an American slave, but a man, and as such, am bound to use my powers for the welfare of the whole human brotherhood."[50] The following year he started *North Star*, and in 1851, when he changed his weekly's name to *Frederick Douglass' Paper,* he also gave it a new motto: "All Rights for All." This was not a sentiment aimed alone at African Americans, for he did not want them to end up alone in American society. The way that Douglass stares us down in the Art Institute's portrait does not threaten us with violence so much as it dares us to extend our rights, privileges, and beliefs to him.

As *North Star* and *Frederick Douglass' Paper* demonstrate, the man we see in this picture had gone his own way, independent of either the violent fanaticism of Brown or the moral absolutism of Garrison. When Douglass

FIGURE 16

Anonymous. *Thomas Auld*, c. 1870. Albumen print; 17.8 x 12.7 cm (7 x 5 in.). Private collection. Photo: courtesy National Portrait Gallery, Smithsonian Institution, Washington, D.C.

was deciding where to set up his newspaper, he knew it must be some place other than Boston because Abolitionists there were under Garrison's sway. He had briefly considered Cleveland, but then he settled on Rochester, New York, where he became involved with a local philanthropist named Gerritt Smith who was to be elected to Congress. This association drew Douglass more deeply into politics and down the road that led to his visits to the White House. Just as he chose a city midway between Boston and the Western Reserve, so did he choose a course of action in between Garrison's and Brown's.

For the rest of Garrison's life, Douglass tried to effect a reconciliation that Garrison steadfastly refused to permit. Where he did not succeed with his mentor, however, Douglass did with his former master. In 1877 Douglass returned to Maryland to visit once again the home of Thomas Auld (fig. 16), the planter who had owned him and who was now on his deathbed. When the two men were reunited, they embraced, and both wept at the national tragedy that their personal relationship represented.

The man who was to be capable of Douglass' gesture toward Auld is the one we see in Samuel J. Miller's daguerreotype. Douglass' was not a monolithic personality like Brown's or Garrison's. His character was more complexly human, more richly self-contradictory, than theirs were. The look that we see on Douglass' face is one of implacable outrage, tempered by a yearning for the common humanity that he knew black and white Americans would have to acknowledge in one another if the Abolitionist cause were ever to triumph. It is a look of reproach for all the injustices that his race was suffering, but also an expression of consternation with himself over what course he should take at this important moment in his life.

Douglass' portrait still has a powerful and unsettling effect on us today because he really became the prophet of his people that he felt destiny had chosen him to be. That is the judgment of his most recent biographer, William S. McFeely, in comments made on an 1852 speech by Douglass typical of his talks throughout the late 1840s and early 1850s. On this particular occasion, as McFeely put it, Douglass not only gave a "prophecy of what the nation's fate would be in less than a decade, . . . but also pointed a haunting finger at our own day, a century after his death."[51]

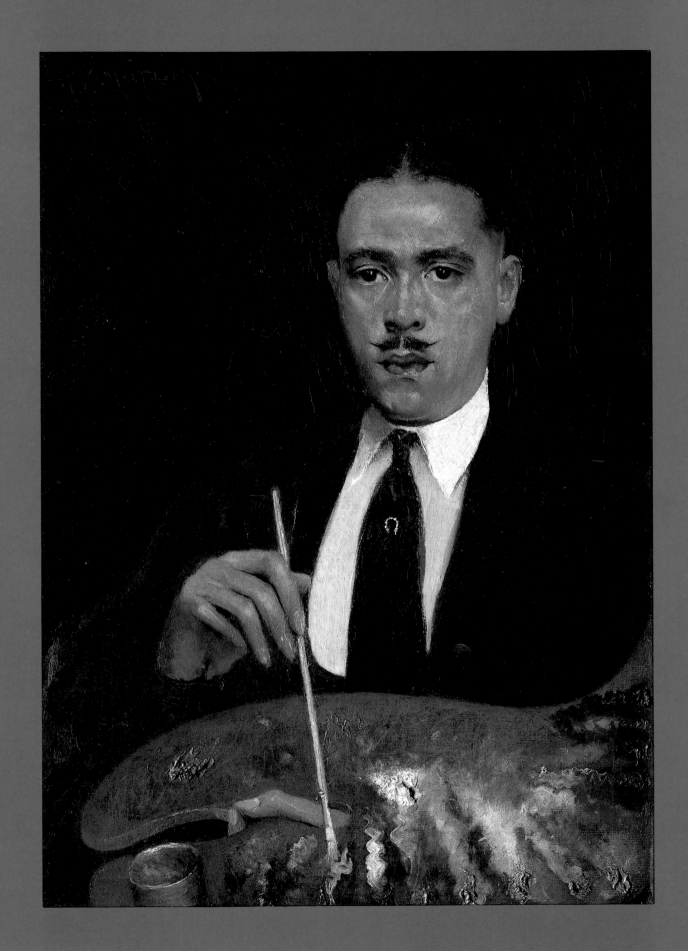

Representing Race: Disjunctures
In the Work of Archibald J. Motley, Jr.

AMY M. MOONEY
Rutgers University

Introduction

In 1978, at the age of eighty-six, the noted Chicago painter Archibald J. Motley, Jr., sat down to reflect on his successful career with Dennis Barrie of the Archives of American Art. Reminiscing about a wide range of topics, he continually returned to the issue of race, asserting that, from the outset, he intended to use his art to portray African Americans "honestly," declaring, "I've always wanted to paint my people just the way they were." He stated further that he wanted to instill a sense of racial pride into his works which could be appreciated "regardless of [the viewer's] race, color or creed."[1]

Embracing the idea that the fine arts are the highest expression of a culture, Motley, along with many contemporaries, believed that the visual arts could improve understanding between races by dispelling stereotypes and raising the consciousness of all Americans. In a 1928 Guggenheim fellowship application, he wrote:

The history of the Negro has indeed been dramatic and perplexing. Many approaches to the heart of the race problem have been tried: political, industrial, educational, economic, sociological, and ethical. Considerable progress has been made along several of these approaches, but I think the art approach is the most practical, the most durable and will cause less friction.[2]

Taking on the "art approach" was an admirable but extremely challenging task, leading Motley and others of his generation down a path that few African American artists had traveled before. As in any transition from old to new, the way was neither always straight nor clear. In this essay, I hope to show how Motley both achieved and contradicted his pioneering goals—to expand the canon of art beyond racial barriers, to create an awareness of and appreciation for African American culture among all races, and to foster greater understanding of the fine arts among African Americans—in a body of work that is at once passionate and complicated, masterful and controversial.

The time in which Motley worked—this essay focuses on the period from the 1920s into the 1940s—saw enormous changes in the United States, from the new vibrancy of life in the nation's growing, northern cities after World War I, to the stress of the Great Depression, and to the sacrifices and traumas of World War II. Inevitably, such major societal shifts affected definitions of class and race. As we shall see, Motley's understanding of race evolved from viewing it as an observable, physical fact to understanding it as an ideological construct dependent on social circumstances.

FIGURE 1

Archibald J. Motley, Jr. (American; 1891–1981). *Self-Portrait*, c. 1920. Oil on canvas; 76.5 x 56.2 cm (30⅛ x 22⅛ in.). The Art Institute of Chicago, through prior acquisitions of Friends of American Art; through prior bequest of Marguerita S. Ritman (1995.239).

Motley both achieved and contradicted his pioneering goals in a body of work that is at once passionate and complicated, masterful and controversial.

His shifting ideas are apparent in a series of portraits of black Americans that he executed in the 1920s, in which he captured a sense of the sitters' dignity and achievements but, in dispelling old racisms, he evoked others. Likewise, in later depictions in which he attempted to scientifically document aspects of the history and beliefs of the peoples of central and east Africa, he incorporated a number of reductive, primitivizing ideas. And finally, in his now-famous genre scenes, in which he succeeded in making vivid the energy, elegance, and amusements of city life, as well as its seductive and corrupting aspects, he employed stereotypes drawn from popular culture that at times undermine rather than support his stated aims.

Biography: Family History and Artistic Training
In his 1978 interview, Motley recalled knowing from the age of nine that he wanted to be an artist: "I just felt it was the only thing I could do; I couldn't do anything else. That's the way I felt within myself."[3] Motley was born in New Orleans; his ancestors included people of African American, European, Creole, and Native American descent. Seeking economic opportunities, the family settled in Chicago in 1894. Motley's father was a Pullman porter for the Michigan Central Rail line, and his mother was a schoolteacher until she married; these were two of the most prestigious professions available to African Americans at this time. Motley's multiracial Louisiana roots, African American heritage, and middle-class status all fostered in him an acute awareness of the social and economic classifications and constraints that skin tone imposed.

In Chicago Motley attended white primary and secondary schools, followed by four years (1914–18) at The School of The Art Institute of Chicago. The senior Motley's acquaintance with industrialist and socialite Frank Gunsaulus, president of the Armour Institute of Technology (now the Illinois Institute of Technology), resulted in an offer to the young Motley of a fellowship to study architecture. He turned it down, convincing Gunsaulus instead to fund his first year at the School of the Art Institute. In subsequent years, Motley received tuition remission and a weekly stipend by working as a janitor at the Art Institute, with such duties as dusting sculpture pedestals in the galleries and setting up chairs for events. Despite the grueling demands of balancing work and school, he earned commendable grades and distinctions, including honorable mentions in life drawing (1917) and in oil painting (1918).[4]

The School of The Art Institute of Chicago was among the first American art academies to admit black students; through the School, Motley met the African American artists Charles C. Dawson, William Farrow, and William E. Scott. About his time at the Art Institute, Motley remembered being treated with "courtesy and respect" by both instructors and fellow students. At one point, however, he reported to the dean the names of students who were harassing him because he was black; they were sternly reprimanded and informed that they would be expelled if this behavior continued.[5]

Shortly after graduation, Motley decided to focus exclusively on African American themes.[6] While his choice of subjects was pioneering, he remained firmly committed to academic principles, such as composition and drawing; he cautioned African American artists that "feeling" alone did not qualify as good art. In a review for the *Chicago Defender*, he wrote, "Give the [artist] of the Race a chance to express himself in his own individual way, but let him abide by the principles of true art, as our [white] brethren do, and we shall have a

great variety of art, a great art, and not a monotony of degraded art."[7]

Motley's decision to concentrate on black subjects coincided with the increasing tensions that led to the outbreak of the Chicago Race Riots of 1919. Perhaps this experience influenced his desire to use art to improve race relations. Neither the riots nor other experiences of racial prejudice precluded his close relationships with whites. On the contrary, his family lived in predominantly white neighborhoods; he counted among his dearest friends Russian-born William Schwartz and Czechoslovakian-born Joseph Tomanek (both painters he met in art school); and, after fourteen years of clandestine courtship, he married a white woman, Edith Granzo.[8]

Motley supported his artistic career in a number of ways, including teaching at Howard University, Washington, D.C., in 1935; working for the Easel and Mural Division of the Federal Art Project of the Works Progress Administration (WPA) from the 1930s to the early 1940s; and creating hand-painted shower curtains for Chicago manufacturers in the 1950s. He exhibited widely and garnered prestigious awards, including the Frank G. Logan Medal and Prize from The Art Institute of Chicago (1925), a Harmon Foundation Award for the Fine Arts (1929), and a John Simon Guggenheim Memorial Foundation Fellowship for Study Abroad (1929).[9] Despite these achievements, Motley, unlike a number of his successful contemporaries, chose not to live in the leading art centers, New York and Paris; rather, he remained in Chicago, dedicating himself to creating, for the most part, works of art that focus on African American culture.

Historical Context: The Issue of Representation
Motley began his career during the Harlem Renaissance, a period marked by the flourishing and growing appreciation of art, literature, and music by African Americans. While named for the vibrancy of life and culture in New York's large, black community, this "Renaissance" extended far beyond Harlem— to New Orleans, for example, and Chicago, whose South Side was a particularly important center, especially for music.[10] For many of the writers and artists of this era, the definition and interpretation of racial identity were pivotal concerns. From the early twentieth century until World War II, black leaders such as W. E. B. DuBois struggled "to protect and project a positive image of blacks in the battle for their civil rights." Through his role as the editor of *The Crisis,* the magazine of the National Association for the Advancement of Colored People, DuBois advocated the use of art as propaganda, in order to counter negative depictions of African Americans that proliferated throughout popular culture and to promote the awareness of the successes and talents of African Americans.[11]

The issue of representation pervaded almost every black public forum, especially newspapers and magazines such as the *Chicago Defender, The Crisis,* and *Opportunity* (published by the Urban League). In 1926 Carl Van Vechten, a photographer, author, and dilettante who encouraged fellow white avant-gardists to explore Harlem, initiated a dialogue among the readers of *The Crisis* with an article entitled "The Negro in Art: How Shall He Be Portrayed?" He posed a series of questions, including:

When the artist, black or white, portrays Negro characters is he under any obligations or limitations as to the sort of character he will play? . . . What are Negroes to do when they are continually painted at their worst and judged by the public as they are painted? . . . Is not the continual portrayal of the sordid, foolish criminal among Negroes convincing the world that this and this alone is

really and essentially Negroid, and preventing white artists from knowing any other types and preventing black artists from daring to paint them?[12]

Most of the readers, black and white, who responded to Van Vechten's queries affirmed the right of artists to freely express themselves, although many also stressed the importance of positive images. As poet Countee Cullen wrote:

There can be no doubt that there is a fictional type of Negro, an ignorant, burly, bestial person, changing somewhat today, though not for the better, to the sensual habitude of dives and loose living, who represents to the mass of white readers the be-all and end-all of what constitutes a Negro. . . . Negro artists have a definite duty to perform in this matter. . . . We must create types that are truly representative of us as a people.[13]

As Motley's paintings and writings make clear, he too was concerned about definitions of race and about what could be considered "truly representative" of African American culture. In a 1947 essay entitled "How I Solve My Painting Problems," written at the request of the Harmon Foundation, a philanthropic organization based in New York that promoted African American artists through exhibitions, catalogues, and awards, Motley stated:

For years many artists have depicted the Negro as the ignorant southern "darky," to be portrayed on canvas as something humorous; an old southern black Negro gulping a large piece of watermelon; one with a banjo on his knee; possibly a "crap shooter" or a cotton picker or a chicken thief. This material is obsolete and I sincerely hope that with the progress the Negro has made he is deserving to be represented in his true perspective, with dignity, honesty, integrity, intelligence, and understanding.[14]

Representation Through Portraiture

According to art historian Wendy Greenhouse, Motley intended to be a portrait painter.[15] This desire grew out of his studies at the School of the Art Institute, where he took classes in portraiture, figure drawing, and composition with such Chicago artists as Karl Buehr, John Norton, and George Walcott. As a student, Motley learned that, in addition to capturing likenesses, portraits are intended to convey social status, profession, character, and psychological state. For many years, American art academies had been influenced in their teaching by such pseudosciences as phrenology (studying the shape and protuberances of the skull to determine character and mental capacity) and physiognomy (judging character on the basis of facial and other body features). A plethora of publications and manuals appeared in the last decades of the nineteenth century and the early years of the twentieth to which teachers and students of anatomy could refer. According to *Characterology, An Exact Science,* for example, the application of phrenological and physiognomic principles made it possible "to diagnose character so accurately that truth and virtue will be cultivated, and evil will be shunned by all for the fear of discovery."[16] Armed with these kinds of analytic approaches, artists assumed that they could scrutinize an individual's appearance to expose his or her invisible, internal self. However, the application of these pseudosciences could be pernicious: claiming that there is a direct connection between physical characteristics and mental aptitudes, many of their supporters invoked them to justify the false belief that certain races, including Africans and African Americans, had limited mental capabilities.[17]

By the time Motley entered art school, such ideas were standardized in instruction manuals for drawing classes, including those

at the School of the Art Institute, where the traditional curriculum followed the lead of New York's National Academy of Design.[18] Despite the fact that this kind of thinking encouraged countless bigoted depictions of African Americans of the sort that he wished to eradicate, Motley appears to have been influenced by such tenets in his portraits, as were many artists of his era. This is demonstrated by the early self-portrait in the Art Institute (fig. 1), in which he showed himself at work, displaying the trappings of a fine artist, including a dark-brown painter's smock and a palette arranged with brightly hued pigments. The conventional, half-length, frontal pose communicates Motley's serious demeanor and academic training. Beneath his protective smock, he is nattily attired in a black vest, white shirt, and black tie embellished with a diamond horseshoe tie tack. With his pomaded hair and dapper moustache, Motley presents himself as the epitome of style and formality.

A comparison of the painting with a contemporaneous photograph (fig. 2) makes it clear that the artist depicted himself accurately. Yet, in keeping with the ideas of phrenology and physiognomy, in his self-portrait he stressed certain aspects of his appearance, further imbuing his image with subtle signs that indicated his talent, refinement, and acumen. For example, he highlighted his forehead: a high forehead was said to "betoken an inquiring mind, high ideals, conscientiousness and religious inclinations." Likewise, medium-sized, slanted eyes such as his were believed to indicate keen insight and self-esteem, qualities that the artist further conveyed through his frank and direct gaze. Motley also emphasized his nose by highlighting the bridge and painting the nostrils in shadow. Physiognomic treatises defined such a nose as aquiline and associated it with a refined

and aristocratic nature. Finally, the artist's elongated, tapered fingers also seem to conform to these conventions, communicating an elevated social status and artistic sensibility.[19]

Stereotypes shaped by such pseudo-sciences seem to have influenced Motley's understanding of the problematic issues of racial and economic classifications in American culture. The artist must have been aware that his light-skinned complexion, together with his educational background and family connections, secured him a privileged position in African American society.[20] Indeed, skin tone, as Greenhouse has pointed out, "became a central motif in his art," first in a series of depictions of women of varying mixed ancestry and later in his studies of city life.[21] The intersection of race and class in Motley's world complicated his goal of "trying to fill," as he put it, "what they call the full gamut, or the race as a whole, not only, you know, being terribly black but those that were very light and those that were in between."[22] Despite his stated intentions, the artist's use here of the word "terribly" reveals a problematic bias.

Motley titled his portraits of racially mixed women with the Creole classifications "Mulatto," "Quadroon," and "Octoroon." Distinguishing the amount of African or

FIGURE 2

Photograph of Archibald J. Motley, Jr., in Karl Buehr's School of the Art Institute class, 1917. Collection of Archie Motley and Valerie Gerrard Browne. Photo: courtesy Chicago Historical Society, Archives and Manuscripts Collection.

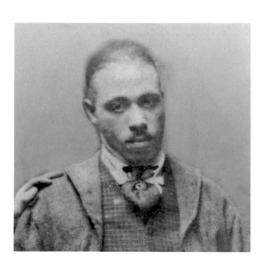

African American blood in his models (half, quarter, and eighth, respectively), these designations at one time determined social status and legal rights as well.[23] The necessity for such distinctions arose during slavery, as the sexual relationships forced on female slaves by their white masters resulted in children of mixed heritage who were granted material and social privileges and, in some cases, freedom. Thus, the amount of "white" or "black blood" was a factor in determining opportunities available to African Americans struggling with segregation and Jim Crow laws.[24] The Creole classifications evolved into the "one-drop rule"—still evoked in modern times—according to which

any person with one drop of African American blood is defined as black. Given that Motley's understanding of race was shaped by this history, as well as by pseudosciences, it is not surprising that he considered these portraits "not only an artistic venture, but also a scientific problem."[25] This helps explain his decision to structure his portraits according to the Creole terms for various racial mixtures, a system that enabled him to classify the physical and psychological characteristics which reveal a sitter's social status.

In *The Octoroon Girl* (fig. 3), Motley portrayed an elegant young woman seated on a sofa against a warm-red wall. In this beautifully balanced composition, the model is posed off center, between a gold-framed painting at the upper left and at the lower right a table on which books and a decorative figurine are arranged. Demonstrating the artist's skill in rendering a variety of textures, she is stylishly dressed in a black-velvet dress trimmed with red satin and a close-fitting green hat and wears a jeweled pendant on a delicate gold chain. Her left hand is carefully positioned to display what appears to be a diamond engagement ring, while, in her right hand, she holds a pair of leather gloves. As in Motley's *Self-Portrait,* the sitter looks directly at the viewer, conveying a sense of confidence and composure. Writing years later about *The Octoroon Girl,* Motley described how difficult it was to determine whether a light-skinned person is "pure Caucasian or Octoroon." He stated:

I have seen Octoroons with skin as white as people from Northern Europe such as the Baltic countries; with blonde straight hair, blue eyes, sharp well proportioned features and extremely thin lips. The head is normally and well constructed and symmetrically balanced. The construction of the body is such as an elongation of the arms, a tendency toward a weak bone

FIGURE 3

Archibald J. Motley, Jr. *The Octoroon Girl,* 1925. Oil on canvas; 96.5 x 76.2 cm (38 x 30 in.). Collection of Carroll Greene. Photo: courtesy Chicago Historical Society, Archives and Manuscripts Collection.

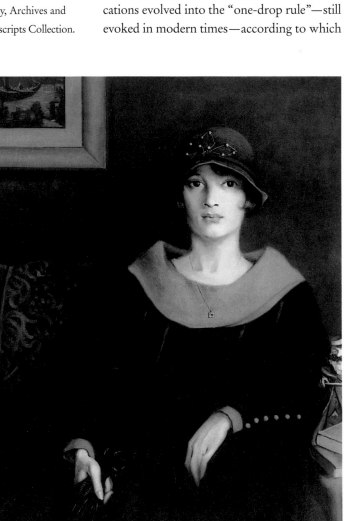

construction found in many of the dark purer Negroes and large fat heels are non-existant.[26]

Because, for Motley, little distinguished "Octoroons" from whites, he depicted women of this "racial type" as elegant and upper class, with Euro-American features and signs of wealth and privilege. To him, such subjects not only appeared cultured and accomplished but also conformed to white America's ideals of beauty and social standing, which Motley shared.

First displayed in 1925 at The Art Institute of Chicago, where it was awarded the prestigious Frank G. Logan Medal, Motley's painting *A Mulatress* (fig. 4) is a three-quarter-length portrait of a woman seated, one leg crossed over the other, in a high-backed armchair. The line created by the bend of her knee is repeated in reverse by a draped table with a vase of flowers and a statuette. Hanging above is a landscape painting in a gold frame.[27] As he did in the two portraits discussed above, Motley meticulously described the details of the sitter's clothing and accessories. Her long, sleeveless gown is embellished with a floral pattern; her jewelry includes a pearl necklace, coral earrings, a brooch, and a gold bangle. Again the artist displayed his bravado in depicting expressive hands: the model rests one in her lap, and her other on the chair arm. Her poise, chic hairstyle, and straightforward gaze seem to indicate a modern self-assurance and sharpness.

Obviously an important work for Motley, *A Mulatress* was featured on the cover of the catalogue accompanying the artist's first one-person show, at the New Gallery, New York, in 1928.[28] Motley described the sitter as possessing "an extremely fiery temper" and explained that, in this work, he had intended to "express the true Mulatress," stressing "the physiognomy of the face and the personality

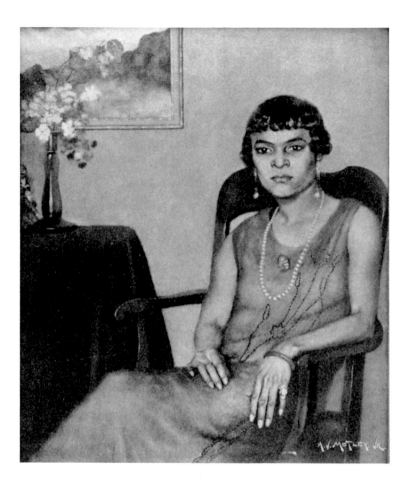

and relation of the hands to the face."[29] In this case, Motley's categorization seems to have been influenced by a character type called the "tragic Mulatto," who appears in literary and visual texts of the late nineteenth and early twentieth centuries as promiscuous and unable to control her emotions, which inevitably results in her demise.[30] The severe, jutting angle of the model's chin and firm set of her mouth are striking. The artist could have read in physiognomic texts that these characteristics indicate a defiant, selfish, and vindictive disposition.[31] Motley included the various props— all accouterments of civility—in an attempt to, as he put it, "reduce to a certain extent the fiery appearance of the figure" and restrain her "temperamental personality."[32] While the setting indicates that a "Mulatto" woman could

FIGURE 4

Archibald J. Motley, Jr. *A Mulatress,* 1924. Oil on canvas; 86.4 x 73.7 cm (34 x 29 in.). Location unknown. Cover illustration of New York, The New Gallery, *Exhibition of Paintings by Archibald J. Motley, Jr.,* exh. cat. by George S. Hellman (1928). Photo: courtesy Chicago Historical Society, Archives and Manuscripts Collection.

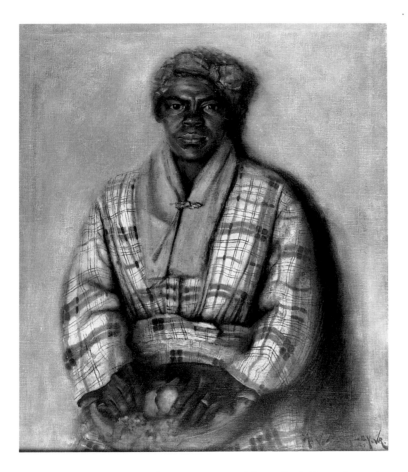

FIGURE 5

Archibald J. Motley, Jr.
Mammy, 1924. Oil on
canvas; 82.5 x 71.1 cm
(32½ x 28 in.). Art
and Artifacts Division,
Schomburg Center
for Research in Black
Culture, The New
York Public Library,
Astor, Lenox and
Tilden Foundations.

also occupy a position of privilege, the artist
nonetheless emphasized her sexualized person-
ality in order to distinguish her from the upper
echelons of African American society reserved
for "Octoroons."[33]

In contrast to Motley's portrayal of the
position and character of racially mixed women
is his depiction of a dark-skinned African
American (fig. 5). Variously titled *Mammy,*
Woman Peeling Apples, and *Nancy,*[34] this
arresting image shows a middle-aged woman
sitting against a white wall with a bowl of
apples in her lap. Motley's treatment of his
subject is as usual carefully observed and ren-
dered. Instead of the tastefully appointed,
modern backgrounds of Motley's *Octoroon
Girl* and *Mulatress,* this setting is plain. The
figure wears a mismatched ensemble com-
prising a blue-and-white checked dress and an

orange-and-green kerchief covering her gray
hair. The purple scarf, pinned around her
neck with a brooch, seems a last-minute addi-
tion, intended to formalize her appearance for
this occasion. She possesses no signs of wealth:
she holds not the gloves of a life of leisure but
rather a paring knife and an apple; she does not
pause in her work as she poses for the artist.
Unlike the model for *A Mulatress,* her wrin-
kled face, with its large eyes and lips and broad
nose, seems tired and kind, and her body
expansive and soft. While the composition's
spartan simplicity emphasizes the subject's
quiet strength and dignified demeanor, the
fact that Motley did not place an African
American with dark skin within the same
material circumstances as he did individuals
with lighter skin seems noteworthy. Perhaps
the settings and props the artist used reflected
the specific circumstances of the individuals
who posed for him. However, Motley re-
peated the same accessories in painting after
painting, which suggests that he exerted con-
trol over how his sitters were depicted. Thus,
it is plausible that in *Mammy* he also revealed
judgments of his own related to skin color,
physiognomic features, and class.

Motley's portrait series, sensitively con-
ceived and beautifully executed, is nonetheless
marked by the complexities that resulted from
the intersection of race and class in his world
and that prevent us from understanding the
distinctions he made between African Ameri-
cans. On the one hand, he relied on established
stereotypes that equated physical appearance,
including facial features and skin color, with
social status and personality traits, thus
generalizing racial "types"; on the other, he
portrayed individual African Americans at
a time when this was an uncommon practice,
in order to convey the subjectivity, achieve-
ments, and variety among black Americans. In
these works, the artist's goal—to depict a "full

gamut"—also allowed him to declare his own racial identity and place in a social hierarchy.

Constructing a Cultural History

In 1927 Motley received a letter from George S. Hellman, director of the New Gallery in New York, where the artist was scheduled to have his first solo exhibition. Revealing his own prejudices, Hellman suggested that Motley paint "some pictures showing various phases of negro life in its more dramatic aspects—scenes, perhaps, in which the voodoo element as well as the cabaret element—but especially the latter—enter."[35] Motley produced five works with African themes: *Kikuyu God of Fire* (fig. 6), *Waganda* [Uganda] *Woman's Dream* (fig. 7), *Waganda* [Uganda] *Charm Makers, Devil-Devils,* and *Spell of the Voodoo.*[36] Of these, only *Kikuyu God of Fire* is extant. These compositions, along with portraits, genre images, and cabaret scenes, were included in the exhibition, which took place in 1928 and generated a great deal of publicity.

Critics at the time assumed that the series Motley exhibited at the New Gallery represented an attempt to forge a connection with his ancestral heritage, to imagine himself as part of the cultures and countries he depicted. In an article on the exhibit to which the *New York Times Magazine* devoted a two-page spread, the series is described as follows:

Myriad age-old racial memories drift up from Africa and glowing islands of the sea to color more recent ghostly memories of plantation days when black was black and slaves were slaves. . . . Mr. Motley appears to be forging a substantial link in the chain of negro culture in this country. . . . The same fundamental rhythms are found whether the setting be a jungle presided over by witchcraft or a cabaret rocking to the syncopation of jazz. . . .[37]

This author's commentary demonstrates the romanticized, reductivist, and primitivist attitudes that were prevalent during the 1920s; his suggestion that Motley's paintings represent a link with the artist's African ancestry reflects, as we shall see, expectations of African American artists that emerged at this moment.

In the catalogue that accompanied Motley's exhibition, the gallery's director dismissed the importance of Motley's portraits, declaring that "the public will find most fascinating those paintings which depict Voodooism— the superstitions, the dreams, the charms of East Africa."[38] Certainly, Hellman's recommendation demonstrates his awareness of the commercial viability of works of art that were perceived as addressing the "primitive." At this time, many equated African American culture and its most predominant artistic voice— jazz—with the idea of a sensationalized, savage Africa and focused their yearning for the exotic and uninhibited on this construct.

Leaders of the Harlem Renaissance also championed the link between African Americans and Africa, but for very different reasons. As philosopher, teacher, and critic Alain Locke asserted, by re-establishing the historic continuity that was destroyed by slavery, African American artists could help their race reclaim its ancestral heritage. In his landmark 1925 publication, *The New Negro,* he urged African American artists to incorporate the formal elements and themes of African art into their work in order to arrive at an "authentic" racial self-expression. In so doing, he believed, black artists would surpass European modernists such as Pablo Picasso, who freely borrowed formal ideas from African art without, in his view, having a valid connection with it. Essentially, Locke prescribed adopting a modernist aesthetic: reducing realistic, African-inspired subject matter to pure form. He hoped this would establish a new pictorial

FIGURE 6

Archibald J. Motley, Jr.
Kikuyu God of Fire,
1927. Oil on canvas; 91.4
x 104.4 cm (36 x 41⅛ in.).
Collection of Judge
Norma Y. Dotson.

tradition whose authenticity would distinguish it from the biased European and Euro-American view of Africa as the uncivilized "Dark Continent."[39]

The artist who most impressed Locke for achieving this goal was Aaron Douglas. In his depictions of Africa (see Portfolio, no. 4), Douglas merged the geometric forms of African and Egyptian art with modernist modes, thereby generalizing and reducing his subjects to abstracted and highly stylized imaginings of "primitive" life. Locke found Douglas's elegant, modernistic interpretations of African subjects much more appealing than Motley's, which he dismissed as experimental fantasies.[40] In fact, although Motley was clearly aware of the vogue for "primitivism" among whites, when conceiving his African compositions,

he totally eschewed an avant-garde manner. Reflecting his commitment to the conservative training he received at the School of the Art Institute, he produced works that, in their attempt to achieve an epic and mythic expression, are much closer in spirit to the visionary images of nineteenth-century Romantic artists such as Thomas Cole and Eugène Delacroix.[41]

In *Kikuyu God of Fire,* the artist imagined a giant, demonic figure, complete with horns, bat ears, and gnashing teeth, rising above a dense, dark forest dramatically illuminated by an abandoned fire. His long arms, ending in menacing claws, reach out beyond the sparks and smoke toward a group of fleeing, tiny figures seeking shelter in the jungle's depths. At the right, peering out at the viewer, is an owl, an odd presence in this frightening

FIGURE 7

Archibald J. Motley, Jr. *Waganda* [Uganda] *Woman's Dream,* 1927. Oil on canvas; dimensions unknown. Location unknown. Reproduced in the *New York Times Magazine,* Mar. 25, 1928. Photo: courtesy Chicago Historical Society, Archives and Manuscripts Collection.

scene. *Waganda* [Uganda] *Woman's Dream* offers an equally bizarre view of Africa, this time in daylight. Picturing an African woman's nightmare, Motley depicted a lush, tropical forest as the site of terror. Here human encounters with animals—gorillas and prehistoric creatures—result in carnage: a woman at the center is being devoured by a dinosaur, and a second female, at the lower left, is about to be ambushed by another beast. Leering faces are visible between trunks and leaves.

I am interested in these images not because of their quality; in fact, it must be said that they are among Motley's least successful works because of their artificiality (for the *New Yorker* critic writing about Motley's show in 1928, they represented "boys' imaginings of Voodooland"[42]). Rather, it is his

reasons for agreeing to this market-driven request, beyond a desire to please a dealer and to gain financial reward, and the methods he adopted to achieve the series that I find intriguing and most revealing.

Since he had never been to Africa and could not paint these subjects from firsthand knowledge, Motley decided to research the themes he was requested to address. He gleaned information from popular magazines—such as *Asia: The American Magazine of the Orient, National Geographic,* and *Survey Graphic*—that featured articles illustrated with photographs of Africa's rain forest.[43] He wrote extensive "legends" (as he called them) that echo the authoritative tone of the explanatory texts which accompany the photographic illustrations of these magazines.[44]

While Motley's efforts to represent Africa scientifically indicate his desire to be objective, the sources on which he relied can hardly be considered scholarly. Instead, such popular publications satisfied the fascination of most Americans of this era—Motley among them—with an Africa they imagined to be backward, exotic, and dangerous. The popularizing of archeology and geography at this time is reflected as well in the depictions of exotic lands and peoples by Miguel Covarrubias, an artist Motley admired. During the 1920s, this Mexican artist lived in New York, where he first became known for his piercing and amusing caricatures. Whether he painted life in Harlem, whose famous nightclubs he frequented, or illustrated the past and present cultures of such places as Mexico, Central and South America, Africa, or Bali, Covarrubias's images (see fig. 8) retain the brashness and exaggeration of caricature.[45]

While the fantastic and cartoonish qualities of Motley's African images are perhaps the result of his lack of authentic experience of

Africa and his reliance on popular sources, as well as his inability to fully embrace a subject the artist was asked to address, the series nonetheless reflects his deliberate aims. Rather than using these works to forge connections, as many have posited,[46] Motley, in my belief, very consciously set out to establish the evolutionary and cultural distance of African Americans from Africa. By distinguishing between the present experience of urban modernity in the United States and a rural, mythic Africa, by emphasizing the sensational, and by concentrating on stereotypical "native customs," he hoped to demonstrate that African Americans were far more evolved than their African forebears. Motley relegated Africa to the past, where it could become most definitely foreign and "Other."[47]

In producing this series, Motley's theories about race and class seem to have changed. In his earlier portraits, he had explored the intersection of race and class through the sitters' physical appearance and material trappings, relying in part on tenets drawn from phrenol-

FIGURE 8

Miguel Covarrubias (Mexican; 1904–1957). *Orchestra,* 1927. Illustration from Miguel Covarrubias, *Negro Drawings* (New York, 1927), fig. 40.

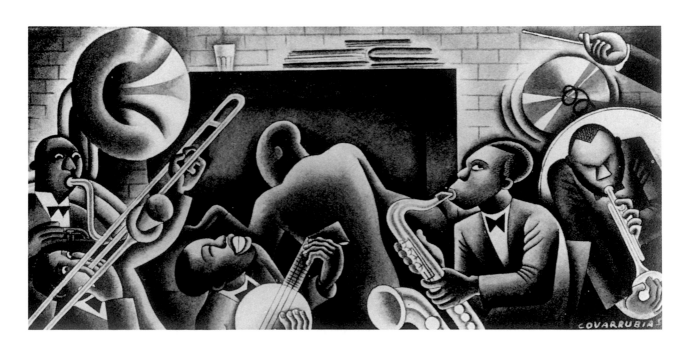

ogy and physiognomy. His African scenes reveal him to be more interested in the cultural and historical forces that determine racial identification and social status. This approach was not new: writing in *The Crisis* in 1910, the anthropologist Franz Boas attacked racist assumptions about the superiority of the white race based on physical characteristics, arguing that the conditions of slavery were responsible for the seeming lack of cultural achievement among African Americans.[48] Boas's contention reflects the then-growing belief that racial identity is not biologically determined but depends on specific historical circumstances.[49]

In 1928, the year after he researched Africa for his series, Motley proposed to the Guggenheim Foundation that it fund his first visit to Paris, "to study painting under the instruction of eminent European masters"; and then southern Africa, so that he could create a series of works documenting the history of the "Negro from his uncivilized and unprogressive stage, through the years to his present state of civilization in the more progressive countries." Significantly, he did not mention any interest in retracing his cultural roots or in forging a spiritual connection with African people. Instead, he hoped to demonstrate the evolution of African Americans and to "bring about better relations and a better mutual understanding between White and Colored races. [This] will be another step toward culture and better civilization."[50] Even though his thinking had shifted, Motley's interest in types continued.

Life in the City: The Modern Experience
Motley did not receive a Guggenheim Fellowship in 1928. He reapplied successfully in 1929 with a different agenda, seeking to go to Paris to "study the masterpieces in the Louvre, as to color, composition, drawing and technique" in order to carry out "a serious study of the

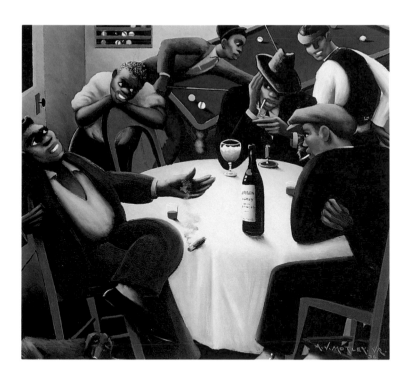

relationship of cold and warm light."[51] While in Paris, Motley completed a few portraits and began to execute multifigural compositions, focusing on cabaret and street scenes. Returning to Chicago in 1930, he concentrated almost exclusively on images of African American life, especially in Bronzeville—the neighborhood of Chicago's South Side that was home to most of the city's black population—producing these, as well as historical and other genre subjects, for the Illinois Art Project of the WPA.

The WPA encouraged artists to create images that celebrated the experience of the common citizen, presenting the past and present of the United States and its people, their labors, leisure, families, and communities, in "typical" ways. Motley developed a visual language—strong patterns, contrasting lights and darks, skewed perspectives, a palette dominated by a single hue—and a cast of characters—each with certain postures, gestures, expressions, and habits—that he used, with some variation, in composition after composition.

FIGURE 9
Archibald J. Motley, Jr.
The Liar, 1936. Oil on canvas; 81.8 x 91.4 cm (32 x 36 in.). Permanent Collection, Howard University Gallery of Art, Washington, D.C.

His works for the WPA, both easel paintings and murals, depict history and scenes of everyday life, such as picnics, parades, and carnivals, as well as more suspect entertainments such as card-playing (gambling) and bar-hopping, smoking and drinking. For example, *The Liar* (fig. 9) draws the viewer into a local pool hall, where a group of males is gathered. In the background, two men play billiards on a table that tilts upward dramatically. At the table in the foreground, on which sit a big bottle of whisky, two shot glasses, and a glass of beer, a tale is being spun by the liar, who leans his chair back boastfully, gesturing emphatically to make his point. His crossed knee comes dangerously close to the burning stub of a cigar hanging off the edge of the table. The two men listening to the story are dressed in a far more fashionable manner than

the storyteller. Their skepticism, evident from their postures, contrasts with the fascination of a young boy, who leans over a chair as if to catch every bit of the exchange. To convey a clear narrative, Motley exaggerated the postures, the facial features, and the expressions of the protagonists.

In another work from this period, *Saturday Night* (fig. 10), people sit at a bar on the left and around tables on the right. A band plays in the background and, in the center, a scantily clad showgirl performs. Although many ignore her, an obviously tipsy gentleman in the foreground is clearly so entranced that he tilts his chair back precariously to get a better look. Not only did Motley use here the motif of the tipped chair, but also that of the stogie hanging off the table's edge. The composition's exaggerated perspective and

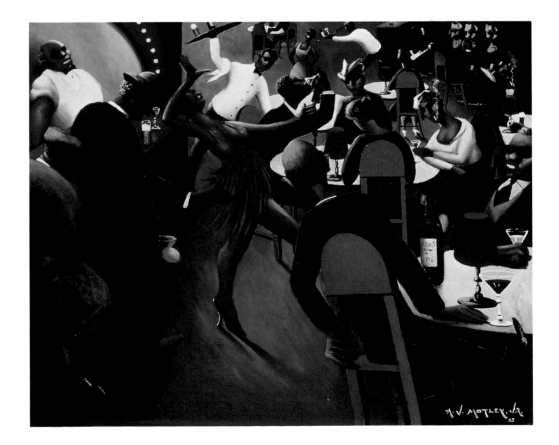

FIGURE 10

Archibald J. Motley, Jr. *Saturday Night*, 1935. Oil on canvas; 81.3 x 101.6 cm (32 x 40 in.). Permanent Collection, Howard University Gallery of Art, Washington, D.C.

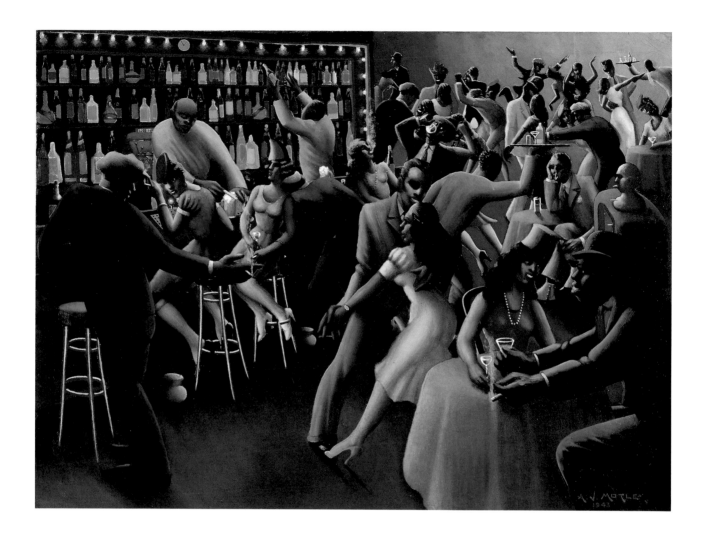

distorted forms make the entire scene appear to sway vertiginously, as if to suggest that it is impossible not to be affected by such a charged atmosphere.

Painted in 1943, the Art Institute's *Night-life* (fig. 11) is perhaps the finest of Motley's late Bronzeville images. It depicts a crowded cabaret, with people seated around tables on the right and at a bar on the left. As the clock on the bar indicates, it is one o'clock in the morning, and the place is hopping with drinkers and dancers. Two bartenders serve customers and restock the well-lit and plentiful display of liquor, and a number of couples dance furiously in the background to music

provided by the jukebox at the right. The strange head on top of the jukebox may have been an inventive coin slot, with its tongue poised to catch and consume one's change. Motley unified his composition through his use of repeated forms and a high-key burgundy tone that bathes the entire scene in intense, artificial light. Typical of his compositions of the 1930s and 1940s, the figures here are tightly interconnected; they are arranged along a sharp diagonal which compresses the space so that it appears to be sliding forward, as if to suggest that we are watching a musical performance on a pitched stage. Motley's mastery of his medium and subject is seen in the

FIGURE 11

Archibald J. Motley, Jr. *Nightlife,* 1943. Oil on canvas; 91.4 x 121.3 cm (36 x 47¾ in.). Restricted gifts of Mr. and Mrs. Marshall Field, Jack Guthman, Ben W. Heineman, Ruth Horwich, Lewis Manilow, Beatrice C. Mayer, Charles A. Meyer, John D. Nichols, and Mr. and Mrs. E. B. Smith, Jr.; James W. Alsdorf Memorial Fund; Goodman Endowment (1992.89).

vibrant palette, assured brushwork, carefully structured composition, dramatic lights and darks, and rhythmic patterns.

In "Characteristics of Negro Expression," Zora Neale Hurston defined settings such as those of *Saturday Night* and *Nightlife* as "jook joints." "Jook," she wrote, "is the word for a Negro pleasure house. It means a bawdy house . . . where the men and women dance, drink and gamble." "The idea of the Jook," she explained, "is to gain sensation, and not so much to exercise."[52] As if conforming to Hurston's description, the man and woman dancing at the center of *Nightlife* appear to lose themselves in slow, swaying movement. A man at the bar gestures toward the couple, perhaps suggesting to the woman beside him that they too should join in. In contrast, the rowdy, boisterous figures in the background are performing the more frantic lindy hop and other dances.

Despite the energy of these images, they include elements that are quite unsettling. As Sharon F. Patton noted, the ebullience of Motley's crowded scenes is frequently undermined by a sense of social isolation.[53] A male

figure, elegantly attired in spats, sits alone at a table in the middle-right section of *Nightlife.* While he may be in the depths of an intoxicated stupor, he may also represent a detached observer, surveying but not participating in the action. This sense of disengagement is augmented by the masklike faces of a number of the figures, such as the man seated in the lower-right corner and a number of the dancers in the upper-right. Rendered in a kind of shorthand, they have the bulging eyes and enlarged lips of minstrel figures. These kinds of images proliferated in the United States and Europe from the antebellum period onward, disseminating stereotypes that degraded and parodied African American culture.[54] Their appearance, over and over, in Motley's genre paintings is disturbing and difficult to dismiss.

Certainly, as we have seen in the case of Covarrubias, Motley was not the only artist to employ caricature and stereotype in his paintings. These were stock-in-trade for many regionalists and WPA artists, who tapped into the vernacular not to promulgate prejudice but rather to extend the appeal of their art to a wide audience through the easy recognition of types and the use of humor. Nonetheless, it is important to note that there were any number of ways, in addition to employing racial or class generalizations, to achieve this goal. This can be seen in Reginald Marsh's 1932 tempera *Harlem, Tuesday Night at the Savoy* (fig. 12). An artist-spectator of urban life and entertainments, Marsh filled the foreground of this work with an energetic crowd of dancers, an engaging melange of a variety of sizes, shapes, and race such as could be found at this famous Harlem nightspot on any given night. Unlike Motley, Marsh did not generalize his figures' features; he seems in fact to have taken great care to individuate each of them. Motley's use, therefore, of racial stereotypes, given his stated desire to depict

FIGURE 12

Reginald Marsh (American; 1898–1954). *Harlem, Tuesday Night at the Savoy*, 1932. Tempera on board; 91.4 x 121.9 cm (36 x 48 in.). Collection of Charles and Marjorie Benton. Photo: courtesy D.C. Moore Gallery, New York.

African Americans with "dignity, honesty, integrity, intelligence, and understanding," requires further thought.

The pervasiveness of stereotypes, as well as of stock characters, in Motley's works could reflect his sense of distance from his subjects and his continuing perceptions of class. Even as a child, Motley was aware of the distinctions between himself and the African Americans he painted. When discussing his formative experiences, he mentioned how his need, as a boy, to find other blacks led him "to go to the places where they gathered." He described watching African American men at a pool hall called Rick's and being drawn to their expressive nature and "peculiar sense of humor." Motley explained that he "would study all those characters" as a way of getting to know his own people.[55] Motley enjoyed easier access to this world as a black man than whites did; yet his awareness of his own social and economic position perhaps prevented his full participation.

Moreover, this distance might have been necessary for other reasons. The cabarets such as those in *Saturday Night* and *Nightlife* were the home of jazz; until World War II, jazz had to make itself heard from the periphery of American life because of its affiliation with vice.[56] Many Americans, black and white, considered jazz cabarets to be the milieu of alcoholics, prostitutes and their patrons, and drug dealers. Thus it was hard to separate the pleasures of the music from these more disreputable, even dangerous, activities. In his images, Motley established a safe distance from the action, a space that permits viewers to observe, enjoy, and, most importantly, control their viewing situation. Like records and sheet music, Motley's cabaret paintings allowed an audience a risk-free way to enjoy the freedoms from American puritanical restraints that jazz represented.[57]

Conclusion

The strengths of Archibald J. Motley, Jr.'s art—its sincerity, expressiveness, innovative subjects, keen observation, and technical mastery—were, and continue to be, recognized and celebrated. He is represented in many prestigious institutions, including, besides The Art Institute of Chicago, the Ackland Art Museum (Chapel Hill, N.C.), Hampton (Va.) University Museum, Howard University Gallery of Art (Washington, D.C.), St. Louis Art Museum, and the Schomburg Center for Research in Black Culture (New York).

The disjunctures between Motley's goals and his depictions reveal the magnitude and challenges of the task he undertook and the idiosyncratic nature of his own experience. Like other contemporaries of his race and profession, Motley was expected to create consistently positive images of and for African Americans, an unrealistic and ultimately impossible task. Rather, Motley produced a complex and very personal vision of American life. The artist's willingness to tackle these new and difficult subjects in the face of prevailing racism is a measure of his fortitude and optimism. Motley's oeuvre, like that of other artists working in this period, must be considered as part of the search for national identity and self-determination that marked American art from the 1920s into the 1950s. Perhaps we needed the lenses of the Civil Rights and Black Power movements of the 1960s—which championed racial pride and solidarity, as well as the sanctity of the individual—to appreciate Motley's art as an honest, and deeply creative, expression of a man and his times, rather than as a cohesive representation of African American culture.

Jacob Lawrence 48

A Portfolio of Works by African American Artists
Continuing the Dialogue: A Work in Progress

ANDREA D. BARNWELL

*MacArthur Fellow, Department of
Twentieth-Century Painting and Sculpture*

KIRSTEN P. BUICK

Lecturer, Department of Museum Education

Introduction

On the threshold of a new millennium, how should we proceed with the dialogue about art made by African Americans? It is often difficult for many late twentieth-century viewers to recognize how irrevocably informed we continue to be by ideologies of race. This difficulty is exemplified in the controversy surrounding *How Ya Like Me Now?* (fig. 1), a fourteen-by-sixteen-foot painting on tin by the New York artist David Hammons depicting the political leader Jesse Jackson with blond, curly hair, blue eyes, pink cheeks, and white skin. Sprayed with black paint is the question "How Ya Like Me Now?," the title of a popular, late-1980s rap song by Kool Moe Dee. Shortly after art handlers from the Washington Project for the Arts (WPA) installed the piece on the corner of Seventh and G Streets N.W., in conjunction with the WPA's 1989 exhibition "The Blues Aesthetic: Black Culture and Modernism," ten black men vandalized it. They regarded the work as demeaning and racist and used sledgehammers to attack it and knock it down from its scaffolding.

Hammons, saddened but not surprised, explained that he wanted the work to show "the white community...very clearly—basically, how racism in America works."[1] Jackson, upon viewing the piece a few days later, responded that the image was not insulting and that it should be seen. "It's the reality behind the picture," he said. "That's the insult."[2]

Richard Powell, acting codirector of the WPA and curator of the exhibition, was disappointed, declaring the work to be "an important image that had to be seen, concentrated upon, talked about." Furthermore, he explained, the provocative painting asked a simple yet profound question: are our likes, dislikes, and expectations of people based on their race?[3]

How Ya Like Me Now? is compelling because it is subject to several interpretations. To white viewers, it poses the question, what would it take to vote for a black man for president? Is it possible to look beyond race and see an individual? The painting asks black viewers whether they would support Jackson if he were white. The work also forces us to look at our expectations of artists based on race. If Hammons were white, not black, would the painting's meaning shift? Would the African American men have vandalized the piece had they known that Hammons is black? Finally, the controversy the painting incited demonstrates the power that images dealing with race can exert over viewers.[4]

Ultimately, the examination of African American art is double-edged, for it inherently involves two goals: to celebrate achievement

LEFT

Jacob Lawrence.
Graduation, 1948
(no. 13).

The term "African American art" is an artificial construct; we would never consider linking art by Benjamin West, Frederic Remington, and Cindy Sherman because of their race.

and to fix/define notions about race. "Race" is an idea, a position; it is a process, undergoing constant change and negotiation. "Race" is not a fact; yet it is real. According to the cultural historian Raymond Williams, the difficulties surrounding the concept "race" began "when it was used to denote a group within a species, as in the case of the 'races of man'."[5] To quote historian Barbara J. Fields, "Race is a product of history, not of nature." Furthermore, ideologies of race vary according to context. In the United States, "race" became current when large numbers of men and women began to question the moral legitimacy of slavery. Subsequently, stereotypes of difference arose from the opposition's need to circumscribe "black" and "white." As Fields noted, the often-contradictory qualities ascribed to the two "races" led to a hardening of categories, which profoundly influenced the lives of those forced to live within them.[6] In order to begin to confront the reality of those experiences mediated by "race," we must acknowledge what historian Elsa Barkley Brown termed the "relational nature of difference." Recognition and inclusion of difference are not enough, she argued; rather, such strategies often function as a way to avoid challenges. Using the example of the large number of African American women employed as domestics and childcare workers in the homes of middle- and upper-class white women, Brown argued that we must comprehend that white women historically were able to live the lives they did precisely because black women lived the lives that they did.[7] Likewise this issue of *The Art Institute of Chicago Museum Studies* could not exist without the understanding that, "out there somewhere," there is a category (often unstated but absorbed as "the norm") that can be labeled "white American art."

How does one introduce a portfolio of twenty-nine works by African American artists in the permanent collection of The Art Institute of Chicago that span from 1803 to 1997 and differ so greatly? What can be inferred when, at the end of the twentieth century, we continue to link works solely because of the race of their makers that were actually produced at different historical moments and created in a variety of mediums and techniques? Since each of the objects mentioned in the Portfolio section is discussed in an individual entry, our aim here is to consider the historic and current implications, as well as the benefits and limitations, of discussing art by African Americans collectively.

Race and the Visual Arts: What is "African American Art"?

It is critical to consider the connotations of the term "African American art" and the ramifications of employing racially defined terminology. Throughout the twentieth century, many terms have been used to describe works by African Americans: Negro art, Afro-American art, Black art, and, currently, African American art (with and without a hyphen). Each term relates to specific moments in United States history; and each term—no matter how it is used—is inherently bound to shifting perceptions about race. Before examining the dangers inherent in this kind of thinking, we should mention its substantial positive effects.

Clearly, African American artists have profited from discussions and exhibitions dedicated exclusively to their work. Research with this focused aim has been crucial to examining, collecting, documenting, discussing, and constructing a history for visual art made by black Americans. Exhibitions and critical scholarship devoted specifically to the subject are still required. Numerous works by African Americans are undocumented or have vanished; many African American artists have

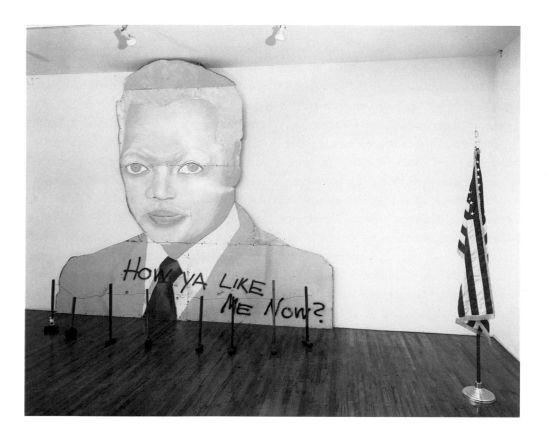

FIGURE 1

David Hammons (b. 1943). *How Ya Like Me Now?*, 1989. Acrylic on tin, plywood, sledgehammers, Lucky Strike cigarette wrapper, American flag; 426.7 x 487.7 cm (168 x 192 in.). Collection of the artist. Photo: Dawoud Bey.

been ignored by the art-historical discourse but deserve visibility and scholarly attention. This sort of focus fosters the recognition (and often the rediscovery) of under-researched artists and their work.

Throughout the twentieth century, African Americans have utilized various strategies to assert that they are vital participants in the American social and cultural environment. In many instances, they have used their art to reflect experiences that are unique to them. Alain Locke (1886–1954), the most influential black voice on art beginning in the 1920s with the Harlem Renaissance, proposed that African Americans create a self-reliant, unique, and authentic art based on their relationship with Africa.[8] The shortcomings of this strategy are apparent, for culture is not biologically inherited and individual visions often extend beyond Locke's romantic and narrow

views. In 1891, long before the Harlem Renaissance, W. E. B. DuBois (1868–1963) explained that racial difference is a sociohistorical distinction rather than a "natural" or scientific one.[9] By this time, black people were ensconced in American soil and, as a critical look at works by such artists as Aaron Douglas (see no. 4), and Archibald J. Motley, Jr. (see Mooney essay) reveal, the attempt to resurrect Africa in America was highly contrived.[10]

Juried exhibitions exclusively for black artists such as the annual Harmon Foundation exhibitions (1925–33), the "Exhibitions of Paintings, Prints and Sculptures by Negro Artists of America" hosted by Atlanta University (now Clark Atlanta University) from 1942 to 1970, and "The Art of the American Negro (1851 to 1940)" at the Chicago Negro Exposition of 1940 prompted many to submit their most important works, since they knew that these would

be assessed by juries composed of leading authorities.[11] These exhibitions resulted in a great increase in the collective visibility of black artists, in the writing of histories about them, and in the creation of institutions to showcase and preserve their achievements.

Yet, while necessary, such events were problematic: they fostered dual standards and negatively reinforced the idea that art by blacks should be judged apart from that by whites and according to different criteria. Moreover, the term "African American art" describes the race of artists rather than qualities visible in or inherent to the work itself. This is an artificial construct; we would never consider linking art by Benjamin West, Frederic Remington, and Cindy Sherman because of their race. Since "African American art" describes the work of black Americans collectively, it cannot address a broad range of interests. Consequently, it suggests that African Americans create art that is monolithic, a view that limits our appreciation not only of individual sensibilities but also obscures the objects themselves. Last, but not least, specifying that a work is by an African American automatically marks it as "different" and separate from the larger context of American art. Not only does this do a disservice to African American artists, but it distorts and diminishes our understanding and appreciation of American art in general.

This issue of *Museum Studies* and the following Portfolio of selections from the permanent collection signal the efforts of the Art Institute to acquire significant works by important African American artists as part of the broader canon of American art. While the entries accompanying the reproductions provide basic information on artists and objects, we hope that readers will bear in mind that labeling continually affects the reception and perception of an artist's oeuvre.

Portfolio: Themes and Strategies
From the array of works featured here, it is clear that artists employ a number of themes and strategies to address a wide variety of interests and ideological stances. We could discuss the twenty-nine works in the following section in a number of ways: art that concerns itself with gender, the complexities of race, issues of social and political oppression, or different perceptions of the "primitive"; artists who were employed by the Works Progress Administration; and the important relationships fostered among artists living and working in specific geographic locales. Briefly here we explore still other topics: attitudes toward the body, portraiture, genre, epic stories, and abstraction.

The perception of race relies wholly on the corporeal and influences how society will shape individual experience. The body is the first arena of perception and, not surprisingly, a number of African American artists have a vested interest in its depiction. Control over the representation of the human form means power over interpretations that the body generates. In two sculptures, *The Boxer* (no. 11) by Richmond Barthé and *Hero Construction* (no. 19) by Richard Hunt, and one drawing, *Harvest Talk* (no. 17) by Charles White, the focus is on the male body. In Barthé's work, a black athlete is unclothed except for the accouterments that mark his profession: boxing gloves and shoes. His nakedness, the disproportionate smallness of his head, and the lean strength and grace of his body all emphasize the physicality of Barthé's specimen: the boxer is a beautiful machine. In *Hero Construction,* Hunt more explicitly explored the relationship between man and machine through the literal transformation of man *into* machine. Here he posed the question of whether heroes are made or born. His work reminds us of the ancient writer Ovid's

fascination with physical metamorphosis. In *Harvest Talk*, White celebrated the courage, strength, and purity of two black farm laborers, allowing their powerful heads, upper torsos, and implements (which are extensions of the body) to fill his composition. Elizabeth Catlett, on the other hand, paid tribute to women workers in *Sharecropper* (no. 18), an image in which technique becomes inseparable from meaning. The artist's obvious empathy with her female subject is underscored by the fact that the deeply etched lines in the woman's face not only reflect the heroic struggles of this field worker, but trace for us the path of the artist's hand as she guided the tools of her own labor to incise the surface of a linoleum plate.

Black artists have not restricted themselves to African American subjects. When, in the early nineteenth century, Joshua Johnson looked across the boundaries of race at a largely white clientele, he affirmed his authority as an "artist" who was also a "freeman of color." From *Mrs. Andrew Bedford Bankson and Son, Gunning Bedford Bankson* (no. 1), as well as a number of other portraits he executed, it is clear that Johnson possessed a significant talent that defied the then widely held belief that blacks could not be fine artists.

Two of the artists represented in this issue depicted their own bodies in self-portraits. Archibald J. Motley, Jr.'s carefully crafted image (Mooney essay, fig. 1) is at once a testament to the artist's upper middle-class upbringing, his academic training, and his considerable skill; and an advertisement for potential clients to take advantage of what he could offer them as a portraitist. In contrast, Beauford Delaney's broadly brushed self-portrait (no. 12) is a disconcerting work; the artist's masklike visage, which, while intended to disguise his profound self-doubts and inner turmoil, in fact reveals his anguish.

The face and body can serve equally to express the conflict between the personal and the social. In *Vanilla Nightmares #2* (no. 26) Adrian Piper drew, over articles about apartheid and sports on pages from the *New York Times*, a prone black female nude on the left and a haunting, hollow-eyed, black face on the right. In so doing, she forced an interplay between body and text, as the words on the page bleed through and impinge upon figure and head; thus, she alluded to the ways in which blacks are verbally and visually monitored through oppression (South African apartheid) and stereotypes (sports). The work forces us to become aware of how we impose our own preconceptions on such images, distorting and shifting their meaning according to our own belief systems. Lorna Simpson's photographs of African American women (see Smith essay, figs. 2–3) suggest similar stresses and complexities.

Genre, or the painting of everyday life, places the body in a social context. Traditionally, the upper classes have been the audience for genre, while the middle and lower classes have served as its subject. Genre is a complex system of representation that is less concerned with the individual than it is with societal types, habits, and mores. Thus, like race, genre has been used to reinforce difference. It has been employed to demarcate those qualities thought to be typical of a region, the poor, the working class, immigrants, and blacks. According to art historian Elizabeth Johns, "From as early as the 16th century . . . such scenes depicted people within a large social fabric who were perceived by viewers as special in a condescending way— as different, amusing, threatening, or peculiar." "The subjects of genre paintings," she continued, "were . . . representatives of social orderings, in characterizations that apparently first achieved permanency in jokes, anecdotes, and stories."[12] Refusing to be

"spoken for," many African American artists have appropriated genre to reflect their own experiences, ranging from the surreal, meditative scenes of Joseph Delaney (see no. 3) to the loving documentaries of Hilda Wilkinson Brown (see no. 9), Jacob Lawrence (see no. 13), and Margaret Taylor Goss Burroughs (see no. 15). Artists such as Walter Ellison (see no. 5) and Vincent Smith (see no. 21) have used genre to address social or political concerns, while others, such as Motley (see Mooney essay, figs. 9–11) and William H. Johnson (see no. 10) have employed it to explore the energy and vibrancy of African American life. In *Many Mansions* (no. 28), Kerry James Marshall transformed genre, which has traditionally been small in scale, into a monumental, deeply symbolic representation.

Many African American artists featured here employed popular literary themes in order to depict universal subjects such as self-discovery, heroic strength, religious faith, and mythic origins. Henry Ossawa Tanner's *Two Disciples at the Tomb* (no. 2) depicts a popular New Testament story. In this image of Christ's resurrection, the expressions of Saints John the Evangelist and Peter, coupled with the light emanating from the tomb, indicate the miracle that has just occurred. In traditional Renaissance and Baroque representations of this event, viewers witness the miracle, seeing not only the evidence of the empty tomb, but often the body of the risen Christ. Here, however, only the disciples behold the miracle; we, a more modern audience, must identify with the awe of the disciples, people like ourselves, to find a way to believe in the truth of the event. Tanner, like Edouard Manet before him and Marc Chagall and Georges Rouault after him, attempted to make religious themes relevant to the modern era.

Encouraged by the intellectuals from the Harlem Renaissance to investigate connec-

tions between Africa and African Americans, Aaron Douglas created a group of murals, *Aspects of Negro Life.* The series depicts the migration of African Americans from a mythic tribal existence in Africa to slavery in the South and urban life during America's jazz era. In a study for the the first scene of the cycle, *The Negro in an African Setting* (no. 4), the artist conjured a romantic vision of a continent he never visited, including mauve-colored figures, striking fetishes, and a junglelike setting, combined with Art Deco motifs. Unlike Douglas, who created a myth, Romare Bearden presented his gloss on a famous Greek myth. In *The Return of Odysseus (Homage to Pintoricchio and Benin)* (no. 25), he substituted black figures for white ones, in order to lay claim to the universality of this epic tale. His title also reminds the viewer that blacks have inherited a history that is ancient and accomplished; the Benin Kingdom of Nigeria flourished at the same time as the Italian Renaissance, when the artist Pintoricchio lived. While Bearden turned white into black, Bob Thompson employed another kind of visual subterfuge. In *Death of the Infants of Bethel* (no. 22), he created a hybrid representation of all of the massacres recounted in the Bible. Here the victims are young men and women, whose vitality, destroyed by horrific violence, is indicated by the artist's rendering of them in deep blue, brilliant red, bright orange, and intense yellow. At the time Thompson executed this work, many Civil Rights leaders were advocating the use of the word "black" instead of "colored." As Thelma Golden, curator of the recent retrospective of Thompson's art at the Whitney Museum of American Art, New York, observed, the artist's high-keyed palette reveals his rejection of "racial coding" and his choice "instead to play on the very word 'color'" with intense hues.[13]

To express epic or mythic themes, many artists after World War II were drawn to abstraction, color, and gesture. Norman Lewis, Melvin Edwards, and Alma Thomas are among a number of African American artists who have generally been omitted from histories of American abstract art.[14] Lewis's *Green Bough* (no. 14), Edwards's *Afro Phoenix No. 1* (no. 20), and Thomas's *Starry Night with Astronauts* (no. 24) stand in opposition to the widely held perception that African American artists have been compelled, out of a desire to combat racism, to produce predominantly narrative, figurative works. These artists have in fact been victims of another, equally unjust exclusion: because they were not committed to the waning philosophies of the Harlem Renaissance or the social directives of the Works Progress Administration—choosing instead to develop more formal, abstract styles—the discussion of their work in many publications and exhibitions surveying African American art has been minimal or skewed in favor of their figurative work.[15]

A Work in Progress

In his seminal 1925 essay "Enter the New Negro," Alain Locke asserted that the mythic Old Negroes—aunties, uncles, sambos, mammies, and the like—were being replaced by a new generation of proud, emancipated, and thoroughly modern blacks. He was confident that they would be recognized for artistic gifts and cultural contributions that are at once unique and on a par with those of any American.[16] The oeuvres of many African American artists, including those with works in the Art Institute's collection, attest to the influence of Locke's vision. It is not surprising, therefore, that, at this point, a number of contemporary artists (including several represented in the Art Institute), while proud of their African ancestry, resent their work being considered primarily as "African American art." They are aware that such classification continues to bind them to stereotypical constraints, preventing broad readings and compromising the significance of their work. They resist being included in projects, such as this issue of *Museum Studies,* dedicated exclusively to African American art. In so doing, they assert that their art should be assessed for its own merits and valued for its contributions to American art.

For this reason, as well as the fact that the Art Institute's representation of works by African Americans is extensive, the Portfolio does not feature every work by an African American artist that the museum owns, nor is it a comprehensive survey of African American art. Despite the precarious nature of considering the artists whose work is included here under the rubric of "African American art," we use the Portfolio format as a way to consider their achievements and careers, as well as to situate them historically within the vast international holdings of the Art Institute.

In conclusion, we hope that, as they study the illustrations and absorb the information in the entries, readers will be brought into the dialogue surrounding African American art and the seminal role it plays in American culture. Indeed, the Art Institute's collection itself is a work in progress.

Portfolio

The Portfolio entries (pp. 53–83) were written by the following individuals. Their entries are signed with their initials. All are associated with The Art Institute of Chicago, except as noted:

ADB Andrea D. Barnwell, *MacArthur Fellow, Department of Twentieth-Century Painting and Sculpture*

KPB Kirsten P. Buick, *Lecturer, Department of Museum Education*

MD Margaret Denny, *Research Assistant, Department of Photography*

MF Martin Fox, *Stanford University*

JJ Jennifer Jankauskas, *formerly Special Projects Assistant, Department of Photography*

DAN Dennis A. Nawrocki, *Professor of Art History, Center for Creative Studies — College of Art and Design, Detroit, Mich.*

MP Mark Pascale, *Assistant Curator, Department of Prints and Drawings*

KNP Kymberly N. Pinder, *Assistant Professor, Department of Art History, Theory & Criticism, The School of The Art Institute of Chicago*

AJW Andrew J. Walker, *Assistant Curator, Department of American Arts*

1. Mrs. Andrew Bedford Bankson and Son, Gunning Bedford Bankson
Joshua Johnson (c. 1770–after 1825)

Joshua Johnson was the first African American artist to gain prominence in the United States. Listed in the 1816 Baltimore city directory as a "free householder of Colour," Johnson was likely of West Indian and French descent, and arrived in this country as a slave from St. Dominique (now Haiti) sometime after 1770. How he gained his freedom is not known precisely, but by 1798 he was advertising his skills as a "self-taught genius" in the *Baltimore Intelligencer* and residing in a neighborhood friendly to free blacks and popular with members of the Maryland Abolitionist Society. Unlike white itinerant portrait painters, including his mentor, Charles Peale Polk, Johnson could not travel to seek out commissions because of the threat of being kidnapped and sold back into slavery. At once free and confined, he was able, through his close ties to Baltimore Abolitionists, to attract local patrons. From the late 1790s through the first quarter of the nineteenth century, he produced likenesses of members of the city's artisan and middle classes, such as the Bankson family, represented here.

The emphasis on fashion in *Mrs. Andrew Bedford Bankson and Son, Gunning Bedford Bankson* is characteristic of much of Johnson's portraiture. The artist preferred, when permitted, to bedeck his female sitters with jewelry: in her portrait, Mrs. Bankson's hair is bound with a double circlet of light, glass beads that accentuates her brown hair and gray eyes. Johnson depicted Mrs. Bankson in a light-brown garment with a lace ruffle around a low neckline. The child is clothed with an equal sense of fashion; he sports a high-waisted, white-muslin gown and holds in his right hand a strawberry, a brightly colored delicacy that Johnson often included in his portraits. (AJW)

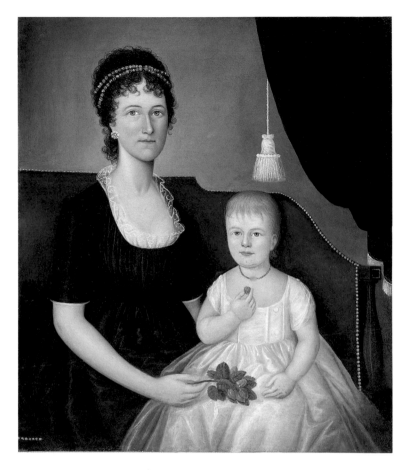

1. **Mrs. Andrew Bedford Bankson and Son, Gunning Bedford Bankson**
1803/1805
Oil on canvas; 81.3 x 71.1 cm (38 x 32 in.) Restricted gifts of Robin and Timm Reynolds and Mrs. Jill Zeno; Bulley & Andrews, Mrs. Edna Graham, Love Galleries, Mrs. Eric Oldberg, Ratcliffe Foundation and Mr. and Mrs. Robert O. Delaney funds; Walter Aitken, Dr. Julian Archie, Mr. and Mrs. Perry Herst, Jay W. McGreevy, John W. Puth, Stone Foundation and Mr. and Mrs. Frederick G. Wacker endowments; through prior acquisitions of the George F. Harding Collection and Ruth Helgeson (1998.315).

Disciples at the Tomb focuses on the individual's response to miraculous events such as the Resurrection.

As the son of a prominent minister of the African Methodist Episcopal Church, Tanner was familiar with the importance of Christian symbolism to African Americans. The theme of resurrection in particular corresponded to the sense of social redemption that followed President Abraham Lincoln's Emancipation Proclamation of 1862. As the black writer and intellectual W. E. B. DuBois noted in 1903, "For fifty years Negro religion . . . transformed itself with the dream of abolition. . . . Thus, when Emancipation finally came, it seemed to freedmen a literal Coming of the Lord."[2] In Tanner's painting, the discovery of Christ's resurrection can be seen as a modern allegory of the salvation of African Americans from slavery.

Like many of the artist's large-scale religious paintings, *Two Disciples at the Tomb* earned Tanner almost instant acclaim. The canvas was exhibited in 1906 at the Art Institute's "Annual Exhibition of American Art," where it won the Harris Prize for being "the most impressive and distinguished work of art of the season."[3] The museum purchased Tanner's painting, its first acquisition of a work by a black artist. Despite the discrimination Tanner experienced living in the United States, he could nonetheless be satisfied with such a positive reception of his art in his homeland. (AJW)

2. Two Disciples at the Tomb

c. 1905

Oil on canvas; 129.5 x 106.4 cm (51 x 41⅞ in.) Robert A. Waller Fund (1906.300).

2. Two Disciples at the Tomb
Henry Ossawa Tanner (1859–1937)

Once dubbed the "Poet Painter of the Holy Land,"[1] Henry Ossawa Tanner was perhaps the most renowned North American painter of religious scenes at the turn of the twentieth century. His achievements were recognized both in the United States, where he first took up painting, and in France, where he spent the better part of his adult life. In its day one of Tanner's celebrated works, *Two Disciples at the Tomb* was inspired by the Gospel of Saint John. The painting depicts Peter and John as they arrive at Christ's tomb, which they find empty except for the slain prophet's linen shroud. Like other paintings by Tanner, *Two*

3. Coney Island
Joseph Delaney (1904–1991)

Joseph Delaney was born in Knoxville, Tennessee. His father was an itinerant minister who moved his family of ten children frequently. Both Joseph and his brother Beauford (see no. 12) became artists of note. In 1930 Joseph Delaney settled in New York, where he studied art with Thomas Hart Benton at the Art Students League. Under Benton's tutelage, Delaney learned the value of depicting genre scenes in which the seemingly mundane is transformed into something timeless or symbolic. By 1936 Delaney himself had become an instructor of drawing under a federal art program administered by the College Art Association. Two years after his move to New York, the artist created one of his most interesting works, *Coney Island,* inspired by the famed public beach and recreational area off Long Island, New York. The site was a popular gathering place for the city's working classes, immigrants, and blacks.

Coney Island is a small painting whose palette is dominated by a hazy blue, giving the image a rather dreamlike quality. The composition focuses on a merry-go-round on which children are riding. Placed front and center is the only black child on the ride; he sits atop a lion, unlike the other children, who ride horses. While the white children are painted rapidly and expressionistically, the black child and his mount are carefully articulated in tight brush strokes, which adds to their weight and underscores their presence. The child seems passive, even motionless, amidst the sense of commotion and laughter that surrounds him. Beyond the merry-go-round wait a black mother and child. They too strike a discordant note, in that they are rendered almost in a shorthand style. With their

3. **Coney Island**
1932
Oil on canvas; 45.7 x
60.9 cm (18 x 24 in.)
Gift of Clarence S.
Wilson, Jr., and Helena
Chapellin Wilson
(1991.99).

clothing and features indicated summarily in white pigment, they resemble gingerbread figures. Thus, here Delaney's blacks occupy two poles: one fully realized and the other two-dimensional. Yet, are the artist's depictions of blacks really that far apart? The young boy rides what appears to be a wild animal that happens to be native to Africa, which could imply that he is circumscribed by stereotype. Using the commonplace, Delaney crafted a subtle exposition of perception and race, questioning whether one can penetrate racial archetypes to perceive the individual. (KPB)

4. *Study for* **Aspects of Negro Life: The Negro in an African Setting**
1934
Gouache on Whatman's artist board;

37.1 x 40.6 cm
(14⅛ x 16 in.)
Estate of Solomon Byron Smith, Margaret Fisher Fund (1990.416).

4. *Study for* **Aspects of Negro Life: The Negro in an African Setting**
Aaron Douglas (1898–1979)

Aaron Douglas was the premier visual artist of the Harlem Renaissance. Part civil-rights activism, part intellectual and artistic upswelling, this cultural movement—centered in the large black population of New York City—was aided by a surge of books, popular magazines, and scholarly journals. Seeking to rekindle a sense of pride and accomplishment within the black community, this "New Negro Movement," as it was called, sought its heritage and sense of self in an African aesthetic. Partly in response to European modernism and its appropriation of African art, Douglas and other blacks felt that, by virtue of an "essence" shared by all peoples of African descent, they were more entitled to and understood the African sensibility better than whites. The movement's chief apologist, Alain Locke (1886–1954), Professor of Philosophy at Howard University and a Rhodes Scholar, called for what art historian Sharon F. Patton has characterized as "an identifiable racial style and aesthetic." Yet, as Patton has argued, Locke "reduced Africa to a cultural trope for the purpose of promoting racial authenticity ... [characterizing it] in simple formalist terms, ignoring the real complexity of its culture."[4]

After receiving his B.F.A. from the University of Nebraska in Lincoln in 1923, Aaron Douglas returned to his hometown in Topeka, Kansas. There he taught art at a local high school. As a regular subscriber to journals such as *The Crisis, Opportunity,* and *Survey Graphic,* which expounded on the significance of the new Renaissance, he knew what awaited him when he left the Midwest in 1925 for the excitement and opportunities offered by Harlem. Soon Douglas himself became a regular contributor to the movement's major

publications, as well as one of the era's leading artistic figures.

In 1935 Douglas received a commission to create a mural cycle in the Countee Cullen Branch of the New York Public Library, located in Harlem. Conceived in five parts, the series, which he titled "Aspects of Negro Life," tracks the journey of African Americans from freedom in their native land to enslavement in the United States, and from liberation after the Civil War to life in modern, urban environments. The fifth panel was to have depicted the union of black and white workers under Marxism. However, Douglas never completed this panel, because he suspected that the entire mural design would have been rejected had he included the scene.[5]

The Art Institute's gouache is a study for the first work in the cycle, "The Negro in an African Setting." Douglas, who had never visited Africa, created this Edenic image of life in ancient Africa before the horrors of slavery. It reflects an African aesthetic transformed by the American experience and, above all, by modernity. For the artist, the starkly silhouetted drummers, dancers, and onlookers represented "Egyptian form," reminiscent of ancient tomb sculptures. Conversely, the spot-lit figures and the concentric circles that radiate around them—all rendered in a restricted, mauve palette—create a pulsing, rhythmic cadence characteristic of the jazz and poetry of Douglas's contemporaries. Uniting past and present, the fetish that floats in the center of the composition reminds us of the spirituality that infuses many aspects of African and African American life. Ultimately, in his liberal borrowing of forms from Egypt to West Africa, which he interpreted in a highly sophisticated Art Deco style, Douglas created an Africa that is purely of the imagination. (KPB)

5. Train Station
Walter Ellison (1899–1977)

Like many African Americans, Walter Ellison migrated from the rural South (also known as the "Black Belt") to the urban North after World War I. Ellison, originally from Eatonton, Georgia, moved to Chicago in the 1920s. In the 1930s, he attended The School of The Art Institute of Chicago and was employed by the Illinois Art Project of the Works Progress Administration. He was also actively involved in the South Side Community Art Center (see no. 15). His work was featured in "The Art of the American Negro (1851 to 1940)," held in Chicago, and in the first "Negro Annual Exhibition" at Atlanta University (now Clark Atlanta University) in 1942.

As demonstrated in books such as Richard Wright's *Black Boy* (New York, 1937) and in paintings such as Jacob Lawrence's *Migration* series (1941; Washington, D.C., The Phillips Collection, and New York, The Museum of Modern Art), many African American writers and artists have used trains and migration as powerful metaphors. On one hand, they can symbolize movement, the future, and hope for prosperity. On the other, they can signify displacement, dispossession, and loss. Ellison's *Train Station* depicts an energetic scene in which many travelers depart from a central terminal. The composition reflects how social values at that time prevented blacks and whites from mixing. Each of the painting's three sections reveals the artist's perceptions of the injustices associated with inequitable social conditions. On the left, white passengers board southbound trains for vacations, while, on the right, black passengers board northbound trains for destinations such as Chicago and Detroit, hopeful of being welcomed in cities where they can prosper. A sign above a doorway on the platform identifying the colored-

5. Train Station
1935
Oil on canvas; 20 x
36 cm (8 x 14 in.)
Charles M. Kurtz
Charitable Trust and
Barbara Neff and
Solomon Byron Smith
funds; through prior
gifts of Florence Jane
Adams, Mr. and Mrs.
Carter H. Harrison,
and estate of Celia
Schmidt (1990.134).

only exit further underscores the dehumaniz-
ing conditions that African Americans had to
endure at this time. In the center section, black
porters help white passengers, but black travel-
ers proceed unassisted.

The sharply exaggerated perspective cre-
ates a space that appears physically inaccessi-
ble, perhaps symbolizing remote destinations
and unimaginable conditions at the end of the
journey. By placing his initials on the suitcase
that an old man in the right foreground tries
to lift, Ellison inscribed his own experiences
of racism and economic struggle into the work,
creating an autobiographical account of his
personal migration north. (ADB)

6. **Cabin in the Cotton**
Horace Pippin (1888–1946)

Horace Pippin has traditionally been charac-
terized as an "outsider" artist because of the
seemingly naïve style of his works. In fact,
he did receive artistic training, and his man-
ner of painting evolved as it did from neces-
sity. Pippin's right arm was permanently
injured during his service in the armed forces
in World War I. He found a rather ingenious
way around his disability: by crossing his legs,
he provided a raised support for his right arm,
which he guided across the canvas with his
left hand.

In 1937 Pippin's art was discovered when
the artist N. C. Wyeth noticed *Cabin in the
Cotton* on display in a shoe-repair shop in
West Chester, Pennsylvania. He encouraged
Pippin to exhibit the painting at the Chester
County Art Association, where it was seen by

curators from The Museum of Modern Art, New York. In 1938 the museum exhibited *Cabin* along with works by other "primitives." Pippin's art also appeared in *Vogue, Glamour,* and *Life* magazines, and was displayed by influential commercial galleries in New York and Philadelphia. Pippin's popularity with white audiences had much to do with their ideas about the "childlike" quality of blacks. His style struck them as authoritative and honest. In *Cabin* Pippin depicted a bucolic scene with a grandmotherly figure, whose head is wrapped in a kerchief, and a small boy, who chases a dog while chickens peck in the yard. Beyond the crudely constructed cabin and barn is a field of white cotton, over which cottonlike clouds float. The painting seems to reference the close association, forged by slavery, between blacks and cotton, as well as the promise of heavenly rewards for earthly labors.

Perhaps inspired by a 1932 movie entitled "Cabin in the Sky," *Cabin in the Cotton* allowed the artist to indulge his love of highly textured surfaces and strong color contrasts. The pigment is applied thickly in broad bands of color—white, black, green, and blue. The (white) art establishment, mistakenly believing Pippin to be a genuine "primitive," would have assumed that the artist here was painting a scene he knew well. In fact, Pippin visited the South only once, and briefly (in 1925), and may never have seen an actual cotton plantation. A native of Pennsylvania, he lived there most of his life. Thus, *Cabin* can be seen as a warm and elaborate reverie, but a fantasy nonetheless. (KPB)

6. **Cabin in the Cotton**
c. 1935
Oil on canvas
mounted on masonite;
45.7 x 83.8 cm
(18 x 33 in.)
In memory of Frances
W. Pick, from her
children Thomas F.
Pick and Mary P.
Hines (1990.417).

7. **Daddy Grace at the Altar with Choir**
1938
Gelatin silver print;
19.3 x 24.5 cm
(7⅝ x 9⅝ in.)
The Sandor Family
Collection in honor
of The School of The
Art Institute of
Chicago (1994.898).

8. **Coming Home from Work**
1938/43
Pen and brush and
black ink on cream
wove paper with pink
fibers; 52 x 45 cm
(20½ x 17¾ in.)
Restricted gift of Mr.
and Mrs. Robert S.
Hartman (1992.179).

7. Daddy Grace at the Altar with Choir
James Van Der Zee (1886–1983)

James Van Der Zee's portraits of artists, musicians, and other notable figures serve as a record of African American society in New York during the exciting and rapidly changing era that was the Harlem Renaissance. Van Der Zee, a self-taught photographer, strove to portray his subjects in a flattering light, in order to emphasize their elegance and dignity. Often working outside of his studio, he explored many aspects of Harlem, including church life. A favorite subject was Daddy Grace (Marcelino Manuael da Graca), a minister and an entrepreneur who gained a following because of his evangelistic and fundamentalist preaching style. Van Der Zee was attracted to the setting of Daddy Grace's church, the United House of Prayer for All People.

Here Van Der Zee photographed Daddy Grace on a platform to the left of the altar; the choir surrounds the stairs leading to the platform, directing our eyes to the church leader and thereby conveying the devotion and awe he inspired. While absent, the members of the congregation are evoked by the two empty rows of chairs in the foreground, which create a sense of depth and, with the light-bulb decorated wall and arches behind, frame the two choral groups. The formal uniforms on one side and the fancy dresses on the other complement the flamboyant character of the interior. The whole image is infused with a luminous quality—from the bright white altar behind Daddy Grace to the glow of the choir's clothing—further connecting the figures to this spiritual setting and suggesting the vibrant theatricality that was so central to Daddy Grace and his church. (JJ)

8. Coming Home from Work
Eldzier Cortor (b. 1916)

Born in Tidewater, Virginia, Eldzier Cortor was raised in Chicago and studied at The School of The Art Institute of Chicago. Before moving to New York, where he still lives, Cortor was employed by the Federal Art Project and was an active member of Chicago's arts community. He served as director of the South Side Community Art Center (see no. 15), which he cofounded.

Cortor is known for his sensual and forthright paintings of black female nudes and for his monumental still lifes comprised of artifacts from African American culture and history. The elongated and exaggerated human forms in his work reflect the influence of African sculpture, to which he was exposed in art-history classes at the School of the Art Institute. He has excelled at drawing and printmaking, which allow him to express his ideas quickly and directly. Although often representing the specific aspects of black life in the United States and the Caribbean, Cortor's works frequently strike a chord to which all viewers can respond. Created while Cortor was working for the Federal Art Project, *Coming Home from Work,* like other images by him from this period, focuses on the difficulties of life for working-class blacks living on Chicago's South Side at a time when many were still experiencing the effects of the Great Depression. The drawing is a testament to the hard work required to survive. An exhausted man, dressed in work clothes, returns home from a long, exhausting day of work. The rag doll at his feet, which suggests that he supports a family, poignantly echoes the spent and weary demeanor of the man. (KNP)

9. Oak Bluffs
Hilda Wilkinson Brown (1894–1981)

9. Oak Bluffs
c. 1940
Graphite with erasing
on cream wove paper;
image: 35.7 x 23.6 cm
(14 x 9¼ in.); sheet:
40.7 x 28 cm (16 x 11 in.)
Restricted gift of
Mr. and Mrs. Robert S.
Hartman; gift of
Lilian Thomas Burwell
(1997.311).

Hilda Wilkinson Brown is noted for the significant impact she had on black art teachers in Washington, D.C. Brown earned her bachelor's degree in education from Howard University. After studying art at the Cooper Union in New York, she returned to the nation's capital and taught art history, design, and fine arts at Miner Normal School (later Miner Teacher's College) from 1923 until 1961. In addition, she lectured extensively throughout the city and introduced classes in the crafts and industrial arts into the curriculum of public schools.

Although her primary interest was teaching, her paintings and works on paper depicting life in her neighborhood deserve critical attention. Several of her drawings and prints appeared in W. E. B. DuBois's monthly children's magazine, *The Brownies Book*, and in E. Franklin Frazier's *Negro Family in the United States* (New York, 1948).

At the close of each academic year, Brown summered at her family's home in Oak Bluffs, a town on Martha's Vineyard, an island off the coast of Massachusetts. It was originally the place where the New England Baptist Association had its camps and meetings. Martha's Vineyard—especially Oak Bluffs—has been a popular retreat for many upper- and middle-class African American families from the East Coast for several generations.[6] In the 1940s, the period when Brown created *Oak Bluffs*, the nation saw the rise of a significant African American middle class as well a steady pattern of migration by African Americans to the North. For many well-to-do blacks, vacations on Martha's Vineyard were associated with a shared sense of community. The Inkwell, a formerly segregated beach, is perhaps the setting of *Oak Bluffs.* The beach continues to be a central site for socializing with friends and engaging in summertime activities. Reflecting Brown's own experiences in Oak Bluffs, as well as Martha's Vineyard's importance in African American history, this drawing clearly alludes to concerns that are central to African Americans, such as spending time with loved ones, and enjoying economic prosperity and social mobility. (ADB)

10. **Jitterbugs II**
William H. Johnson (1901–1970)

William Henry Johnson was born in Florence, South Carolina, to a woman of black and Sioux ancestry. His father was thought to be a well-to-do white man who never acknowledged him as a son. Johnson studied under Charles W. Hawthorne and George Luks at New York's National Academy of Design. Realizing that his chances of success in the United States were limited by racial prejudice, Johnson moved to Paris in 1926. After a brief return to the United States, he settled in Denmark in 1930 and married Holcha Krake, a Danish weaver and ceramist he had met in France. The artists remained in Scandinavia until the threat of Nazism forced them to move to the United States in 1937. Thereafter, Johnson concentrated on aspects of African American life with a new style of bold outlines and colors. His wife's death made Johnson despondent, leading to his institutionalization in 1947.

Johnson produced *Jitterbugs II*, a silkscreen print, while teaching at the Harlem Community Art Center. The print's jagged contours and bright hues communicate the energy of the dances in fashion among the young people whom Johnson observed upon his return to New York. He combined the abstracting methods of Synthetic Cubism and the strong patterns of Scandinavian folk art to address the vitality of jitterbugging, communicating movement and energy through graphic forms. Art historian Richard J. Powell has characterized the works in the series of which this print is a part as "overtures to a palpable, *living* Cubism . . . [which] . . . indicate that Johnson fully understood that the hyperkinetic dances and fashion extremes of contemporary black culture were appropriate inspirations for a modern African-American art."[7] Space is collapsed in his composition, which

focuses on the dramatic poses of figures engaged in fast-paced movement. The dancers' facelessness draws attention to their bodies and dress and emphasizes the anonymity of the dancehall. The musical instruments seem to be playing themselves and moving to their own sounds. The jostling, interconnected forms of dancers and instruments evoke the syncopated rhythms of jazz. So connected are the figures to their actions that the dancers become almost inseparable from their dance. (MF)

10. **Jitterbugs II**
c. 1941
Color screenprint and pochoir on wood-pulp board; 43 x 34.5 cm (17 x 13½ in.)
Restricted gift of Mr. and Mrs. Robert S. Hartman (1995.231).

11. The Boxer
Richmond Barthé (1901–1989)

Born in Bay St. Louis, Mississippi, Richmond Barthé demonstrated artistic talent at a very young age. In 1924 he enrolled at The School of The Art Institute of Chicago, where he pursued painting. During his senior year, he began modeling in clay in order to enhance his skill at depicting three-dimensional forms on canvas.

Following his graduation from the Art Institute in 1929, Barthé moved to New York, where he earned attention and praise, including that of leading black art critic and theorist Alain Locke. Almost immediately, he began to establish himself as a sculptor. In the 1930s, Barthé was the most widely exhibited artist affiliated with the Harmon Foundation, an organization that promoted the achievements of African American writers and artists from 1922 until its activities ceased, in 1967. His work was purchased by such important New York museums as The Metropolitan Museum of Art and the Whitney Museum of American Art. He received commissions for public sculptures depicting biblical figures, African American luminaries, and African dancers and garnered prestigious honors, including a Julius Rosenwald Fellowship in 1931–32 and a Guggenheim Fellowship in 1940–41.

When *The Boxer* was exhibited at the Metropolitan Museum in an exhibition sponsored by Artists for Victory, Inc., in 1942, it earned a $500 prize. This piece, executed during Barthé's most productive period, was inspired by a prize fight the sculptor attended. In a letter to the Art Institute, Barthé explained, "I saw Kid Chocolate, the Cuban light weight. He moved like a ballet dancer. He danced back and forth ducking his head as though he didn't want his hair messed up. I did him from memory, years later."[8] The boxer's sinuous, lithe physique and attenuated limbs suggest agility, elegance, and sensuality—qualities evident in the majority of Barthé's work. (ADB)

12. Self-Portrait
Beauford Delaney (1901–1979)

Following the advice of his first art teacher, Lloyd Branson, Beauford Delaney left Knoxville, Tennessee, in 1923 to pursue his education in Boston. In 1929 he moved from Boston to New York; there he exhibited portraits at the Whitney Studio Galleries and at the 135th Street branch of the New York Public Library and supported himself by working as a janitor at night. Although he primarily executed portraits, by 1941 he was painting street scenes of Greenwich Village and experimenting with non-objective painting and light effects. In 1953 Delaney left the United States for Paris, where he remained for the rest of his life. By 1960 museums and galleries throughout Europe were exhibiting his abstract compositions.

Unlike the flatly painted portraits of friends and family Delaney executed throughout his career, this self-portrait stands out for its expressionistic brushwork and intense feeling. *Self-Portrait*—with its richly textured layers of reds, greens, yellows, and blues—is clearly informed by the artist's interest in abstraction. It also reveals the profound discomfort and inner struggles that increasingly troubled and eventually overwhelmed him. According to a recent biography based on his journals, painting for Delaney was a way to "remember and confront the pain," and "expressionistic" portraits served as "defenses against the inner demons."[9] These included his increasingly strong conviction that racism was impeding his career, that his patrons would cease to support him if they knew he had performed menial jobs, and that he

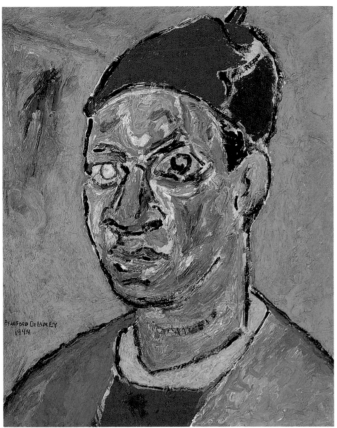

12. **Self-Portrait**

1944

Oil on canvas; 68.6 x
57.2 cm (27 x 22½ in.)
Restricted gift of
Alexander C. and
Tillie S. Speyer
Foundation; Samuel
A. Marx Endowment
(1991.27).

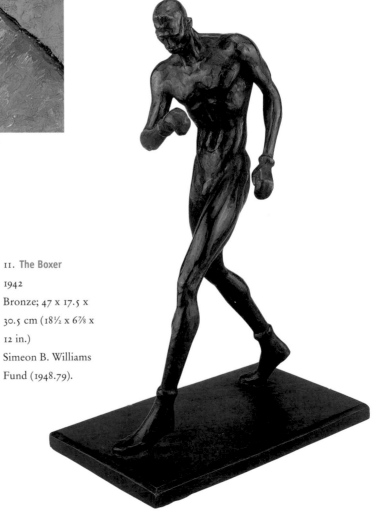

11. **The Boxer**

1942

Bronze; 47 x 17.5 x
30.5 cm (18½ x 6⅞ x
12 in.)
Simeon B. Williams
Fund (1948.79).

would be further condemned for his homosexuality—the latter fear prompted to no small degree by the fact that he was the son of a minister. The number of masks he wore to conceal these concerns involved a psychological effort that, as the Art Institute's self-portrait poignantly suggests, took a significant toll.[10] (ADB)

13. Graduation
1948
Brush and black ink over graphite on cream wove paper; 72 x 49.8 cm (28⅜ x 19⅛ in.) Restricted gift of Mr. and Mrs. Robert S. Hartman (1997.429).

13. Graduation
Jacob Lawrence (b. 1917)

Throughout Jacob Lawrence's long and distinguished career, he has demonstrated a deep interest in African American history and in black peoples' collective struggle to attain racial equality. He is perhaps best known for his powerful narrative series on topics such as migration and the achievements of Toussaint L'Ouverture, Frederick Douglass, and Harriet Tubman. Lawrence grew up in Harlem during the Great Depression and received his early training at the Harlem Art Workshop, beginning in 1932. A precociously gifted young man, he thrived in the dynamic and creative atmosphere Harlem provided.

Graduation, a recent acquisition, is one of six ink drawings made by Lawrence to illustrate *One-Way Ticket,* a book of poetry about the plight of blacks in America by Langston Hughes. Many of the poems refer to subjects specific to Chicago such as State Street, Calumet Avenue, and the city's jitneys. Inscribed below this drawing's lower left edge are the words "South Side Chicago."

Like graphic art by the German Expressionists, whose work and concern for social issues continue to inform Lawrence's art, *Graduation* employs bold outlines, flat forms, and the interplay between light and dark areas. Indeed, the work's strong graphic impact resembles the effects achieved in woodblock prints by Käthe Kollwitz and others. In the graduates' caps and gowns, for example, the juxtaposition of positive and negative space (the relationship between solid and void) creates the illusion of shadows and light. The repetition of the graduates' profiles and onlookers' bodies produces an insistent rhythm that builds toward a crescendo, creating a sense of ascension. (Lawrence has addressed the theme of upward movement throughout his oeuvre.)

Commencements were cherished occasions for the migrant communities that had settled in northern cities; Lawrence's image invokes proud families coming together to honor the scholastic achievements of loved ones. The language and imagery of Hughes's poem "Graduation" emphasize the energy and import of such an occasion: "The Diploma bursts its frame/To scatter star-dust in their eyes."[11] (ADB)

14. Green Bough
Norman Lewis (1909–1979)

Born in Harlem, Norman Lewis was among the first generation of Abstract Expressionist painters, although he and other African Americans have until recently been excluded from accounts of the New York School.[12] Throughout the 1930s, he was employed by the Works Progress Administration's Fine Arts Project, painting scenes of the unemployed and destitute. Like many painters in the 1940s, Lewis shifted to a non-figurative style. He became involved with the Abstract Expressionists, exhibiting like many of them at the Willard Gallery in New York and attending discussions at "The Club," where such figures as Willem de Kooning, Franz Kline, and others fraternized. Lewis also served as the first chairman of Spiral, an important group of African American artists organized in 1963 (see no. 25).

Lewis believed that African American artists should devote themselves to seeking universal truths rather than narrowing their focus to pursue ideals of racial or ideological identity. In *Green Bough*, nebulous clusters are rendered in yellow and green pastels, which emphasize the texture of the paper, and in translucent watercolor, which, applied over the pastel, creates subtle tonal modulations. Over this is a structure of thin, black lines of ink that taper out into triangular nodes. The effect is that of looking through the leaves of a tree backlit by the sun, but made more universal and transcendent because of the artist's avoidance of mimetic rendition. As Romare Bearden and Harry Henderson put it, "Lewis's art focuse[s] on the energies and tensions underlying the abstract forms of clouds, trees, and the sea, revealing in elegant, harmonious and never-overpainted colors the natural unity of earth, sea and air."[13] In *Green Bough,* Lewis created a structure which suggests by its form that the process of its making is analogous to organic growth. (MF)

15. Birthday Party
Margaret Taylor Goss Burroughs (b. 1917)

A native of St. Rose, Louisiana, Margaret Taylor Goss Burroughs moved with her family to Chicago in 1922 in search of better job and educational opportunities. Growing up on Chicago's South Side, Burroughs remembers the neighborhood's deep sense of community. Throughout her career, as both a visual artist and a writer, she has often chosen themes concerning family, community, and history. "Art

14. **Green Bough**
1951
Pastel with brush and black ink and watercolor, on ivory wove paper; 61.1 x 48.7 cm (24 x 19 in.)
Frank B. Hubachek Fund (1954.122).

is communication," she has said. "I wish my art to speak not only for my people—but for all humanity."[14] This aim is achieved in *Birthday Party,* in which both black and white children dance, while mothers cut cake in a quintessential image of neighbors and family enjoying a special day together. The flexibility of linoleum allowed the artist to create an array of patterns and textures. Flowered dresses, draped streamers, swinging pigtails, and rippled icing convey the liveliness of a child's party.

Burroughs received degrees from the School of the Art Institute and the Teacher's College at Columbia University, New York. She has traveled extensively in Africa, Asia, and Europe, and has exhibited her art for over fifty years. In addition to her activities as a painter, sculptor, printmaker, and poet, she has been an important activist. In 1941 she was involved in the opening of the South Side Community Art Center in Chicago. This center, one of the only Works Progress Administration projects still operating, was founded to provide arts opportunities and training for

residents of this predominantly black neighborhood. (Many of the artists represented in this volume have shown their work there; see nos. 5, 8, and Schulman essay.) Burroughs also founded, with her late husband, Charles, the DuSable Museum of African American History, another prominent cultural institution in Chicago (see no. 27). Today she serves on the board of the Chicago Park District, continuing to be a strong advocate for cultural awareness among the city's diverse communities. (KNP)

16. **Man Coming Up Subway Stairs**
Roy DeCarava (b. 1919)

Roy DeCarava initially pursued painting and printmaking with Charles White (see no. 17) at the George Washington Carver Art School in Harlem. He began to explore photography as a way to create sketches for his prints, but he was so taken with the medium that, by the 1940s, he changed his focus to photographs. DeCarava's career received a significant boost in 1950, when Edward Steichen, the renowned photographer who had joined the Department of Photography at The Museum of Modern Art, New York, saw DeCarava's first photography exhibit and purchased three prints for the museum. In 1952 DeCarava became the first African American photographer to win the John Simon Guggenheim Memorial Foundation Award.[15]

"Roy DeCarava: A Retrospective," featuring fifty years of DeCarava's photographs, was organized by The Museum of Modern Art, New York, and appeared at the Art Institute in 1996. On the occasion of the exhibition, the museum acquired DeCarava's *Man Coming Up Subway Stairs.* The activity of the subway was an important early subject for DeCarava, who would start to photograph at 5:00 p.m., after his day job as an illustrator for an advertising agency. He set forth his goals

15. **Birthday Party**
1957
Linocut on cream wove paper; block: 40.5 x 48 cm (16 x 19 in.); sheet: 45.5 x 57.5 cm (18 x 22⅛ in.) Joyce Turner Hilkovitch Collection in memory of Jonathan Turner (1991.895).

for his photographs in his Guggenheim fellowship proposal:

I want to photograph Harlem through the Negro People. Morning, noon, night, at work, going to work, coming home from work, at play, in the streets, talking, laughing, in the home, in the playgrounds, in the schools, bars, stores, libraries, beauty parlors, churches, etc. . . . I want to show the strength, the wisdom, the dignity of the Negro people. Not the famous and the well known, but the unknown and the unnamed, thus revealing the roots from which spring the greatness of all human beings.[16]

Man Coming Up Subway Stairs fulfills these goals, exhibiting the insight into African American life that became the hallmark of DeCarava's oeuvre. His image recalls the thematic and stylistic concerns of Eldzier Cortor's *Coming Home from Work* (no. 8). The poignancy of DeCarava's photograph derives from the posture of the work's subject, a thin, haggard man, whose expressive clenched jaw and hunched shoulders indicate his weariness after a long day's toil. With his shirtsleeves rolled up and fedora pulled tightly over his head, the anonymous figure is a picture of determination and pride.

When DeCarava saw this ideal subject at the bottom of the stairs, he realized he only had one frame left on his roll of film. He had to choose whether to take the time to reload the camera or to chance his one opportunity. According to DeCarava, he decided he had to change the film: "So, do you know what happened? He got to the landing, and he rested. By the time he reached me I had changed the film, and I was ready for him."[17] (MD)

16. **Man Coming Up Subway Stairs**
1952 (printed 1996)
Gelatin silver print;
27.9 x 35.6 cm
(11 x 14 in.)
Restricted gift
of Allison Davis
(1997.407).

LEFT

18. **Sharecropper**
1957 (printed 1970)
Color linocut on cream
Japanese paper; block:
45 x 43.1 cm (17¾ x
17 in.); sheet: 54.4 x
51.3 cm (21 x 20 in.)
Restricted gift of Mr.
and Mrs. Robert S.
Hartman (1992.182).

ABOVE

17. **Harvest Talk**
1953
Charcoal, Wolff's
carbon drawing pencil
and graphite, with
stumping and erasing
on ivory illustration
board; 66.1 x 99.2 cm
(26 x 39 in.)
Restricted gift of Mr.
and Mrs. Robert S.
Hartman (1991.126).

17. **Harvest Talk**
Charles White (1918–1979)

18. **Sharecropper**
Elizabeth Catlett (b. 1915)

Charles White is recognized for the richness of his graphic work and his paintings, which typically depict aspects of the history, culture, and life of African Americans. A native of Chicago, White attended The School of The Art Institute of Chicago, the Art Students League in New York, and later in Mexico at the Taller de gráfica popular (The People's Graphic Workshop), with Elizabeth Catlett (see no. 18), to whom he was married at the time. Beginning in 1939, he was employed by the Illinois Art Project of the federal Works Progress Administration. Afforded the time, materials, and artistic freedom to work as he chose, White gained widespread recognition.

White, whose father was a railroad and steel worker and mother a domestic worker, had a deep respect for labor. *Harvest Talk,* one of six charcoal and carbon pencil drawings originally exhibited at the ACA Gallery in New York in 1953, exemplifies the artist's mature drawing style. Here his strong, assured manner, coupled with the heroic proportions of the figures and the emphasis on the large scythe, evokes the indomitability of his subjects in the face of hard work. The presence of the scythe (an emblem often associated with the Soviet Union), as well as the social realist sensibilities that prevail throughout White's oeuvre, his travels to the U.S.S.R. (where he exchanged ideas with Russian artists), and his writings for and affiliation with left-wing publications (such as *Masses & Mainstream, Freedomways,* and the *Daily Worker*) suggest that *Harvest Talk* was inspired by socialist ideals. Like many of White's works on paper, *Harvest Talk* conveys the power of a mural, despite its relatively small format. (ADB)

Elizabeth Catlett, a printmaker and a sculptor, considers the goal of her art to be the transformation of society. Addressing the National Conference of Negro Artists in 1961, she stated, "Whether we like it or not, we Negro artists are part of a worldwide struggle to change a situation that is unforgivable and untenable. . . ."[18] Born in Washington, D.C., Catlett attended Howard University, where she studied under the important African American art theorists Alain Locke and James A. Porter. In graduate school at the University of Iowa, she worked with the regionalist painter Grant Wood. In 1946 Catlett received a Julius Rosenwald Fund grant and used the money to travel to Mexico with Charles White (see no. 17), to whom she was then married. There she worked at the Taller de gráfica popular (The People's Graphic Workshop), a printmaking collective dedicated to the principles of social realism, including the use of public art forms, such as murals, which are large and can be accessible to all, and of prints, which can be easily and cheaply disseminated, as agents for social change. Because of her belief in Communist ideals at a time when leftists were being persecuted by the United States' House of Representatives Un-American Activities Committee, Catlett remained in Mexico. Barred from 1962 to 1974 by the State Department from returning to the United States, she became a Mexican citizen in 1964 and married Francisco Mora, a colleague at the Taller.

In *Sharecropper* Catlett combined her dedication to championing the oppressed with her abiding concern for women. This print focuses on the head of a female farm worker, whose face, made rough and leathery by years of toil in the fields, is nonetheless determined and commanding. After the Civil War, sharecrop-

ping, an economic system in which farmland was rented for a portion of the crops grown, trapped many African Americans in a cycle of subsistence-level poverty. Catlett's dignified portrayal shifts the focus of traditional heroic portraiture, which is often reserved for the powerful or famous, by concentrating on someone who is poor and dispossessed. The implied placement of the viewer slightly below the sharecropper helps to ennoble the figure. In this print, Catlett made a powerful political statement about the enduring strength of even the most economically deprived. *Share-cropper* was cut into a linoleum block in 1957; the image became so popular that the artist

has continued to print it on and off ever since in variants of the original. The Art Institute's impression dates from 1970. (MF)

19. **Hero Construction**
Richard Hunt (b. 1935)

Richard Hunt considers *Hero Construction* to be one of the most important works of his early career. It reflects an interest in mythology the young artist had when he made this sculpture. As Hunt recalled, "I was creating two tensions in the piece: one between the modern methods of construction and the ancient imagery; and the other between the anatomical and the machinelike qualities of the sculpture."[19]

For the last forty years, Hunt has enjoyed widespread success, with his works adorning public spaces and private collections in his home state of Illinois and around the world. After receiving a degree in art education at The School of The Art Institute of Chicago in 1957, Hunt gained national recognition with his first one-person exhibition at the Alan Gallery in New York the following year. The museum acquired *Hero Construction* in 1958 through the museum's first curator of modern art, Katharine Kuh, who had recognized Hunt's talent when he was a student. Kuh arranged for the collector Arnold H. Maremont to purchase *Hero Construction* for donation to the museum.

The geometric qualities and reductive forms of *Hero Construction* reflect the many artistic traditions that have inspired the sculptor. He has studied everything from Cubism and African smelting techniques to Native American art and the art of innovative sculptors such as Spaniards Julio Gonzalez and Pablo Picasso and the American David Smith, many of whose works he saw for the first time in the exhibition "Sculpture of the Twentieth Century" at the Art Institute in 1953. Hunt's goal

19. **Hero Construction**
1958
Welded and chromed steel; h. 175.3 cm (69 in.), base 12.7 cm (5 in.)
Gift of Mr. and Mrs. Arnold H. Maremont (1958.528).

in this piece, as he has put it, was to "develop the kind of forms Nature might create if only heat and steel were available to her."[20] (KNP)

20. **Afro Phoenix No. 1**
Melvin Edwards (b. 1937)

Melvin Edwards's interest in art was encouraged by his family and reinforced by visits to the art museum in Dayton, Ohio, where he spent his childhood. When his family moved to Houston, Texas, in 1949, he became passionate about jazz. Its riffs and improvisational character inspired his interest in abstraction, as it has many avant-garde artists in the Americas and Europe. After high school, Edwards moved to Los Angeles and studied painting and art history at City College, the University of Southern California, and the Los Angeles County Art Institute (now the Otis Art Institute of Parsons School of Design). Initially a painter who worked in an Abstract Expressionist mode, Edwards, in the 1960s, began exploring three-dimensional forms, especially welded steel.

Afro Phoenix No. 1 is an early piece from *Lynch Fragments*, a series of approximately two hundred sculptures that Edwards began in 1963 and has continued to work on at various stages of his career. Each piece is a metaphor for the struggles of the early Civil Rights movement, particularly for violent assaults against blacks. The critic Michael Brenson has described the series in terms of its compositional dynamism and has explained how the various metal objects the works comprise often offer a number of contrasting meanings: chains suggest the horrors of slavery and the supportiveness of bonding; scissors connote severing and the cutting necessary to piece things together; nails evoke crucifixion and construction.[21] In this sculpture, Edwards associated black people with the phoenix, the

legendary bird that lived for several hundred years, was consumed by fire on a funeral pyre, and rose from the ashes to endure for several more generations. The shape of the horseshoe located in the center of the work further associates it with the theme of wings, ascension, and flight. Like many examples in this series, *Afro Phoenix No. 1* is a testament to Edwards's fascination with demonstrating the flexibility, strength, and beauty of steel and his interest in combining disparate materials and in manipulating space. In title, medium, and form, the entire series exemplifies Edwards's ability to fuse modernist abstraction with personal and collective history. (ADB)

20. **Afro Phoenix No. 1**
1963
Steel; 29.3 x 14.1 x 10.2 cm (12½ x 9½ x 4 in.)
Restricted gift of Stanley M. Freehling (1997.411).

21. First Day of School
1965
Etching on off-white
wove paper; plate:
22.7 x 25.2 cm (8¹⁵⁄₁₆ x
9¹⁵⁄₁₆ in.); sheet: 38.2 x
56.3 cm (15 x 22⅛ in.)
Elizabeth Templeton
Fund (1994.259).

21. First Day of School
Vincent Smith (b. 1929)

Vincent Smith was born in Brooklyn, New
York, where he continues to reside. In the 1950s,
he attended New York's Art Students League,
the Brooklyn Museum Art School, and the
Skowhegan School in Maine. This enabled
him to study with social realists Reginald
Marsh and Ben Shahn, among others. Smith's
expressionistic paintings and prints focus on
contemporary African American life, often in
an insistently political fashion. According to
the artist, "What I hope to achieve is for black
kids to go into a museum and see what they
can relate to. . . . I can't go into the Museum
of Modern Art and see Malcolm X, so I paint
Malcolm X. . . . The spirit of Malcolm X."[22]

First Day of School savagely caricatures
savage actions—those of racists determined
to maintain segregated schools. Since the his-
toric desegregation case *Brown vs. the Board
of Education of Topeka* (1954), the introduc-
tion of African American students into for-
merly all-white schools has been a funda-
mental issue in the struggle for civil rights.
Although desegregation was ordered by the
Supreme Court with "all deliberate speed," it
was bitterly and sometimes violently resisted
by those determined to maintain racist insti-
tutions. Federal marshals were still required
to protect children in integrated schools ten
years after the ruling. Smith traveled in the
South in 1963–64, observing this resistance
firsthand. In the tradition of artists such as
Honoré Daumier, James Ensor, George Grosz,
and Thomas Nast, Smith here satirized and
condemned a mob jeering young, black stu-
dents who are escorted by police to school.
The exaggerated features of the menacing fig-
ures imply their crudity and cruelty. Rather
than individualizing the participants, Smith's
distortions render them part of an inchoate,
unthinking mass, which includes drunkards,
a man in Klu Klux Klan garb, and a saluting
figure with a strong resemblance to Adolf
Hitler. The mob is led by a man in a suit hold-
ing a paper or sign stating "never." Perhaps he
is meant to suggest politicians such as George
Wallace and Orval Faubus, who capitalized on
racist fears to advance their own careers.
Smith's indignation at those who tried to
block racial equality is expressed clearly and
forcefully in *First Day of School*. (MF)

22. **Death of the Infants of Bethel**
Robert (Bob) Thompson (1937–1966)

Kentucky-born Bob Thompson studied art at the University of Louisville and Boston University before moving to New York in 1959. Between 1961 and 1966, he moved twice to Europe, where he avidly toured museums and painted. He died an untimely death in Rome, following complications from surgery and prolonged drug addiction. A prolific artist, Thompson produced approximately one thousand paintings and drawings in a career that lasted only six years.

Although Abstract Expressionism was the vanguard style of the 1950s, Thompson and others preferred the naturalistic mode and religious-mythic themes of traditional art. Revealing a variety of influences—from the Old Masters to Henri Matisse and contemporary figurative artists such as Red Grooms and Lester Johnson—the large-scale *Death of the Infants of Bethel* is characteristic of Thompson in its hot and brilliant palette, flattened shapes, and summary rendering of form. Yet, for all its vividness and its Edenic setting, *Bethel* is a tragic scene. The limp bodies of at least nine youths litter a roadway and the bank of a stream. These corpses are painted monochromatically in bright colors—orange, yellow, red, or blue—as if to contradict their lifelessness. In suppressing individuating details (except to distinguish gender), the artist allowed the figures' poses to communicate the savagery just perpetrated. While several blocks of architectural debris at the lower left imply the destruction as well of a city or a building, the spacious landscape, with its blue sky, flowing brook, and lush foliage appears silent and undisturbed.

Thompson's *Bethel,* in the spirit of Old Masters Titian and Nicolas Poussin, whom Thompson admired, evokes such classic subjects as a massacre of the innocents or the

22. **Death of the Infants of Bethel**
1965
Oil on canvas; 152.4 x 213.4 cm (60 x 84 in.)
Walter Aitken Endowment (1997.217).

aftermath of a fierce battle, but the cause of the carnage is not specified. "Bethel" does not refer to an individual but rather to a city described in the Book of Genesis as "the house of God." Perhaps the deaths here refer to an analogous violation of promising lives. In 1965, the year the work was created, Malcolm X was assassinated and riots devastated the Watts section of Los Angeles. While Thompson had been painting massacre scenes since 1960, these immediate tragic events may bear upon the meaning of this composition and its depiction of young lives lost. In *Bethel,* as in much of his art, Thompson fused classical subjects and modern themes, thereby reinvigorating formulaic conventions with contemporary relevance. (DAN)

23. Mt Mowbullan in Dividing Range near Brisbane Australia Mar 28 1970
Joseph Yoakum (1890–1972)

Born to a family of mixed parentage in Ash Grove, Missouri, Joseph Yoakum began to produce a remarkable body of work around 1962, when he was seventy-two years old.[23] During the last ten years of his life, he created as many as two thousand drawings, mostly of landscapes. Yoakum claimed to have traveled internationally, a point that some find hard to believe, given his modest financial circumstances as a pensioner living on Chicago's South Side. He insisted that, between 1901 and 1908, he traveled the world with various circuses and as a hobo-stowaway. Today we accept some of his claims as fact, while realizing that he may have visited many places in his fertile imagination, fed in part by a world atlas and Bible he kept close at hand.

Mt Mowbullan, one of two hundred drawings by Yoakum in the Art Institute's collection, is a prime example of his fully developed, later work. Yoakum devised a personal language of marks and shapes, repeated throughout this composition to create a density of forests, undulating rock formations, and the illusion of spatial depth. He also used whatever was available as a drawing aid; here he appears to have traced a large coin to make the sun. His inscriptions, although often misspelled, invariably refer to real places, as if he were creating a postcard view. While it is not clear whether Yoakum visited Australia, there are rock formations near Brisbane that possess an almost animistic presence, not unlike that suggested in this image. Such animism is the most distinctive quality of Yoakum's drawings and demonstrates his ability to suggest, in delicate lines and smoothly rubbed pastel colors, the awesomeness of nature and its power to inspire poetic thought and vision. (MP)

23. Mt Mowbullan in Dividing Range near Brisbane Australia Mar 28 1970
c. 1970
Red fiber-tipped pen, blue ball-point pen, and colored pencils, with colored chalks and smudging, dated with rubber ink stamp, on off-white wove paper; 48.3 x 30 cm (19 x 11 13/16 in.) Whitney Halstead Bequest (1979.417).

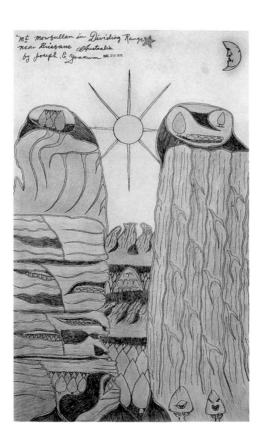

24. Starry Night with Astronauts
Alma Thomas (1895–1978)

Alma Thomas, a graduate of Howard University, taught art in the Washington, D.C., public school system. After her retirement, in 1960, she pursued a career as an artist. In the late 1950s, she enrolled in painting classes at American University and subsequently developed professional relationships with members of the Washington Color School, such as Gene Davis, Morris Louis, and Kenneth Noland, whose luminous, color-field paintings strongly influenced her. By 1964 she had abandoned realism and, painting with acrylics, developed her own, signature style, methodically layering small bars of bright colors that she applied thickly onto light, spacious backgrounds. Thomas's work has been featured in numerous one-woman exhibitions, including retrospectives at the Corcoran Gallery of Art, Washington, D.C.; the Whitney Museum of American Art, New York; and the Fort Wayne (Ind.) Museum of Art.

Starry Night with Astronauts is the final work in *Space Series*, a group of abstractions that Thomas initiated in 1969 in response to the Apollo missions' exploration of space and landings on the moon. The canvas's title, palette, and facture reference Vincent van Gogh's *Starry Night* (1889; New York, The Museum of Modern Art). As with other paintings in the series, the Art Institute's composition exhibits no obvious pictorial references to or symbols of the expeditions. Rather, the artist depended solely on color, form, and application to suggest her theme. To evoke the night sky, she filled the large canvas with vertical strokes of blue—ranging from sky blue to indigo—and, in the upper right-hand corner, added a small kaleidoscope of reds, oranges, and yellows to suggest a star. The colorful bars seem translucent, recalling tesserae, the small

shards of glass or glazed terracotta arrayed in mosaics. From various angles, the light background and traces of white paint strategically placed over the blues create the sensation of flickering light. Thus, the entire surface appears to glisten, suggesting the mysterious beauty of outer space, and inspiring a sense of wonder reminiscent of what many felt in the 1960s and 1970s upon witnessing the courage and effort that permitted humankind to explore the unknown. (ADB)

24. Starry Night with Astronauts
1972
Acrylic on canvas;
137.2 x 152.4 cm
(54 x 60 in.)
Gift of Mary P. Hines in memory of her mother, Frances W. Pick (1994.36).

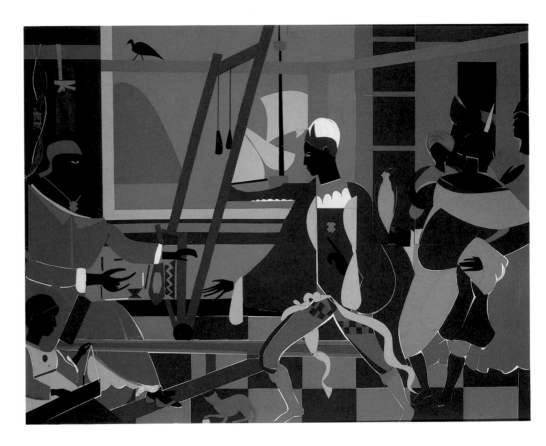

25. The Return of
Odysseus (Homage to
Pintoricchio and Benin)

1977
Collage on masonite;
112 x 142 cm (44 x
56 in.)
Mary and Leigh Block
Fund for Acquisition
(1977.127).

25. The Return of Odysseus (Homage to Pintoricchio and Benin)
Romare Bearden (1911–1988)

Born in Charlotte, North Carolina, Romare
Bearden moved with his parents to Harlem as a
child. After graduating with a degree in math-
ematics from New York University, Bearden
enrolled in the Art Students League, where
he studied with the German artist George
Grosz. Bearden's colleagues included William
Baziotes, Stuart Davis, Carl Holty, Jacob
Lawrence (see no. 13), Norman Lewis (see
no. 14), and Hale Woodruff, among others.
In 1963 Bearden cofounded Spiral, a group
convened "to examine the plight of the Black
American artist" in response to labor leader
A. Phillip Randolph's call for wide cultural
participation, including that of visual artists,
in the Civil Rights movement.[24] Already

established as a painter, Bearden created his
first collages for Spiral's inaugural show by
juxtaposing enlarged photographic fragments
to convey scenes of African American life. As
the writer Ralph Ellison put it, Bearden's col-
lages convey the "sharp breaks, leaps in con-
sciousness, distortions, paradoxes, reversals,
telescoping of time and Surreal blending of
styles, values, hopes and dreams which char-
acterize much of Negro American history."[25]

The Return of Odysseus is part of a series
based on Homer's epic, a subject to which the
artist, long interested in myth, was particu-
larly attracted. Here Bearden drew from mul-
tiple sources, mixing art-historical references
from widely separated cultures to sug-
gest the universality of the story. The col-
lage's composition is based on Renaissance
painter Pintoricchio's last surviving fresco,
The Return of Ulysses (c. 1508/1509; London,

National Gallery), but is transformed by Bearden's manipulations. By the time of his Odysseus collages, Bearden had moved away from using photographic reproductions. Instead, he worked with colored paper in a mode suggesting Henri Matisse's late paper cutouts. Bearden also reconceived Pintoricchio's Caucasian figures as black ones, basing their heads on the sculptural traditions of the African kingdom of Benin. As Bearden put it, "I do not burden myself with the need for complete abstraction or absolute formal purity but I do want my language to be strict and classical, in the manner of the great Benin heads. . . ."[26] The artist's quotation of various styles extends the medium of collage, which fuses disparate materials into a whole. (MF)

26. Vanilla Nightmares #2
Adrian Piper (b. 1948)

Born in New York, Adrian Piper studied at the city's School of Visual Arts and later at Harvard University, Cambridge, Mass., where she received a Ph.D. in philosophy. As a professor of philosophy, Piper has written extensively on racism, xenophobia, and stereotyping. As an artist, she has worked in a variety of idioms, from performance and video to photography and drawing, seeking to effect change in racist attitudes by exposing their deep-rooted sources; "I am interested in truth rather than in beauty," she has asserted.[27]

Vanilla Nightmares #2 is the second of a group of twenty charcoal and crayon drawings

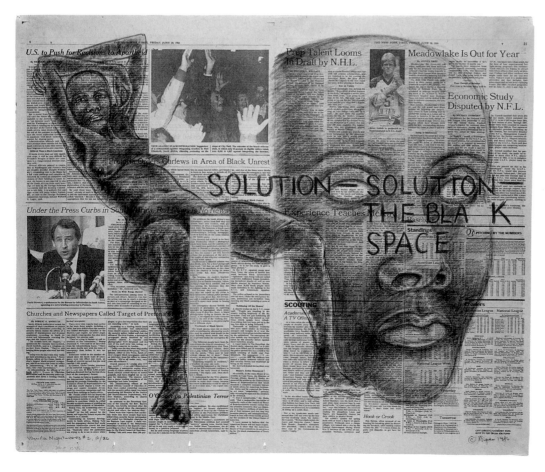

26. **Vanilla
Nightmares #2**
1986
Charcoal and red
crayon, with erasing,
on tan wove paper
(newsprint); 60 x
70.3 cm (23⅝ x 27⅝ in.)
Margaret Fisher
Endowment
(1992.744).

that Piper began in 1986 on pages from the *New York Times.* By choosing this august newspaper as the ground for her series, Piper suggested that advertising and "factual" reportage contain hidden messages which feed prejudice in insidious ways. In this work, she executed two charcoal renderings and hand-printed an abbreviated text, in red crayon, over a spread from the newspaper's June 20, 1986, issue. At the left, sprawled across several articles dealing with apartheid, is a reclining black nude female whose impassive gaze belies her availability, indicated not only by her out-stretched limbs but also by the column of type that rises between her open legs. At the right, on a page dedicated to sports, a large, bald head of a black person, its eyes blank and gender undefined, floats beneath the words "SOLU-TION—SOLUTION—/THE BLA K/ SPACE." The phrase "bla[n]k space" under-scores the expressionless character of the large head and refers to a discussion, on the opposite page, of a form of official censorship according to which South African newspapers published blank, white spaces where articles or photo-graphs that the government found objection-able should have been. This "solution" inevi-tably rendered the excised information more powerful than had it been allowed to appear. Nonetheless, such deletions deny real knowl-edge as well and contribute to the blankness, as seen in face at the right. Piper reiterated her indictment of suppression of information by erasing the delineation of a muscle on the inner right leg of the nude female, as well as part of her left breast. Piper's figures, aptly described by art critic Lucy Lippard as "impas-sive intruders [that] infiltrate and overlay the marching columns of print, emerging from the shadows like slaves whispering behind the plantation house," are at once haunting and threatening, the stuff of nightmares for those in power.[28] (DAN/MP)

27. Second Annual Carnival Ball, DuSable Museum of African American History
Kerry Coppin (b. 1953)

Kerry Coppin was born in Peekskill, New York, and grew up in the South Bronx. Since earning his M.F.A. in photography from the Rhode Island School of Design, Providence, in 1977, Coppin has taught at colleges and uni-versities across the United States; he is cur-rently on the faculty of Kansas State Univer-sity, Manhattan, Kansas.

Second Annual Carnival Ball is one of some six hundred photographs commis-sioned from a number of artists to document Chicago (see *Changing Chicago: A Photodocu-mentation* [Urbana/Chicago, 1989]). Coppin's contribution to this project was a series of images related to openings at various galleries and institutions in Chicago devoted to African American art and culture. In this photograph, he situated himself on the street, in order to capture the arrival of guests at a masked ball at the DuSable Museum of African American History. Evoking the intrigue and romance of carnival celebrations in such places as New Orleans, Rio de Janeiro, and Venice, the pho-tograph features a man and woman wearing formal dress and striking metal masks. They seem be moving from the right, where several figures appear to bustle around what might be a registration table, to the left, behind a young worker, in dress shirt and bow tie, who sports a ribbon labeled "DuSable" and looks shyly at the camera. Coppin captured a moment of transition; the couple is about to enter an interior space that has been trans-formed by decorations into a fantasy that, for several hours, they will share with others who have dressed up in similar fashion. But here, in broad daylight and in the street, they appear mysterious, incongruous, and awk-ward. This is underscored by two figures, in

27. Second Annual
Carnival Ball, DuSable
Museum of African
American History
1987
Gelatin silver print;
19.7 x 29.8 cm
(7¾ x 11¾ in.)
Gift of David Ash
(1989.608.3).

street clothes, who, from the shadows behind the couple, watch the spectacle unfold.

The DuSable Museum was founded in 1961 by Margaret Taylor Goss Burroughs (see no. 15) and her husband, Charles, and named after Jean Baptiste Pointe DuSable, an eighteenth-century explorer of African descent who founded the first non-Indian settlement in Chicago. The museum has become the center for a wide range of activities celebrating the achievements of African Americans and plays an integral part in the cultural life of Chicago's South Side. (MD)

28. Many Mansions
Kerry James Marshall (b. 1955)

Kerry James Marshall has made African American life the predominant subject of his art. Born in Birmingham, Alabama, Marshall moved with his family in 1963 to Los Angeles, where he attended the Otis Art Institute. After a two-year stay in New York, the artist settled in Chicago in 1987; he continues to live

and work in the city. In 1994 Marshall, who prefers to delve into a topic in a series of paintings, became intrigued by the frequent use of the word "garden" in the names of Chicago and Los Angeles housing projects. He set out to explore the successes and failures of these much-maligned developments in a group of paintings entitled *Garden Project*. With these works, the artist—who had himself lived in projects in Birmingham and Los Angeles—hoped to challenge stereotypes of public housing. As Marshall remarked, "We think of projects as places of utter despair. All we hear of is the incredible poverty, abuse, violence and misery that exists there but there is also a great deal of hopefulness, joy, pleasure and fun."[29]

In the background of *Many Mansions* loom the angular, modernist towers of Chicago's Stateway Gardens, an immense complex comprising eight high-rises. Its bureaucratic identification—"IL 2–22"—is emblazoned in red at upper right. In the foreground, three men tend an elaborate garden, which, with its profuse and curving forms,

contrasts strikingly with the austere apartment buildings behind it. Negating misconceptions of the black male, the dark-skinned trio—attired in white dress shirts and ties—enterprisingly beautify their harsh surroundings. The initials of their community—"SG"—are fashioned from multicolored flowers; and cellophane-wrapped Easter baskets, stocked with plush, stuffed animals, await their recipients. The flattened figures, decorative patterns, and shallow space create a formal, somewhat other-worldly aura, heightened by the marked disparity of scale between the tall men and smaller towers behind—all of which serve to heroicize the figures.

While full of images symbolizing the grim realities of urban existence, *Many Mansions* also attests to the sense of community and humanity that Marshall believes can define life even in difficult circumstances. It is spring, the season of joy, hope, and resurrection; at left two bluebirds support a banner proclaiming "Bless Our Happy Home"; at top a radiant sun seems on the verge of dispelling an ominous-looking cloud. Floating above the other images is a red ribbon whose message—"In My Mother's House There Are Many Mansions" (a feminist gloss on a phrase from the Book of John [14:2])—expresses an inclusive understanding of the idea of home and offers a promise of happiness. (DAN)

28. **Many Mansions**
1994
Acrylic and collage on canvas; 289.6 x 343 cm
(114 x 135 in.)
Max V. Kohnstra Fund
(1995.147).

29. **Keys to the Coop**
Kara Walker (b. 1969)

Keys to the Coop is a luridly shocking depiction of a young, black girl about to bite into the neck and head of a decapitated chicken. The stark, black-and-white contrast of the monumental linocut evokes the life-sized, cut-paper silhouette installations for which Kara Walker attracted critical attention in 1995. Although born in California, at thirteen Walker moved to Georgia with her family and later attended the Atlanta College of Art. She continued her studies at the Rhode Island School of Design, Providence, where she lives and works.

An eighteenth-century French invention, black-paper silhouettes became increasingly prevalent in the nineteenth century, particularly as a way to limn profile portraits and portray sentimental scenes. Walker has found the technique appealing in part because of its associations with a decorous and popular pictorial mode. As she has explained, "I want accessibility, something that is easily read and could operate on some innocuous level to engage people—then I could pull the rug out from under them."[30] *Keys to the Coop* is just such a discomfiting image. About to taste her prey, which she holds in one hand, a girl nonchalantly twirls and flaunts a large key in the other. She has not only managed to feed herself, but has done so by securing access to the coop, perhaps by a lucky accident, theft, or some other means. Regardless of her method, she has succeeded in satisfying her hunger and attaining a measure of control over her life. Walker portrayed her subject as bestial: the girl approaches her prey ferociously; and girl and fowl, although clearly distinct, are nevertheless conjoined by similarly restless, animated contours, and analogous poses.

Walker's use of stereotype—she portrays the protagonist as a "savage animal," an asso-

ciation whites have traditionally used to denigrate and oppress African Americans—here and elsewhere has concerned a number of people who feel that, among other things, her work too unreservedly embraces attitudes which generations of blacks and whites have struggled to overcome.[31] Walker's defenders applaud her head-on confrontation of such constructs. In effect, her antiheroine also possesses the force and acuity necessary to secure the key, an emblem of freedom and accomplishment. As Walker has provocatively suggested, "I think of my art as a kind of melodrama, producing a certain giddiness that entertains but also empowers."[32] (DAN)

29. **Keys to the Coop**
1997
Linocut on white wove paper; 117.5 x 153.8 cm (46¼ x 60½ in.)
Restricted gift of Dr. and Mrs. Paul Sternberg (1997.433).

Marion Perkins:
A Chicago Sculptor Rediscovered

DANIEL SCHULMAN

*Associate Curator of Twentieth-Century
Painting and Sculpture*

In the 1950s, Marion Perkins (1908–1961) was one of Chicago's foremost sculptors. He participated in nearly one dozen invitational exhibitions at The Art Institute of Chicago from 1942 to 1957 and received three awards of distinction. His career was capped by the museum's 1951 purchase of one of his most extraordinary pieces, *Man of Sorrows* (figs. 1, 21). In spite of these achievements, Perkins failed to attain national recognition. Today, almost forty years after his death, he is remembered only by family, friends, colleagues, and a handful of collectors and specialists in the field of African American art. Perkins's work, which is almost totally absent from major public collections of twentieth-century art, has never received scholarly attention. However, the enduring power of his work and the story of his struggle for creative expression provide ample reason to reconsider his career.[1]

Why is Perkins so little known today? First, his career was brief. It began when the artist was in his early thirties and ended with his untimely death at the age of fifty-three. His need to work forty-hour weeks to support his family—at jobs ranging from dishwasher to freight handler—further curtailed his output.[2] Moreover, a shortage of mainstream exhibition opportunities for black artists beyond the Art Institute also limited his exposure.

Perkins's technique is another factor influencing his posthumous neglect. He preferred direct carving in stone or wood; this process, adopted by European modernists such as Constantin Brancusi, André Derain, and Amedeo Modigliani, came to be considered passé by mid-century. Other methods, including assemblage and welded steel, were taking its place. Perkins's aesthetic conservatism was prompted in part by his uncompromising political convictions. As a committed Marxian activist,[3] he believed that art could convey ideas effectively only through recognizable imagery, an approach that put him at odds with the phenomenally successful New York School of abstraction. Furthermore, he regarded figurative sculpture as participating in the grand tradition of public art, in contrast to abstraction, which he believed was elitist in nature. Stylistically conservative, Perkins's work nonetheless is remarkably beautiful, emotionally authentic, and politically impassioned.

Although he was softspoken and reserved in manner, Perkins's intensity, physical attractiveness, and attentiveness to others lent him a magnetic presence. Perkins was deeply devoted to people and to a number of causes. An intellectual, he became a fervent and outspoken advocate for social reform and racial equality, both in the United States and abroad. Yet, even with all these passions competing for his attention, Perkins labored intensively on his sculp-

FIGURE 1

Marion Perkins posing with his prize-winning sculpture *Man of Sorrows* (1950), at the Art Institute's "55th Annual Exhibition by Artists of Chicago and Vicinity," in the spring of 1951. Photo: Mike Shay, courtesy Johnson Publishing Company.

The enduring power of Perkins's art and the story of his struggle for creative expression provide ample reason to reconsider his career.

ture late at night and on weekends, in makeshift studios in the street, yard (see fig. 17), or kitchen. The powerful and original body of work that he produced reflects his sympathies for those who have experienced inequality and oppression.

Background and Artistic Beginnings
An only child, Marion Perkins was born in 1908 on his grandparents' farm near Marche, Arkansas, about ten miles from Little Rock. After the death of his parents in 1916, the eight-year-old boy was sent to Chicago to be raised by an aunt, Doris Padrone.[4] His arrival coincided with a period of momentous change in American cities—it was the height of the first Great Migration of southern blacks to the North—and marked the beginning of a new phase of awareness of the social, political, and cultural position of blacks in the United States.

Between 1910 and 1920, fifty thousand African Americans came to Chicago from the South.[5] Restrictive covenants on real estate forced the new arrivals to squeeze into a narrow area of the city's South Side reserved for blacks, which came to be known as Bronzeville. Housing was inadequate, living conditions were poor, and the neighborhood developed as an isolated city within a city.[6] However, Bronzeville in the 1930s saw the emergence of an exceptionally talented group of African American writers and artists, including Gwendolyn Brooks, Elizabeth Catlett (see fig. 5 and Portfolio, no. 18), Eldzier Cortor (see Portfolio, no. 8), Willard Motley, Theodore Ward, Charles White (see Portfolio, no. 17), and Richard Wright. All shared in the struggle for expression and recognition and were close to Perkins.

Perkins attended Wendell Phillips High School, but left to find work before his senior year. Around this time, he married Eva Gillon; very quickly, he was supporting a family: his son Robert was born in 1929, followed by Toussaint and Eugene in 1930 and 1932, respectively. Eva, originally from Louisiana, played a decisive role in Perkins's life.[7] Strikingly beautiful, she served as his model and muse. Two works in particular demonstrate her importance: a plaster mask and a highly idealized marble head (figs. 2–3). The first, which may date from as early as the mid-1930s, reveals Perkins's skill in creating naturalistic, three-dimensional form. Executed in the late 1940s, the second portrait, recently acquired by the Art Institute, shows the strong features of the artist's wife, in the manner of the stylized, intensely powerful symbolic heads he was to produce in the 1950s.

Eva, who worked occasionally, created a stable home life for her husband and children. She and Marion also maintained strong ties with a community of intellectuals and profes-

FIGURE 2
Marion Perkins (American; 1908–1961). *Mask of Eva,* c. 1935. Plaster; 26.7 x 22.9 x 14 cm (10½ x 9 x 5½ in.). Collection Thelma and Toussaint Perkins, Chicago. Photo: Michael Tropea.

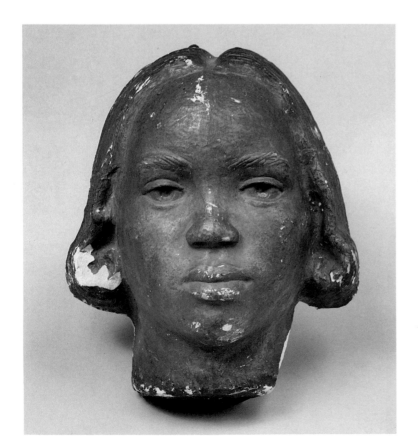

sionals—both black and white—who shared leftist or progressive political views. A fascinating glimpse into the milieu of this South Side liberal elite was provided by Gwendolyn Brooks, in a 1951 article. Employing a fictive "stranger" to guide the reader, the poet described an idealized party at the Perkinses:

To get another picture of Bronzeville, the Stranger might go to a party; not the "typical" Bronzeville party . . . , but to one that is indicative of a current trend: the "mixed" party. This one is in the home of Marion and Eva Perkins. . . . Perkins [sic] parties are always thickly attended, and so tonight it is no surprise to find writers like Paul Mills, Dick Orlikoff and Willard Motley; teachers like Evelyn Gans and Cecil Lewis; Ed Gourfain, the advertising mogul, and Joyce, his artist wife; physicist Robert Bragg and his wife Violet, a social worker; and twenty others, notables and Just People, sitting on the floor, the stairs, and hanging over the banisters, balancing perilously their Martinis or their punch, as well as perched more normally on sofas, chairs, chair arms and tables. Everyone is talking and laughing but there is no over-mastering din. A Bronzeville teacher, Margaret Taylor Goss (now Mrs. Charles Burroughs), sits cross-legged on the floor, and sings, without being invited, Hard Times Blues. When she is finished Lester Davis, photographer and journalist, leaps to his feet and with the voice of an M. C. forces everyone to contribute an "act," a song, a dance, a recitation, an imitation. One Saturday-night party in Bronzeville.[8]

This circle also provided Perkins with patrons, especially the Gourfains. This couple's Saturday night soirées in Hyde Park (the wealthy, predominantly white neighborhood adjacent to Bronzeville and close to the University of Chicago) are remembered by many Chicagoans as occasions at which they met politically progressive cultural heroes such as W. E. B. DuBois, Paul Robeson, and Richard Wright. The Gourfains' collection of works by Perkins today comprises the majority of examples by the artist at Chicago's DuSable Museum of African American History.[9]

The 1930s

Perkins's artistic beginnings are difficult to trace, partly because the artist himself obscured them. In his own account of his employment and training—contained in his 1948 application for a Julius Rosenwald Grant, and in several newspaper profiles and reviews from the 1940s and 1950s—Perkins claimed to have been employed from 1933 to 1939 as a handicraft instructor for the Federal Art Project of the Works Progress Administration (WPA).[10] Yet, Perkins's WPA employment records, pre-

FIGURE 3

Marion Perkins. *Portrait of Eva*, c. 1947. Marble; 31 x 21.6 x 20.3 cm (12⅕ x 8½ x 8 in.). The Art Institute of Chicago, through prior acquisitions of the George F. Harding Collection (1996.400).

served at the National Personnel Records Center, show that the artist was not on the Illinois Art Project of the WPA; rather, between 1935 and 1941, he worked in various, menial jobs for the WPA—as a construction worker, a custodian setting rat-traps, a clerk, and a recreational instructor at a field house in a public park.[11]

Why did Perkins misrepresent his experience with the Federal Art Project? Perhaps he felt that he lacked the training and experience of artists who preceded him as Rosenwald fellows (such as Charles Alston, William Artis, Catlett, Cortor, and Jacob Lawrence [see Portfolio, no. 13]). He may have also wanted to be associated with the talented group of South Side artists, including William Carter, Cortor, Ramon Gabriel, Bernard Goss, Charles Sebree,

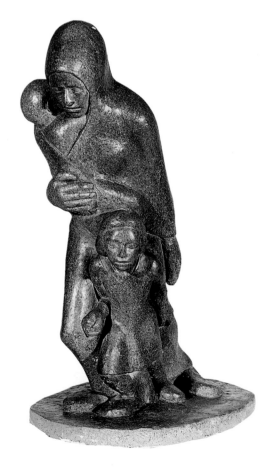

FIGURE 4

Si Gordon (American; 1908–1961). *Onward,* late 1930s. Plaster; 73.7 x 55.9 x 36.8 cm (29 x 22 x 14½ in.). Illinois State Museum Collection, gift of Louis Cheskin (1967.036.088).

and White, who gathered together in the late 1930s to found the South Side Community Art Center (SSCAC).[12] Many of them had attended The School of The Art Institute of Chicago and were employed by the Illinois Art Project. Perkins's name, though, is conspicuously absent from early published accounts of the activities of these artists.[13] Finally, Perkins's exaggeration of his training may have stemmed from a desire to avoid being labeled self-taught or "primitive."[14]

Perkins's remoteness from the 1930s art scene in Chicago may also be due to his competing interest in theater. "Prior to the Depression," he told a reporter for *The Pittsburgh Courier* in 1947, "I had a great desire to become a playwright. Theodore Ward was a co-partner of mine in the Little Theater Group."[15] Ward, who arrived in Chicago in the early 1930s, was one of the few black playwrights in the country to have his work staged by the short-lived Federal Theater Project. His gritty, social realist play *The Big White Fog* was produced in Chicago and New York in 1938.[16] Through Ward, Perkins would have known a range of illustrious African American writers who spent time in Chicago in the 1930s, including Ward's theater-project colleague Richard Wright, as well as Arna Bontemps, Langston Hughes, and Willard Motley. Ward and Wright, who were members of the Chicago John Reed Club, may well have schooled Perkins in leftist political philosophy.[17] Unfortunately, none of Perkins's creative writing has survived.

Peter Pollack and Si Gordon
Perkins had been carving informally in wood and soap since high school, but his work first attracted attention in 1937 or 1938 at the newsstand he had managed to buy at the corner of 37th Street and Indiana Avenue, just two blocks from his home at 36th Street and Wabash Avenue. Here, when he was not working for

the WPA, Perkins carved heads and figures from large pieces of stone and wood. He was noticed in 1937 by Margaret Taylor Goss (see Portfolio, no. 15), a young student at the School of the Art Institute and a founding member of the SSCAC; and by Peter Pollack, who would become Perkins's most important promoter.[18] In the mid-1930s, Pollack was one of a small group of gallery owners in Chicago to show work by African American artists (another was Katharine Kuh, who was later to become the Art Institute's first curator of modern art). In 1938, while running the Chicago Artists' Union gallery, Pollack was appointed by the Illinois Art Project to rally community support to acquire a building for the future SSCAC. At about this time, he encountered Perkins:

One day in 1938 I was driving my car down on 37th Street at Indiana Avenue, and there I saw a huge red stone, next to a newsstand. A few days later, I was driving down there again, and noticed that a head of Lincoln was beginning to emerge. I stopped after a double take, and asked a little negro boy who the stone belonged to; he said it was his father's.[19]

The media-savvy Pollack sensed the appeal of this story, and never failed to press it on reporters and feature writers. In any event, it was apparently through Pollack that Perkins met Art Project sculptor and teacher Si Gordon, who gave the aspiring artist his first formal training in sculpture.[20]

Today Gordon's artistic legacy is more obscure than Perkins's. In the late 1930s, he was one of a group of progressive-minded, predominantly Jewish artists who lived on Chicago's South Side and taught art at various settlement houses with WPA adult-education funding.[21] Articles in the *Chicago Defender* confirm that Perkins began studying with Gordon in 1938 at the black YMCA at 38th

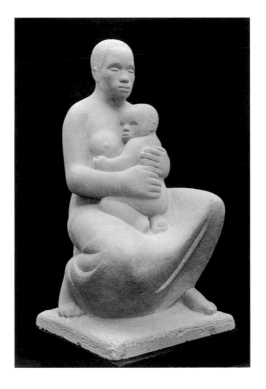

FIGURE 5
Elizabeth Catlett (Mexican [born in United States]; b. 1915). *Negro Mother and Child,* 1940. Limestone; h. 91 cm (35⅞ in.). Present location unknown. Photo: courtesy the University of Iowa.

and Wabash. Perkins's sculpture was first exhibited there, in October of that year, in a display of student work.[22] Given how little we know of Gordon's art in the late 1930s and early 1940s, it is difficult to say precisely how he influenced his student. Most of Gordon's surviving works portray family groups or workers (see fig. 4) in a heroic, but stilted, social realist mode. Primarily Gordon seems to have given Perkins basic instruction, encouragement, and a knowledge of the processes of sculpture. Their ideological sympathies would have made them entirely compatible. On questionnaires and in interviews, Perkins never failed to cite Gordon as his teacher.[23]

The 1940s: South Haven

By 1940 Perkins possessed the confidence to tackle a demanding, private commission: a group of six life-sized figures for the exterior of the Biltmore Hotel in South Haven, Michigan. A small town on the eastern shore of Lake Michigan, South Haven, in the 1930s, was a

major summer resort for a mainly Jewish clientele from such midwestern cities as Chicago, Detroit, and St. Louis. The Biltmore, one of the town's grandest hotels, was erected at the turn of the century and purchased in 1940 by Maurice and Belle (Becky) Steuben. Although Perkins's sculptures have disappeared, they can be seen in photographs of the hotel dating from the mid-1940s (see figs. 6–7).[24] The Steubens' daughter, Genevieve Baim, vividly recalled visiting Perkins in Chicago with her parents. They met in a corner unit of a brand new, low-rise public housing project, the Ida B. Wells homes, where the Perkins family lived throughout most of the 1940s. The sculptor's studio was in the backyard. The Steubens were in the process of renovating the old hotel, and they asked Perkins to make several pairs of children, dressed in traditional Dutch costume, to complement the vaguely neo-Dutch ornamentation of the

building. (Much of the area had been settled by immigrants from Holland, and Dutch motifs are still ubiquitous today.)

Perkins produced a decorative ensemble in cast concrete, comprising pairs of figures placed at intervals along the terrace wall, which extended around the building. A postcard (fig. 7) shows a group portrait of the hotel staff framed between two of Perkins's figures—fanciful, doughy-faced children with pails over their shoulders—appropriate to the clients' decorative (and slightly kitschy) requirements. Baim remembered the overwhelming impression, shared by all who saw the sculptures, that the children's faces had black features—an observation difficult to confirm from existing photographs. Nevertheless, both the hotel proprietors and guests believed that Perkins intended these Dutch mascots to be black. If indeed this was the case, the artist seems to have used a basically decorative

FIGURE 6

Biltmore Hotel, South Haven, Michigan, c. 1945. Photo: courtesy Lake County (Ill.) Museum/Curt Teich Postcard Archives.

commission to make a political statement. But what was his intention? Were the improbable "Afro-Dutch" figures an expression of distaste over his patrons' employment of exclusively black help? Was he making the point that ethnicity is irrelevant to national identity? Or was the artist reminding his audience of the simple fact that people come in all colors? Whatever Perkins's intention, the Steubens, according to Baim, were pleased with the sculptures, which became a cherished landmark. They were pre-sum-ably lost or destroyed between 1968, when the Steuben family sold the hotel, and 1971, when the city ordered its demolition.

The 1940s: The "American Negro Exposition" and the South Side Community Art Center
The 1940s were years of rapid artistic growth for Perkins. In the summer of 1940, two of his works—stone heads of a boy and girl—were included in the "American Negro Exposition" in Chicago.[25] This event, celebrating the progress of African Americans in the seventy-five years since the end of the Civil War, was held at the Coliseum, on 15th Street and Wabash Avenue. An art component, the "Exhibition of the Art of the American Negro (1851 to 1940)," was organized by Alonzo Aden, curator of the Howard University Gallery of Art, Washington, D.C., and Alain Locke, a professor of philosophy at Howard and the era's leading impresario and polemicist for African American art. With more than three hundred paintings, sculptures, and works on paper, in addition to work by children and African art from Chicago and New York collections, the show was the most ambitious survey of artwork by African American artists to date.

The exposure this critical event provided for the works of such highly trained and nationally recognized African American sculptors as William Artis, Richmond Barthé (see Portfolio, no. 11), Meta Warrick Fuller (see

fig. 19), Sargent Johnson, and Augusta Savage must have been inspiring to Perkins and others. Catlett's powerful *Negro Mother and Child* (fig. 5) won first prize for sculpture; this piece was particularly important for Perkins, whose early works exhibit a similar brooding monumentality (see for example fig. 8). Catlett, who carved the sculpture as her master's thesis under the supervision of painter Grant Wood at the University of Iowa, lived in Chicago in the early 1940s. Since she shared an apartment with Margaret Taylor Goss, she and Perkins almost certainly knew each other.[26]

The "Exhibition of the Art of the American Negro" was also a prelude to the opening, that same year, of the South Side Community Art Center. Peter Pollack had been working with the WPA, community leaders, and local artists for two years to lay the groundwork for the center.[27] Money was raised at lavish "Artists and Models Balls," held at the Savoy Ballroom on 47th Street and South Parkway. Community support for the art center cut across class and and racial lines. The center's dedication, on May 7, 1941, was presided over by none other than First Lady Eleanor Roosevelt, as well as by Alain Locke. The lively celebration, which spilled onto the streets, was

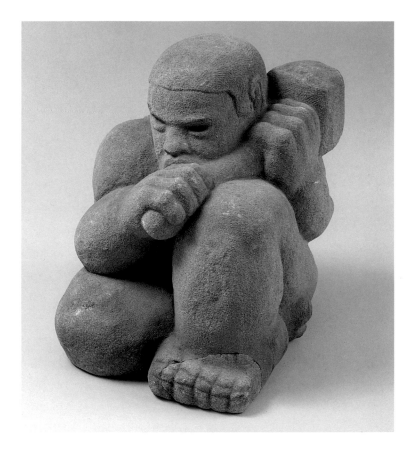

FIGURE 8

Marion Perkins. *John Henry,* 1942. Lime-stone; 41.9 x 27.9 x 33 cm (16½ x 11 x 13 in.). Collection Thelma and Toussaint Perkins, Chicago. Photo: Michael Tropea.

FIGURE 9

E. Simms Campbell (American; 1906–1971). *Let John Henry Go.* Cover illustration, *Opportunity* 20, 3 (Mar. 1942).

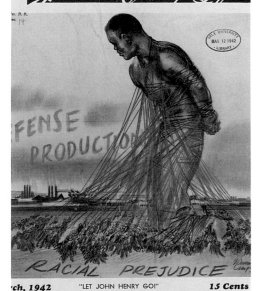

carried by radio stations across the country. Perkins was not mentioned in the extensive local and national coverage, but he soon began to teach at the center and he exhibited there frequently throughout the 1940s.[28]

"John Henry"

Pollack's support of Perkins paid a handsome dividend in 1942, when the busy, but still largely unknown, artist was invited to show his powerful limestone sculpture *John Henry* (fig. 8) at the "53rd Annual Exhibition of American Paintings and Sculpture" at The Art Institute of Chicago—one of the oldest and most prestigious annual juried competitions in the country.[29] The 1942 exhibition was notable for two events: it included a memorial retrospective of forty-eight works by Grant Wood, and it occasioned the museum's purchase of Edward Hopper's *Nighthawks,* painted the same year. The inclusion of a sculpture by Perkins in this historic exhibition was a major step forward for him. One of the artist's most memorable works, *John Henry* proclaims his mature style. Most striking about the piece is the degree of emotional and psychic intensity that the sculptor was able to achieve through very spare means— this would be the hallmark of his best work.

Tightly squeezed within the contours of a nearly cubic limestone block, the figure of John Henry grasps a hammer and presses it against his neck and shoulder. His massive, coiled limbs convey an overwhelming sense of power that is unused, frozen, and frustrated. Incidental details add to the sense of untapped energy: the intense glare of his eyes, his right hand pressed against his upper lip. He clutches the shaft of the hammer so tightly that it seems to bend around his neck. The muscles of his back strain visibly to maintain the diagonal movement of his shoulders and his hold on the hammer. Capping this image of

repressed potential, the head conveys a strong sense of John Henry's inner life. The complex interplay of masses that define the figure is a measure of Perkins's ability to invent a pose which is at once expressive and poetic.

John Henry, the black laborer of legend who pitted his strength against the steam shovel, was one of the country's most durable and versatile folk characters. He was often used as a symbol of the black worker during the labor struggles of the 1930s. In 1940 the tale was adapted by the writer Roark Bradford for a Broadway musical starring Paul Robeson.[30] During World War II, John Henry was evoked to refer to the depreciation of blacks in the still-segregated armed forces and their vulnerability to job discrimination in the defense industry. An example of the latter is illustrated by a cover created by E. Simms Campbell for the March 1942 issue of *Opportunity*, the National Urban League's magazine (fig. 9).

For a 1943 article on the presentation of *John Henry* at the Hall branch of the Chicago Public Library, Perkins supplied his own perspective on his subject:

He has never been just the crude muscle type of bad Negro, who gambled, got drunk, and "played with women" and ended up by merely pitting his brawn against the machine to support the challenge of his boss. With the first advent of the machine, many workers felt bitter toward it because it took their jobs, robbed them of their bread, and worse still, their creativeness.[31]

For Perkins *John Henry* was more than a generic symbol of alienated and underused black labor; his sculpture of this folk character may have been a self-portrait as well. At just this time, Perkins's own job situation had changed. He applied for work at Douglas Aircraft. Although he was "qualified to do a technical job of plastic molding needed in

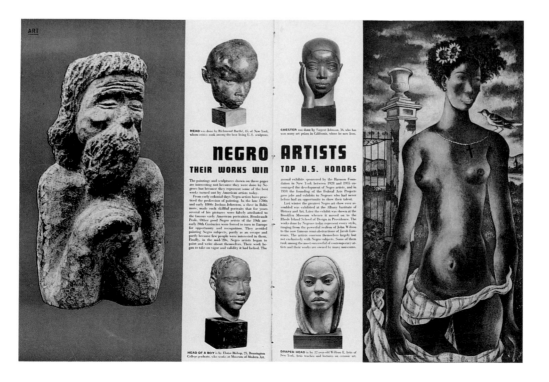

FIGURE 10

Far left: Marion Perkins. *Moses*, c. 1943. Stone; h. 35.6 cm (14 in.). Present location unknown. Photo: *Life* (July 22, 1946), pp. 60–61. This spread also includes reproductions of sculptures (clockwise from the upper left) by Richmond Barthé, Sargent Johnson, William Artis, and Eloise Bishop, and a painting on the right by Eldzier Cortor.

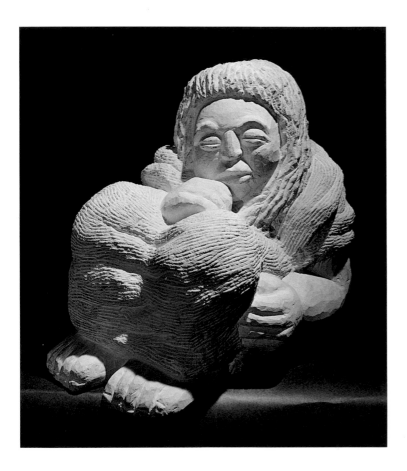

FIGURE 11
Marion Perkins.
Woman with a Shawl,
c. 1943. Stone (?);
dimensions and pre-
sent location
unknown. Photo:
Ralph Crane, courtesy
Time/LIFE magazine
© TIME Inc.

airplane and design and construction," as the article cited above explained, "the Douglas Air-craft company [acknowledged] his qualifica-tions, but offered him only a janitor's job."[32] He sold his newsstand in 1942 and took a position as a junior custodian at the United States Post Office, where, despite his considerable work experience and artistic achievements, he was as underutilized as his John Henry appears to be.

Nonetheless, Perkins's success at the Art Institute continued. In 1943 he and eighteen other black artists (most of whom were associ-ated with the SSCAC) were invited to show together as part of an ongoing series of exhibi-tions held in the museum's "Room of Chicago Art." Records for most of these shows, which were staged through the 1940s, are sketchy. Perkins's two submissions, *O! Israel* and *Woman with a Shawl,* are difficult to identify.[33] How-

ever, the latter can be linked, in subject and style, to a work photographed in 1951 for an unpublished *Life* magazine piece (see fig. 11). The figure of a seated woman reveals the inter-est in mass and pose seen in other early pieces, but exhibits increased involvement with com-plex textural effects. No visual record of *O! Israel* has been found, but the title indicates that here Perkins linked an Old Testament theme with the oppression of blacks, as seems to be the case with another work from this time, his *Moses* of c. 1943 (see fig. 10). In its spiritual intensity, this craggy, suffering figure anticipates the artist's 1950 *Man of Sorrows* (figs. 1, 21).[34]

In the 1940s, Perkins spent more time at the SSCAC and took a ceramics course at Chi-cago's most famous settlement organization, Hull House.[35] His technique improved, his confidence grew, and he worked in a greater range of styles. Sculptures from the later 1940s, such as *Seated Figure* of 1947 (fig. 12), show increasing refinement of surface. Included in the Art Institute's 1949 "Artists of Chicago and Vicinity" exhibition, the corpulent, resting fig-ure is typical of Perkins's works of the late 1940s and early 1950s, primarily his female fig-ures and mother-and-child groupings.

The more fluid forms of *Figure at Rest* (fig. 13), purchased by International Business Machines Corporation (IBM) in 1947, bear the strong imprint of the leading masters of direct carving, such as José de Creeft (see fig. 14), John Flanagan, John Rood, and William Zorach, all of whom were influential exponents of the technique. Their participation in the Art Insti-tute's "American Exhibitions" during this period allowed Perkins to study their work directly.[36] In their compact contours and con-centrated form, both *Seated Figure* and *Figure at Rest* also bring to mind sculpture from the pre-Columbian cultures of Mexico and Mesoamerica. In general, Perkins's male sub-jects display spiritual intensity and anxiety,

BELOW LEFT

FIGURE 12

Marion Perkins. *Seated Figure,* 1947. Limestone; 40.6 x 25.4 x 22.9 cm (16 x 10 x 9 in.). DuSable Museum of African American History, Chicago. Photo: Michael Tropea.

BELOW RIGHT

FIGURE 14

José de Creeft (American [born in Spain]; 1884–1982). *Seated Woman,* 1938. Marble; 40.6 x 25.7 x 28.6 cm (16 x 10⅛ x 11¼ in.). Hirshhorn Museum and Sculpture Garden, Smithsonian Institution, Washington, D.C., gift of Joseph H. Hirshhorn (1966).

RIGHT

FIGURE 13

Marion Perkins. *Figure at Rest,* 1947. Marble; 27.3 x 26.7 x 21.6 cm (10¾ x 10½ x 8½ in.). Present location unknown (ex-collection International Business Machines Corporation; sold at Parke-Bernet Galleries, New York, Feb. 18, 1960, lot 88). Photo: Helga Photo Studio, New York, courtesy Johnson Publishing Company.

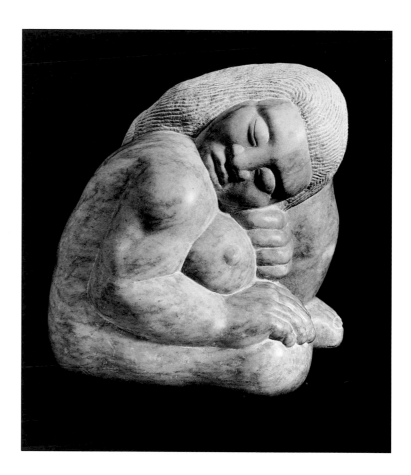

RIGHT

FIGURE 15

Marion Perkins.
Mother and Child,
c. 1949. Stone;
dimensions and present
location unknown.
Photo: Mike Shay,
courtesy Johnson
Publishing Company.

FAR RIGHT

FIGURE 16

Marion Perkins.
Untitled, c. 1947. Lime-
stone; 57.2 x 38.7 x
24.8 cm (22½ x 15½ x
9¾ in.). South Side
Community Art Cen-
ter, Chicago. Photo:
Michael Tropea.

OPPOSITE

FIGURE 17

Marion Perkins shown
carving *Untitled*
(fig. 16) in the court-
yard behind his home
in the Ida B. Wells
project, Chicago, 1947.
Photo: Janet Peck,
"'Relax' is Word of
Action for Artist
Perkins," *Chicago
Tribune,* Aug. 24, 1947,
sec. 3, p. 2.

while his female figures often symbolize refuge and tranquility. Although the artist's sculptures from this period are quite beautiful, they lack some of the power of *John Henry* and *Moses.*

While Perkins was devoted to an art based on appearances, his interest in abstraction is evident in a number of examples, including *Mother and Child* (fig. 15), completed in the late 1940s. This piece retains the voluptuous forms of his female figures of the late 1940s, but its masses are conceived with a more formal geometry. Moreover, here Perkins defined the facial features with line rather than volume. An intriguing untitled work of about 1947 (fig. 16) may show the beginnings of this trend toward abstraction. The pose of the kneeling figure, with its head nestled in the crook of its wrist, resembles a famous crouching, sixteenth-century écorché figure once given to Michelangelo (Berlin, Staatliches Museen; Paris, Ecole des beaux-arts). Yet, the machinelike, geometric forms of the figure's arm and leg are reminiscent of works by Henry Moore, the pre-eminent

sculptor of his generation. Perkins would have observed firsthand Moore's typical synthesis between abstraction and naturalism at the English artist's first major exhibition in the United States, which came to the Art Institute in the spring of 1947.[37]

Stylistic Maturity

Perkins's formal experimentation found resolution in a totally original, emotionally powerful series of heads and figures that date from the late 1940s and signal his mature style. One of the first may have been exhibited at the Art Institute's 1947 "Chicago and Vicinity" exhibition. Perkins, who had rarely been mentioned in the white press, was given a huge boost by Chicago's best-known artist at the time, Ivan Albright, in his review of the show in the *Chicago Herald-American.* Albright mentioned Perkins's *Negro Woman* as the highlight of the sculptures on display and praised it at the expense of a respected local sculptor and teacher (and perennial exhibitor), Sylvia Shaw Judson, whose sentimental sculpture *Lambs* was also in the show:

Chicago Sunday Tribune: August 24, 1947
Part 3—Page 2 S

'RELAX' IS WORD OF ACTION FOR ARTIST PERKINS

Sculpturer Wins Praise and Pay with Hobby

BY JANET PECK

Many a warm summer evening finds Marion Perkins relaxing in the back yard of his home at 600 E. Pershing rd. The Perkins' relaxation method, however, is neither puttering in a garden or plunking himself down in a hammock to read the paper.

Instead he hauls out a heavy block of limestone [often obtained from some vacant lot or razed building], and an assortment of tools including a mallet and chisel. Standing on the overworked feet that supported him at the postoffice, he sets out to sculpture another piece so pleasing to the artistic world.

It is just such periods of relaxation that have put the Perkins name on art exhibit programs as well as in the critics' stories. One of his pieces recently was on exhibit in the Chicago Aritst's show at the Art institute.

Finds Art in Depression

Perkins first discovered he could "make things" in the depression days when jobless he spent many idle hours carving out of soap the faces and figures of his wife and three sons.

"It was a good way to pass the time and good practice," he said. The precious soap, carved or not, was used by Mrs. Perkins for the family laundry.

Then the amateur became friends with Sy Gordon, a sculptor, who then had a studio at 36th st. and Cottage Grove av. Soap carving was replaced by learning to use a mallet, chisel, and wood carving tools as Gordon, recognizing the young man's talent, taught him.

Attracts Artist's Attention

Meanwhile the Perkins financial circumstances took a turn for the better when they bought a newsstand at 37th st. and Indiana av. That newsstand turned out to be one of Perkins' luckiest breaks. While Perkins was tending it—and simultaneously working on a large limestone piece—Peter Pollack of the Art institute, then connected with the South Side Community Art center, noticed the work while driving by.

He stopped to inquire and eventually was instrumental in introducing Perkins and his work to the art world. Perkins' first piece to be shown was exhibited at the Negro exposition in 1940. It was a head entitled "John Henry" and now is in possession of Hall library, 48th st. and Michigan av.

Youngsters "Help" Perkins

During the years since Perkins studied in and taught WPA classes, studied ceramics at Hull House, has had a couple of fine commissions, and a few years ago obtained a job in the postoffice. Among his pieces are a head, "Moses," owned by a corporation in New York, a head of Frederick Douglass, and several pieces partially abstract in subject.

Summer times while pursuing his hobby in the back yard he often is surrounded by a crowd of wide eyed youngsters whom he calls his "public." "They're a big help," he said, "always telling me where I can get some more limestone in near-by lots —sometimes even bringing it to me."

When winter comes the artist moves his paraphernalia into the kitchen.

Critical Audience Watches Sculptor at Work

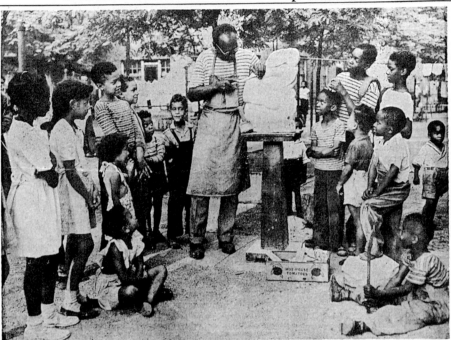

When Sculptor Marion Perkins of 600 E. Pershing rd. gets set for an evening with his chisel and mallet, he quickly draws a group of wide-eyed youngsters from the Ida B. Wells housing project where he lives to watch him with great interest. Perkins, whose hobby has brought his name to the front in artistic circles, is an employe in the main post office. He follows his art in his spare time. The material he works with most frequently is limestone and his young audience is quick to tell him where some discarded chunks of the stone may be found.

S. AREA COUNCIL WORKS TO SPEED FLOW OF TRAFFIC

Reports 7 Projects Are Completed

Seven projects of the south area council of the Chicago Motor club were completed during the 60 day period between the June and August meetings. Progress was reported on four others at the recent meeting in the Windemere West hotel.

Completed projects are:

Installation of no parking signs 50 feet in all directions from the intersections of 68th and 69th sts. and Stony Island av.

More Control Signs

New traffic control signs at the intersection of Dorchester and Lake Park avs., and 47th st.

Repairs on Baltimore and Ohio railroad crossings from 83d st. to Dorchester av.

Installation of new traffic control equipment facilitating left turns at 67th st. and South Park av.

Bus loading zones on Jeffery blvd. from Jackson park to 90th st. Motor club officials stated police have been requested to enforce regulations requiring bus drivers to pull into the curb when taking on or discharging passengers.

Traffic Lanes Painted

Marking of traffic lanes near Vincennes av. and 107th st.

Installation of 20 mile an hour speed signs in the business area around 90th st. and Loomis blvd. and painting of pedestrian cross walks at the intersections.

Progress was reported on the following:

'Traffic signs'

Perkins is both an intent and rapid worker. Three of his recent works (from left) include the head of a friend cast in plaster, the head of Frederick Douglass, and a piece entitled, "Fat Girl." The latter two are of limestone. Another of his works, "Negro Woman" was shown recently in the Chicago Artists' exhibit at the Art institute.

OPEN TICKET BOOTHS IN HOTELS FOR GIRLS' BALL GAME SEPT. 8

Members of the Chicago women's division of the National Jewish hospital at Denver, Colo., have opened ticket booths in three south side hotels to further sales of box seats for the All-Star Girls baseball game Sept. 8 in Comiskey park.

Proceeds will go to the building

15 SOUTH SIDERS TO GET DEGREES AT ROOSEVELT

Degrees will be conferred on 15 south siders at summer school commencement exercises of Roosevelt college. A total of 58 will graduate.

South siders to receive degrees include Mirron Alexandroff, 5320 Dorchester av.; Eleanor Boxerman, 5214 Woodlawn av.; Clifford Doyle, 4730 South Park way; Leonard Ehrlich, 5112 Harper av.; Katialice Evans, 6110 Eberhart av.; Jane Frankel, 7856 Eberhart av.; Herbert Giblichman, 7443 Jeffery av.; Marsha Helmer, 1116 E. 54th pl.

Others are Donn L. Jordan, 1549 E. 65th pl.; Massie L. Kennard, 4123 Prairie av.; George Kndelik, 9356 Harper av.; Edward Schwartz, 5400 Dorchester av.; Q. E. Smith, 4151 Indiana av.; Marcia Thayer, 268 W. 39th st., and Georgia Smith, 5940 Prairie av. All will receive bachelor degrees.

East Chicago Pupils to Learn Auto Driving

Roosevelt High school, East Chicago, will inaugurate a driver training course this fall, the Chicago Motor club has announced. A sedan has been furnished the school by a motor sales company. Teachers were trained by the motor club at Northwestern university. Dual controls, class material, and mechanical devices to assist in the also are provided

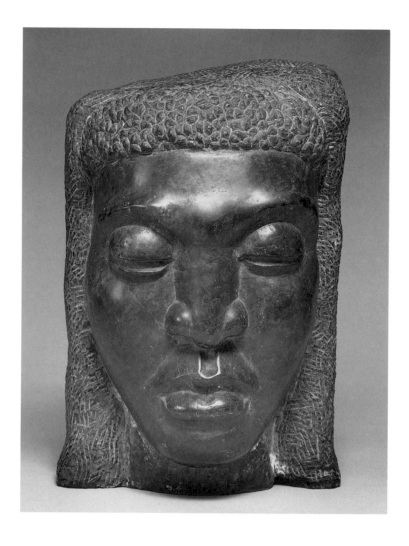

FIGURE 18

Marion Perkins. *Ethiopia Awakening*, 1948. Marble; 31.1 x 21 x 21 cm (12¼ x 8¼ x 8¼ in.). DuSable Museum of African American History, Chicago. Photo: Michael Tropea.

Up and beyond the rest of the sculpture rises the pure art in the marble head of "Negro Woman" by Perkins. A former newsboy, he chiseled this head out of a piece of stone from a torn down building at 37th and Indiana. It carries the burning humbleness of centuries in his work. There is no shout. It is such fine art that the two bleating lambs standing and mushing on the ground next to it by Sylvia "Boo Peep" Judson could be taken out immediately to the nearest toy counter for child consumption.[38]

While *Negro Woman* cannot be positively identified, it may be the Art Institute's *Portrait of Eva* (fig. 3), unmistakably a stylized

depiction of Perkins's wife, with her planar face and prominent cheekbones. The calm perfection of the surface and facial features gives this piece an hypnotic effect. It represents a new phase in Perkins's work.[39]

The year 1947 was a watershed in Perkins's career. As noted above, IBM purchased *Figure at Rest*; he exhibited at the Art Institute; and he was the subject of several newspaper articles. This last achievement was perhaps the work of Pollack, who had left the SSCAC to assume the post of public-relations counsel at the Art Institute. The *Chicago Tribune* reproduced several works (fig. 17), one of which is lost (a monumental portrait of Frederick Douglass). The article shows *Seated Figure* (fig. 12) and establishes a date for the SSCAC's kneeling figure (fig. 16), which Perkins is shown carving in the courtyard behind his home at the Ida B. Wells project.[40]

Later in 1947, Perkins received a grant from the Chicago-based Julius Rosenwald Fund. In operation since 1917, the fund initially supported the building of schools and libraries and the work of scholars that led to better conditions for blacks and poor, white southerners. In the mid-1920s, the fund began to offer grants to individuals in the arts: Barthé, Catlett, Cortor, and White were all recipients.[41] Perkins proposed creating a series of portrait heads of children of various races. His application also reveals he intended to enroll at Chicago's famed Institute of Design. He secured references from artist Joseph Hirsch, Locke, Pollack, and David Ross (Pollack's successor at the SSCAC). Hirsch and Ross remarked that Perkins's financial responsibilities prevented him from devoting all of his time to his creative output. But the most persuasive endorsement came from Langston Hughes:

What I have seen of his work has visual beauty and emotional power. What I know of him as

a person causes me to believe him hard working, persistent, a man of character and determination, dedicated to his art, continually interested in experimentation, growth, and improvement.[42]

The awards panel, which included Katharine Kuh and Jacob Lawrence, awarded Perkins $2,400.

When he received the grant money, in April 1948, Perkins left for New York City. Regrettably, nothing is known either about the trip or whether he completed the series of portrait heads. The award and the New York visit may have coincided with his dismissal from the post office, perhaps because of his leftist political beliefs. In this time of increasing polarization over the American position toward the Soviet Union, thousands were fired from government jobs in 1948 under the new United States Loyalty-Security program.[43]

Before leaving for New York, Perkins took second prize for sculpture at the 52nd "Chicago and Vicinity" show—his first award at the Art Institute. His entry, *Ethiopia Awakening* (fig. 18), is one of his landmark works.[44] The features of this powerful female head are again inspired by the physiognomy of Eva, here amplified to heroic proportions. Bulbous, heavily lidded eyes and a bladelike nose emerge dramatically from a veil draped over the head and hair. Perkins's manipulation of texture, contrasting the highly polished face with two patterns of coarse carving in the veil and hair, is more elaborate than in previous work. Examination of the back of the inky green marble block reveals that the stone was originally a section of a fluted column. The title of the work has a double significance, for it refers not only to Meta Warrick Fuller's influential sculpture of the early 1920s (fig. 19), but also to post-World War II Ethiopia, which was emerging from its second traumatic bout with colonialist violence in this century.[45] *Ethiopia Awakening,*

FIGURE 19

Meta Warrick Fuller (American; 1877–1968). *Ethiopia Awakening,* after 1921/22. Bronze; 170.2 x 40.6 x 50.8 cm (67 x 16 x 20 in.). Schomburg Center for Research in Black Culture, Art & Artifacts Division, The New York Public Library, Astor, Lenox, and Tilden Foundations. Photo: Manu Sasoonian.

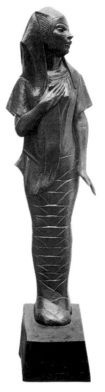

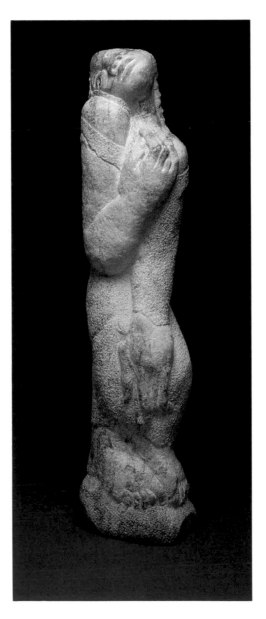

FIGURE 20

Marion Perkins. *Standing Figure,* late 1940s. Marble; 90.8 x 20.3 x 15.2 cm (35¾ x 8 x 6 in.). The Art Institute of Chicago, through prior bequest of Marguerita S. Ritman (1996.401).

like *Portrait of Eva* (fig. 3), was purchased by the Gourfains.

Echoes of Fuller's historic work can also be seen in the extraordinary *Standing Figure* (fig. 20), which Perkins must have made in the late 1940s. For many years in the collection of Perkins's SSCAC colleague the artist William McBride, this piece seems never to have been exhibited or reproduced. Carved from an oblong marble slab (perhaps a salvaged sill or threshold), the figure is unusual in Perkins's oeuvre in that it is full-length, but the use of closed contours is typical. The woman presses her arms tightly to herself; one bends at the elbow, allowing her hand to cover her breast,

FIGURE 21

Marion Perkins. *Man of Sorrows*, 1950. Marble; 44.5 x 22.9 x 22.9 cm (17 ½ x 9 x 9 in.). The Art Institute of Chicago, Pauline Palmer Purchase Prize (1951.129).

and the other crosses her body diagonally. Her head is thrown back, as if in anguish or despair; and her hair cascades down her back in a delicate, scalloped pattern. A layer of sheer, clinging drapery alternately covers and exposes parts of the body, serving to define and reinforce the pose.

This figure's complicated posture and exquisite drapery recall classical sculpture, while its subdued angularity and anticlassical proportions bring to mind medieval jamb sculpture.[46] Although the pose clearly suggests suffering, the restraint of the gestures and expression keeps this work from being melodramatic. In contrast to Fuller's sculpture, the unidealized quality of Perkins's *Standing Figure* establishes a direct, almost visceral connection to the viewer. The combination of classical calm and medieval turbulence exemplifies Perkins's inspired eclecticism. A diligent student of art history, he drew from many traditions—ancient, pre-Columbian, Renaissance, African, and modern—and yet achieved a highly individual style.

"Man of Sorrows"

Perkins showed work at two more Art Institute annuals before displaying one of his most important sculptures, *Man of Sorrows* (figs. 1, 21), in the 1951 "Chicago and Vicinity" exhibition. Not only did this Christ figure win a prize, but the museum purchased it from the show, which brought Perkins an unprecedented measure of recognition.[47] Although the dispute between the modern and antimodern camps of critics was running high and would reach a fever pitch with the Art Institute's acquisition, later that year, of Willem de Kooning's extraordinary abstraction *Excavation* (1950), praise for Perkins's work was nearly unanimous. Two national magazines picked up the story. *Ebony*, the black-owned and -oriented magazine based in Chicago, published a long

ABOVE

FIGURE 22

Marion Perkins scavenging for materials, Chicago, spring 1951. Photo: Mike Shay, courtesy Johnson Publishing Company.

ABOVE

FIGURE 23

Marion and Eva Perkins outside their home, Chicago, spring 1951. Photo: Ralph Crane, courtesy Time/LIFE magazine © TIME Inc.

LEFT

FIGURE 24

Marion Perkins with Peter Pollack in the galleries of The Art Institute of Chicago, spring 1951. Photo: Ralph Crane, courtesy Time/LIFE magazine © TIME Inc.

FIGURE 25

Marion Perkins.
Dying Soldier, 1952.
Marble; dimensions
and present location
unknown. Photo:
The Art Institute of
Chicago.

article in its October issue, illustrated by local photographer Mike Shay (see figs. 1 and 22).[48] *Life* magazine's Chicago staff also became interested in the story, and noted photographer Ralph Crane was sent from New York to document it. The number and range of the pictures taken suggest that Crane and Perkins may have spent several days together. Crane photographed Perkins at work in his studio/home at 57th and Wells (figs. 23, 30); on the job at the freight company where he was now employed; looking at art in the Art Institute with Pollack (fig 24); at the home of his friends and patrons Joyce and Edward Gourfain; and at demolition sites where Perkins scavenged for materials. For unknown reasons, *Life* never published the piece.[49]

In comparison with earlier, negative assessments of Perkins's work in the white press, *Man of Sorrows* prompted glowing responses, with the exception of the *Chicago Tribune's* arch-conservative critic, Eleanor Jewett, who

condemned it. The *Chicago Sun-Times* art writer, Frank Holland, who had declared in 1943 that Perkins's *O! Israel* and *Woman with a Shawl* were not at the same level as the work of his colleagues in "Negro Artists of Chicago," now found that the "magnificent" *Man of Sorrows*, "with its simplified forms, contrasting textures and noble conception, well deserves its reward." For critic C. J. Bulliet, who longed for the elusive "African" element in work by black artists, it seemed as though Perkins's work had finally met his criterion: "Christ seen through the eyes of a devout Negro, at once reverent and physically strong like the gods of the Congo."[50]

Man of Sorrows is indeed powerful, but its emotional intensity is achieved not through brute force of carving or any "primitivizing" influence. Rather, it succeeds through its brilliant balance of exaggeration and restraint. Its sheer physical presence is conveyed through the impressive bulk of the the marble block,

with its tapering, clublike contour. Nothing breaks the continuity of the surface. The head's simplified, protruding eyes are shut tight; the pursed lips are both hidden and defined by a short, stubbly beard that closely follows the contours of the face; the hair is veined with smoothly carved thorns. Christ's contained expression of agony is arresting. Although many representations of a black Christ preceded Perkins's piece, including works by Aaron Douglas and William H. Johnson, none is as invested with the quiet, convincing intensity of *Man of Sorrows*.[51] Perkins, who was less spiritual than political, was blunt in his comments about the sculpture:

This is a piece that says what I want it to say. It shows the Negro peoples' conception of Christ as a Negro—which is as it should be. We cannot conceive of Christ as a weakling and there is nothing weak about this piece. This head reflects the suffering of our people but it reflects it in a strong and forceful way. The reflection of the suffering of the Negro people in this head of Christ is an acid test of American democracy. The major problem facing America today is the solution of the Negro problem.[52]

The photographs by Crane and Shay of the artist standing next to *Man of Sorrows* (see fig. 1) raise the issue of Perkins's sense of personal identification with this sculpture. The artist as Jesus is after all a long-standing tradition in Western art, with the most familiar examples being works by Albrecht Dürer and Paul Gauguin. As Eva stood behind a great number of Perkins's female figures, Perkins may have been the model for many of his male figures, including the intense, hammer-wielding John Henry and Christ, who, despite pain and anguish, maintains his calm restraint and physical beauty.

The 1950s

Although Perkins continued to create fascinating and moving works over the next ten years, he never surpassed the achievement of *Man of Sorrows*. In some ways, his loss of artistic focus was part of a trend that affected a generation of artists who came to prominence before the end of World War II. For the socially committed of the 1930s and 1940s, the rigidly anti-Communist, Cold War mentality of the 1950s was deeply troubling. Alliances of blacks and whites, established through shared progressive political thinking, came under severe stress and began to crumble. Perkins's commitment to racial and social equality and to anticolonialism in Asia and

FIGURE 26

Marion Perkins. *Unknown Political Prisoner*, 1953. Limestone; 50.2 x 20.3 x 30.5 cm (19¾ x 8 x 12 in.). Collection Ruth and Quentin Young, Chicago. Photo: Michael Tropea.

Africa did not waver, but it did isolate him, as it did others.

The works that Perkins submitted to exhibitions in the 1950s were very direct in their political implications. In the 1952 "Chicago and Vicinity" exhibition at the Art Institute, he showed a moving sculpture entitled *Dying Soldier* (fig. 25).[53] His last prize-winning entry, it portrays the tragic figure of an expired soldier, laid out in defeat. In 1953 Perkins created an even more disturbing work: *Unknown Political Prisoner* (fig. 26) was the last piece he exhibited at the Art Institute, at the 1957 "American Exhibition."[54] It shows a kneeling, almost childlike figure of a soldier, facing forward with an expression devoid of hope, protest, or comprehension. The isolation and vulnerability of the figure are chillingly conveyed in part by the fact that the soldier is stripped bare above the waist.

Perkins, however, was anything but silent about his convictions. An article he wrote for a 1952 issue of the Marxist monthly *Masses & Mainstream* expressed his opposition to imperialism with stinging clarity. Describing the

thinking behind his final, unfinished series of sculptures, the *Skywatchers*, Perkins wrote:

The decadent trend in American culture is sharply reflected in sculpture. The stench in Korea, the atom bomb war-cries, along with the domestic crises, require the ruling class to suppress realism and humanity in art. Hence the fashionable craze to throw out all idea-content in art. In the face of this situation, at times depressing to the spirit, I find myself engaged in conjuring up great sculptural projects whose complete realization may be somewhat dubious. The Hiroshima group which I am now working on has turned into a challenge which I am a long ways from meeting satisfactorily.[55]

Perkins's belief in the viability of such an ambitious sculptural monument attests to his ongoing commitment to revolutionary ideology. He doubted not that such work should be done, but that it would be acceptable to the public, given a cultural climate increasingly hostile to figurative art and a political and economic system that, in his view, sanctioned racism and violence worldwide.[56]

Perkins began thinking about his *Skywatchers* series in 1945, but did not initiate it until a few years later. Instead of planning for a single, large monument, he approached the subject in the form of a group or ensemble "with each individual figure portraying some aspect of Hiroshima."[57] Since he worked in various media and modes, his progress is difficult to chart. He may have begun with a figure that is so slender it is practically a two-sided relief (fig. 27). First exhibited in 1954, this marble was followed by a large number of true reliefs, which are among Perkins's most beautiful sculptures. The series includes as well two works in plaster, *Study in Flight* (fig. 28) and *Man Looking Upward* (see fig. 30). These sculptures mark a significant departure from

FIGURE 27

Marion Perkins. *Skywatcher*, c. 1948. Marble; 66.7 x 10.8 x 55.9 cm (26¼ x 4¼ x 22 in.). The Peace Museum, Chicago, gift of Roslyn Rosen Lund. Photo: Jo-Banks Creative Photography, courtesy Toussaint Perkins.

Perkins's previous work. In contrast to his generally contemplative figures, compact in mass and form, these terrified figures, with their open contours, interact vigorously with the surrounding space. However, the sculptor seems never to have pushed them beyond the "study" stage.[58]

Conclusion

The house to which Eva and Marion Perkins moved in the late 1950s was well-suited to work on the *Skywatchers*. Their home—actually a former coach-house—was set back from the street about seventy-five yards, giving Perkins an extended, private, and bucolic setting in which to work and site his sculptural arrangements. On the property, one can still find the marble patio he installed, as well as a pile of fine stone gathered on expeditions he referred to as "midnight requisitioning."[59]

Perkins continued to be very active until his death in 1961, but tracing his development after the early 1950s is difficult. The kind of photographic documentation generated by the publicity surrounding the Art Institute's purchase of *Man of Sorrows* in 1951 never reoccurred, and many of his works of this period have proven impossible to identify or locate. It appears that Perkins experimented with materials and techniques that he never had time to develop fully. Several works from the period are worthy of notice, including a pair of busts of Sancho Panza and Don Quixote, whose physiognomies are expressively elongated (fig. 29); a soulful, stone likeness of the jazz singer Bessie Smith; and a celestially calm and unruffled head of Buddha that he is thought to have carved on commission.[60]

Perkins also seems to have spent more of his time actively promoting his work in this period. Although he never had gallery representation, he showed frequently with Chicago nonprofit collectives and at one of the huge,

no-jury exhibitions of Chicago art held at Navy Pier.[61] Perkins's activity as an art-fair exhibitor merits discussion. While he was never officially listed as an exhibitor, at least two private collectors met the artist and purchased works from him at the Old Orchard Art Fair on Chicago's North Shore.[62] The presence of his works at other venues in the late 1950s—including the Atlanta University Invitational and National Brotherhood Week exhibitions sponsored by the National Conference of Christians and Jews—suggests that Perkins must have expended an enormous amount of time and energy in exhibiting his sculpture. Moreover, throughout this time, he made himself available to counsel other artists, a

FIGURE 28

Marion Perkins. *Study in Flight,* c. 1950. Plaster; dimensions and present location unknown. Photo: Mike Shay, courtesy Johnson Publishing Company.

FIGURE 29

Marion Perkins.
*Sancho Panza and
Don Quixote,* c. 1955.
Limestone; 59.7 x
11.4 x 25.4 cm and
86.4 x 40.6 x 20.3 cm
(23½ x 4½ x 10 in.
and 34 x 16 x 8 in.).
Collection Thelma and
Toussaint Perkins.
Photo: Michael Tropea.

FIGURE 30

Marion Perkins with
several of his works on
the stairs to his home,
Chicago, spring 1951.
Man Looking Upward
is the sculpture
on the left of the fifth
step, next to Perkins.
Photo: Ralph Crane,
courtesy Time/LIFE
magazine © TIME Inc.

quality that his colleagues—including Cortor and Burroughs—have consistently praised.[63]

One of Perkins's final gestures of support for his fellow artists was an address he delivered at the inaugural meeting of the Black Artists Conference (now the National Conference of Artists) in Atlanta in 1959. In his view, the problems confronting black artists—derived from the experience of centuries of domination and discrimination and from the severing of ties with African culture—would not be resolved in his lifetime. He urged artists to agitate for equal education and training and for fair representation in galleries and museums. As he had done in the *Masses & Mainstream* article, but in a less polemical tone, he stressed the importance of communicating clearly in art. He also strongly recommended that black artists look to their African heritage and advocated solidarity with African political and social liberation movements.[64]

Tragically, Marion and Eva Perkins both succumbed to cancer in 1961. Their untimely deaths were a shock to their families and wide circle of friends. Most of the works remaining in Perkins's studio at his death have been dispersed, with few records kept. Although his art has received only occasional exposure in the ensuing years, Marion Perkins was one of the most remarkable artists to have worked in Chicago. He produced a large and varied body of work that engaged the issues and art of his time with sophistication and skill. His art, as well as his personal commitment, also left a lasting impression on colleagues who gained greater recognition. A reconsideration of his valuable, but largely unknown, legacy is long overdue.

BLACK AND TANNED
YOUR WHIPPED WIND
OF CHANGE HOWLED LOW
BLOWING ITSELF-HA-SMACK
INTO THE MIDDLE OF
ELLINGTON'S ORCHESTRA
BILLIE HEARD IT TOO &
CRIED STRANGE FRUIT TEARS

Fragmented Documents

Works by Lorna Simpson, Carrie Mae Weems, and Willie Robert Middlebrook at The Art Institute of Chicago

CHERISE SMITH

Stanford University

Introduction

Roy DeCarava's 1952 photograph *Man Coming Up Subway Stairs* (Portfolio, no. 16) features a middle-aged African American with jacket under his arm, ascending a stairway. The diagonal of the handrail and the right angles formed by the steps and lines of the building draw our attention to the subject's expressive face, as do the light tones of his shirt and the partially lighted window, against the darkness of the wall. He focuses his eyes forward and bites his lip, revealing a wrinkled and scar-riddled cheek. Judging from his misshapen hat and soiled shirt, he appears to be a laborer; whatever his occupation, his demeanor communicates both the persistence and resignation attributable to the daily grind of work. DeCarava's choice of an obscured and anonymous identity tempers the African American specificity of the image with the generality of urban experience. In this way, the photographer rendered this subject symbolic of anyone who works hard for a living, encouraging viewers to identify with him. The strength of *Man Coming Up Subway Stairs* lies not just in DeCarava's formal and technical dexterity, but also in the way he allows us to layer the image with our preconceived notions of work, African American men, and city life. At once a document of African American experience and a symbol of human existence, this photograph, an excellent example of DeCarava's efforts in a social-documentary mode, has an impact that is simultaneously individual and universal.

In the 1980s and early 1990s, a new generation of African American artists emerged. Lorna Simpson, Carrie Mae Weems, and Willie Robert Middlebrook may be considered the beneficiaries of the equal-rights movements: each had the advantage of coming of age in a society in which under-represented and disenfranchised people had more educational and financial opportunities than were previously available. Yet, even after certain concessions to equality have been made, Simpson, Weems, and Middlebrook exist, as do we all, in a media-driven world in which ethnically- and gender-based prejudices still prevail. At the crux of these artists' work lies a deep-rooted questioning of how mass media and art participate in the creation and dissemination of stereotypical information.[1] Determined to assert the individuality of African Americans, they produce art that explores issues such as race, personal relationships, cultural repatriation, sexual orientation, the nature of gender, and the importance of family. Their work will be considered here in terms of the similarity of their approaches to art-making, modes of representation, and intentions.

FIGURE 1

Carrie Mae Weems (American; b. 1953). *Black And Tanned Your Whipped Wind Of Change Howled Low Blowing Itself-Ha-Smack Into The Middle of Ellington's Orchestra Billie Heard It Too & Cried Strange Fruit Tears,* from the series *From Here I Saw What Happened and I Cried,* 1995. Chromogenic color print, overlaid with text sandblasted in glass; image: diam. 45.7 cm (18¾ in.); overall: 59.7 x 49.4 cm (23½ x 19½ in.); framed: 68 x 58 cm (26¾ x 22⅞ in.). The Art Institute of Chicago, Horace W. Goldsmith Fund (1996.424).

At the crux of these artists' work lies a deep-rooted questioning of how mass media and art participate in the creation and dissemination of stereotypical information.

Simpson, Weems, and Middlebrook have been influenced indelibly by documentary photography, such as DeCarava's *Man Coming Up Subway Stairs*, which seeks to classify data in order to communicate broad, sweeping ideas about its subjects. Although each of the artists was originally drawn to the didactic, communicative, and social aspects of documentary photography, each later came to critique the objectivity, veracity, and authority with which documentary photographs are invested. They also questioned the stereotypes on which documentary images rely. Ultimately, these artists switched to photography-based, mixed-media work, which, by its very nature, is an inclusive process, involving the weaving together of materials from different sources. A guerrilla technique, mixed media disrupts the high-versus-low arrangement of artistic media, according to which painting is primary. It also blurs the hierarchical distinction between the aesthetic and the utilitarian, whereby functionless objects are deemed more artistically valuable than functional ones. The artistic ideal of authenticity—in which originality is prized and reproduction devalued—is arguably the most taboo convention that mixed-media works challenge, as their appropriation of found images and materials undermines the uniqueness of the work of art. Paradoxically, the process reaffirms the singularity of the art object by producing something entirely different from its various parts. Simpson, Weems, and Middlebrook combine the documentary mode of representation with mixed media not only to subvert the unquestioned authority of documentary photographs, but also to assert the identity of African Americans. Thus, as this essay will show, they use the inherently disruptive nature of mixed media to reveal both the variety among African Americans and the many forces that shape African American "subjectivity," a

term encompassing a number of factors, including an individual's beliefs, intelligence, and creativity, among other sensibilities.

The Legacy of Documentary Photography
In order to understand the art of Simpson, Weems, and Middlebrook, it is first necessary to contextualize it within a brief overview of the histories of documentary photography and modern African American art. From its beginnings, photography's capacity for impartiality has been invoked to establish photographs as both evidence and record. The "scientific" objectivity of documentary photographs is based in their indexical and mimetic qualities, that is, in the conviction that what is pictured really existed. Because it is assumed that "the camera never lies," truthfulness is deemed to be inherent to the medium. As photography scholar Allan Sekula noted, "Photography, according to this belief, reproduces the visible world: the camera is an engine of fact . . . independent of human practice."[2] This truism presupposes that only the camera is involved in taking a photograph and does not account for the fact that it is a machine operated by the photographer. Indeed, since photographers decide how and what to depict, photographs are the result of their creators' intent. For instance, photographers manipulate imagery by making any number of choices, including such things as film type and speed, using available or artificial light, and employing different format cameras. Because photographers, like other artists, are shaped by social ideology, photographs inevitably reflect the sociopolitical concerns of their makers. Understood this way, documentary photographs are anything but objective.

Furthermore, a documentary photograph is considered successful when it captures the subject realistically and communicates persuasively. This often results when the image

draws upon a set of strongly held beliefs about a subject, extending the motif beyond the specific to the general and introducing symbolism into the image. In this way, a single motif or individual, such as the subject of DeCarava's photograph, represents a larger community—a part stands for the whole—creating a kind of metaphor, or "synecdoche." The right mixture of realism and symbolism allows us at once to identify sympathetically with and to differentiate ourselves from the subject, the "every person." Unfortunately, this essentializing process relies on and perpetuates stereotypes. Shorthand classifications that we form based on our own values and experiences, stereotypes are not inherently wrong; it is only when we consider "who controls and defines them, [and] what interests they serve" that we comprehend how nefarious they can be.[3] In this essay, I intend to demonstrate how Simpson, Weems, and Middlebrook use the concept of synecdoche to enable viewers to identify with their subjects and to subvert the devices and effects of stereotyping.

Documentary photographs have been employed in a variety of circumstances, ranging from evidence to propaganda, to rally support for various enterprises. A group of mid-nineteenth-century images in the Peabody Museum at Harvard University, Cambridge, Massachusetts, exemplifies the use of documentary photographs toward a supposedly scientific end. In 1850 Louis Agassiz, a Harvard professor of biology, commissioned J. T. Zealy to make fifteen daguerreotypes of seven slaves from the area around Columbia, South Carolina.[4] To facilitate his studies and insure "objectivity," Agassiz had the individuals portrayed in frontal and profile views and in various stages of undress, adhering to the established conventions of illustrating physical, criminal, and psychological characters.[5] Using these and other typological images as evidence

in his studies of cranial structure, Agassiz attempted to prove his erroneous and racist belief that, because of the different sizes of their brain cavities, individuals of African descent are inferior to whites.[6] *Delia* (Westerbeck essay, fig. 2) shows a young female slave who sits frontally with her hands in her lap; her dress is dropped around her waist, and her breasts are exposed to the camera. In another image, a male slave, Jack (Westerbeck essay, fig. 3), faces forward; his shirt has been removed, and he too sits with his hands in his lap. Taken at a time when Delia and Jack were not regarded as individuals, but rather as property, the daguerreotypes strike sensitive nerves in contemporary viewers. As our gazes shift from the slaves' eyes to their bare chests, we become aware of our own tendencies toward voyeurism, evoking feelings that shade from anger to sadness, from empathy to sympathy, and from guilt to shame. Although it has been implied that these sitters were able to maintain their dignity in this compromising situation through their proud bearing and clear, direct gazes,[7] the fact remains that they were subjected to the legalized brutality of slavery and forced to pose for these images. Agassiz's daguerreotypes illustrate that documentary images are in fact not objective and that the intentions and desires of the photographer and/or commissioner inevitably influence representation. It is the perceived objectivity and authority of documentary images, including ones like *Delia* and *Jack*, that Simpson, Weems, and Middlebrook challenge in their art.

Continuing the African American Tradition
The work of Simpson, Weems, and Middlebrook responds not only to documentary image-making, but also to the efforts of a long line of African American artists who have struggled against negative representations and fought for recognition of their experiences.

In the 1920s, during the Harlem Renaissance, black artists and intellectuals determined to represent the variety and richness of African American life. At the same time, they wrestled with the question of how to represent blacks in a manner that would counter negative and stereotypical images and finally establish their subjectivity. In 1926 the intellectual W. E. B. DuBois urged black artists to create works of art using the principles of truth and goodness, and declared, ". . . all art is propaganda and ever must be, despite the wailings of purists."[8] That same year, the poet Langston Hughes noted that African American culture "furnish[es] a wealth of colorful, distinctive material for any artist" because of its individuality. He stated, "We younger Negro artists who create now intend to express our individual dark-skinned selves without fear or shame."[9] Later the artist Romare Bearden (see Portfolio, no. 25) claimed, "The artist must be the medium through which humanity expresses itself. In this sense, the greatest artists have faced the realities of life, and have been profoundly social."[10] These artists' words and images imply a profound hope that art can function propagandistically, helping to erode the inequities of prejudice.

While all seemed to agree that African American life and culture should be the inspiration for African American art, they did not agree as to how this art would take shape. For artist Aaron Douglas (see Portfolio, no. 4), representing African American culture meant combining aspects of contemporary black literature, music, and performing arts, such as improvisation and syncopation, with ancient Egyptian and traditional African art forms in order to establish African American individuality. Photographer James Van Der Zee added to the dialogue by producing images of various Harlem residents, such as the intelligentsia and political leaders; religious figures (see Portfolio,

no. 7); and social, military, and school groups to suggest the multifaceted and unique nature of African American culture.

Just as Harlem Renaissance artists had their own opinions about how to depict African Americans and their world, Simpson's, Weems's, and Middlebrook's portrayals of black culture are individualistic. And, in spite of the fact that more than seventy years separates their work from the classic examples of their earlier counterparts, Simpson, Weems, and Middlebrook, along with other artists of their generation, must still grapple with negative and pejorative depictions, in order to assert the voice and sensibilities of African Americans. Thus, while they may not share the lofty ideal of Harlem Renaissance artists that art has the power to change peoples' minds, they are nonetheless equally committed to reclaiming African American identity and to embracing the variety within it.

Lorna Simpson

Invoking visual documents such as Agassiz's *Delia* and *Jack*, Lorna Simpson's work questions the authoritative voice through which such images communicate, as well as the political exigencies with which they are invested. It also examines the manner in which we approach documentary photographs and the imbalance of power between photographer and photographed subject.[11] Simpson's desire to critique these constructs led her to explore the proliferation of information that the documentary genre has necessitated and the resulting relationship of photographs and text. Her subversive intent is apparent in the lack of clear connection between her images and the words she chooses to employ with them. As she explained, "I still use the documentary images, but I try to insert a text in the same way that you would maybe find a caption in a magazine [but] that doesn't actually

fit. Either logically it doesn't fit . . . or there's a contradiction in the meanings of the words and what you would expect the photograph to reveal."[12] Simpson uses the visual language of documentary photography—she often works in black and white, positions her models against monochromatic backgrounds, and situates her subjects squarely before the camera to create a "head" or "full-body" shot. However, she eliminates the information the documentary genre usually offers by not revealing their faces.[13] In so doing, she not only forces viewers to examine their expectations of documentary images but also allows the single individual she photographs to signify many others. Likewise, Simpson's decision to employ standard plastic plaques, of the type used to label doors, among other things, undermines conventions of artistic media by incorporating utilitarian objects originally intended for commercial use.

In her 1990 diptych *Outline* (fig. 2), Simpson synthesized her critique of the documentary genre with her debunking of gender and racial stereotypes. The left panel of *Outline* features a horizontally oriented, black-and-white photograph of a thick braid of a curly hair, positioned to form three sides of a rectangle. Attached to the glass covering the image is a black plaque inscribed with white, lowercase letters reading "back." The right panel displays a vertically oriented, black-and-white photograph of the back of an African American woman's head, shoulders, and torso. The plaques on the glass over this image feature the words "lash / bone / ground / ache / pay," also in white, lowercase letters. Simpson deliberately fashioned a work that asks more than it answers: Who is the model? Why is her face not visible? To whom does the braid belong? Does the model's short haircut indicate that the braid was once hers? To what do the captions refer?

Simpson expressed the sitter's lack of identity in the flattened effect of her image, as though the subject's outlined form had been cut from one photograph and pasted onto the black background of another. This blunt presentation invokes nineteenth-century typological photographs, such as those of Delia and Jack, and twentieth-century "mug shots" of accused criminals, and suggests that the subject has no depth or that she merely exemplifies a category. Simpson implied that, by virtue of the fact that the model in *Outline* is African American, she has been stripped of her subjectivity and is defined instead by a collective identity circumscribed by classification and perpetuated through stereotype. In *Outline* Simpson's anonymous model becomes a symbol of African American women, illustrating how little viewers actually know about them.[14] In this way, the artist reveals to us our passive acceptance of received information and implicates us in the production of meaning. At the same time that Simpson used the documentary mode to focus attention on the negative effects of categorizing black women, she appropriated the style in order to protect the model and render her—and by extension all black women—unknowable. Because viewers cannot scrutinize either the sitter's features or her expression, they are unable to categorize, reduce, or subjugate her.

As its title suggests, this work, with its enigmatic, abbreviated images and captions, provides us with only an outline of a woman and an outline of information. Nevertheless, it infers that we tend to fill in gaps in our knowledge by drawing upon precoded ideologies that shape our opinions and judgments about people, things, and events. Simpson's text-plaques are crucial to the artist's investigation of the relationship between photographs and text and of the narratives these elements imply. The plaques problematize the typical and

expected function of the caption in connection with the image it accompanies—establishing a narrative and assigning meaning—by leaving to the viewer the responsibility of relating one to the other. The text does not provide readily accessible information about the sitter. The viewer must move continually from left to right, and back again, to derive more complete meanings from the words by combining them: "back/lash," "back/bone," "back/ ground," "back/ache," "back/pay."

But even these compound nouns add to the elusive quality of this work. "Backlash" suggests a violent reaction—the lashing of victims/slaves—directed at a particular segment of society. "Backache" invokes the physical price of hard work. "Back pay" refers to money owed by an employer and suggests his or her power over an employee. Notwithstanding the reality of these experiences, "backlash," "backache," and "back pay" are all quick and ready signifiers of the stereotype of African American women as victims. The model and those she stands for blend into the "background," alluding to their anonymous status and perceived lack of importance in society. "Backbone" indicates not only the area in the center of the model's back that is visually defined by the left side of the stacked, vertebraelike plaques, but more generally to the strength derived from moral stature. The work also invites the viewer to read from right to left (counter to the way English reads): "lash" a "back," "pay back," and "bone" of a "back."[16] By not providing concrete images of these highly suggestive concepts and constructs and by forcing us to reverse our linguistic habits by reading right to left, as well as left to right, *Outline* pushes us to examine deep-rooted conventions, habits, and assumptions.

Simpson's depiction of the braid and the model's shortly cropped coiffure in *Outline* relates to a complicated issue within the African American community about hair. An individualistic and personal display, hairstyle can communicate a person's sociopolitical positions, including sexual orientation, class identification, and commitment to nationalism, among others.[16] Central to the "great hair debate" is the straight or curly nature of hair; its texture has been used to situate an individual on the ideologically and biologically defined spectrum of African ancestry. Since the time of slavery, when miscegenation produced ranks within the slave groups and one's genetic proximity to the master was deemed advantageous, "good" hair has been defined as that which is closest to white hair—relatively straight and long. Today among blacks the terms "good" and "bad" are still applied to hair; yet their definitions are less fixed and more open to interpretation. For instance, "good" may be used in the sense described above, to identify unprocessed and natural hair, or to refer to any flattering style, regardless of length and texture. Likewise, "bad" may be used in its traditional sense to signify kinky hair, or ironically to refer to any stylish "do."[17]

Understood that way, Simpson's image of the braid may indicate, among other things, a political identification with African American culture, or assimilation of white values, or may merely depict a quick and neat hairstyle. The artist's juxtaposition of the long braid with the short-haired model complicates these implications by introducing issues of gender. Short hair—defined stereotypically as less feminine and more androgynous than long hair—is a style that some women wear to subvert the feminine ideal, perhaps to appear professional and serious, or to communicate sexual orientation. Further, the rectangular arrangement and length of the braid may imply that African American women are contained by, or trapped within, an ideological construction of ideal (white) femininity and beauty, of which long

FIGURE 2

Lorna Simpson (American; b. 1960). *Outline,* 1990. Two gelatin silver prints with applied plaques; braid: 30 x 53 cm (11 13/16 x 20 7/8 in.); braid frame: 124 x 103.5 cm (48 7/8 x 40 3/4 in.); back: 121 x 101 cm (47 7/8 x 39 3/4 in.); back frame: 124 x 103.5 cm (48 7/8 x 40 3/4 in.). The Art Institute of Chicago, gift of Martin Edelstein (1992.601a–b).

hair is part. Attempting in her work to decenter the idea of black women as victims, Simpson allows them to confront their own investment in such social conventions. In the end, here she questioned the ideology that has defined white women and straight hair as emblematic of beauty and that has required women to conform to this code in order to feel and be found appealing and feminine.

Simpson continued to challenge societal assumptions about race, gender, and sexual orientation, based on socially determined stereotypes, in her triptych *Suit* (fig. 3). Composed of a column of three color photographs, each with a black frame, *Suit* features an African American dressed in a man's suit. The figure is viewed from the back and posed with right hand on hip. An accompanying, transparent plaque declares, in black letters, "An average size woman in an average suit with illsuited [*sic*] thoughts." The text assumes the bland, descriptive tone and unpunctuated syntax of newspaper and magazine captions in order to focus our attention on the anonymity of this kind of writing and the weight we give it. While this statement seems, at first glance, to explain the photographs it accompanies, text and image actually offer contradictory information. From the clothing and pose, one might assume that the model is male, yet the caption states that the model is female. We cannot verify the truthfulness of the text, since the subject turns away from us. In this way, Simpson exposed the manner in which we rely on preconceived ideas and social conventions to render familiar someone or something that might be different or unknown. *Suit* also provides an opportunity to examine "feminine" roles and behaviors that have been ascribed to women, as well as conclusions we make about people, such as their sexual orientation, based on superficial signs such as clothing, hairstyle, and body language.

The anonymity and androgyny of the model, along with Simpson's repetition of the word "average" in the plaque, also allowed her to examine the concept of "average." This word can signify "normal," or the "usual." It can also refer to a mean reached by dividing a sum by the number of its total parts, a definition presupposing that mathematical or scientific methods are objective and free from political and personal bias. In fact both meanings of "average"—embodied in the depiction of the model as three fragmented sections— imply an ideal that Simpson throws into question. The work strongly implies that comparing a person to the "average" is an "ill-suited" practice that falsifies and demeans individuality. In any case, the "ill-suited thoughts" to which the work alludes permeate the image and undermine any assumptions we may make about it.

Carrie Mae Weems
Like Simpson, Carrie Mae Weems is concerned with ways in which African Americans have been compromised, but she has appropriated actual popular and historical representations to critique these practices.[18] At the same time, her work strives to honor and bring attention to identities that have been obliterated. Adapting the traditional photographic essay format in which certain themes and events are explored in multiple images, Weems produces photographic series that maintain the communicative and social nature of the genre. Weems has said about photography, "I'm not so much stuck on the medium as I am on what I can do with it," conveying her interest in exploring the boundaries between photographic representation and communication.[19]

In her recent work, Weems integrates the didactic aim of documentary photography with her study of folklore and storytelling, producing highly discursive, photography-based

FIGURE 3
Lorna Simpson.
Suit, 1992. Three color
polaroids, plastic;
image and plaque:
193 x 113 cm (76 x
44½ in.); image: 193 x
55.9 cm (76 x 22 in.);
plaque: 17.8 x 35.6 cm
(7 x 14 in.). The Art
Institute of Chicago,
gift of the Society
for Contemporary Art
(1992.284a–b).

pieces incorporating narrative texts. She couples a straightforward visual presentation, including elegant frames and mats, with an indirect, narrative approach that reflects the multifaceted African American concept of "signifyin'."[20] "Signifyin'" can involve the use of references and borrowings from earlier sources; Weems makes use of photographs, folktales, myths, and songs to pay homage to African American expressive traditions and to various African American individuals, both known and unknown.[21] For her *Sea Island Series* (1992), Weems appropriated reproductions of the Agassiz daguerreotypes (including *Delia* and *Jack*), and then memorialized these individuals by offering their images as framed and matted

portraits. Another series, *From Here I Saw What Happened and I Cried* (1995), also features images of anonymous African Americans taken from photographs and other sources that Weems confiscated or, to look at it another way, rescued. The texts that accompany two of the works from this series read *For Your Names You Took Hope & Humble* and *Black And Tanned Your Whipped Wind Of Change Howled Low Blowing Itself-Ha-Smack Into The Middle of Ellington's Orchestra Billie Heard It Too & Cried Strange Fruit Tears.* They address the pictured individuals directly, functioning to honor these unnamed, unknown subjects. Weems modified the images by changing their presentation; she enlarged, colored, and framed them. Further, by recovering, or repatriating, historic documentary photographs, the artist reclaimed the dignity and pride that whites attempted to wrest—through stereotyping and mistreatment—from individuals of African descent. By depicting anonymous African Americans, Weems drew attention to attempts to obliterate the identities and experiences of African Americans and embraced their compromised subjectivities.

For Your Names . . . (fig. 4) features an image, taken by the white American photographer Doris Ulmann in the late 1920s, of a seated African American male, surrounded by three others: two sit at either side of the figure, while one squats in front of him. The men's body language—heads lowered and hands clasped in their laps—communicates a sense of humility, while their formal clothing and restrained expressions convey a sense of solemnity. The faded and worn appearance of the image underlines the fact that it was taken from a reproduction of a vintage black-and-white original. Weems framed the red-toned photograph with a round, black mat which crops out much of the three younger men. Presented in two centered lines, the text

divides the image into sections. The arc of the mat and the visual break provided by the text focus our attention on the upper, larger area, in which the men's torsos appear.

Evoking quiet and contemplation, *For Your Names* . . . conveys a sense of intimacy and familiarity, created by the close proximity in which the men sit and by the half circle that encloses them. Etched into the protective glass, the text reads, "For Your Names You Took / Hope & Humble," which seems to refer to the modest expressions on the men's faces. It also calls to mind Christian tenets that instruct believers to wear the cloak of faith and modesty and to accept their fate unassumingly. The gentle, quiet comraderie of these men is in stark contrast to the angry, intense, and hypersexualized expressions with which African American males have been portrayed, both historically and contemporarily. At the same time that this work seems to extol Christian virtues, it also possesses an air of irony: African Americans were forced — sometimes violently, as suggested by the red tone of the photograph—to assume the virtuous but self-effacing attitudes of "hope" and "humble" in order to survive the oppression they experienced.

In *Black And Tanned*. . .(fig. 1), Weems's subject is a man of African descent who sits with his back to the camera, his head presented in profile from the left, and his left arm extended away from his body. The grainy, softly focused, and washed-out quality of the print suggests that it is many generations removed from its original. Indeed, the black-and-white photograph of a slave's back on which it is based was probably produced in the 1860s.[22] Weems reproduced the print in crimson—symbolizing blood and adding to the layers of violence—and framed it with a circular black mat, suggesting a peephole through which we, as voyeurs, gaze at something forbidden yet compelling. The circular mat, in combination with the centrally placed lines of text, draws attention to the man's back, on which can be seen a hideous constellation of scars, caused either by heavy lashing (or tanning) with a whip or by branding with a hot iron. The model's darkened face lends a haunting quality to the work, as if it too may bear scars. With his face in shadow and the abused skin surface of his back highlighted, the anonymous model functions as a surrogate, allowing viewers to imagine other violated individuals or to put themselves in his place.

Sandblasted into the protective glass covering the photograph, the text reads, "Black And Tanned / Your Whipped Wind / Of Change Howled Low / Blowing Itself-Ha-Smack / Into The Middle Of / Ellington's Orchestra / Billie Heard It Too & / Cried Strange Fruit Tears." Weems's text collapses narratives, forcing viewers to draw on their understanding of certain words and phrases. An important aspect of "signifyin'" upon which Weems often relies is the once-necessary, but now-voluntary, encoding of information in texts and images in such a way that only insiders may understand its meaning. Some of the words here, including "whipped," "blowing," and "smack," denote brutal actions, while others, such as "howled" and "cried," suggest suffering. The word "black" may refer to the designation given to the skin tones of African Americans, to the historic practice of tarring individuals, or to evil associations. "Tanned" may indicate not only skin color but the action of beating skin during the leather-making process or punishment, as in "tanning a hide." Likewise, the artist's construction of the phrase "black and tanned" brings to mind another expression, "black and blue," connoting beaten and bruised flesh. Furthermore, Weems's mention of "Strange Fruit," a gut-wrenching song about the lynching of an African American man by hanging him from a

FAR LEFT

FIGURE 4

Carrie Mae Weems. *For Your Names You Took Hope & Humble,* from the series *From Here I Saw What Happened and I Cried,* 1995. Chromogenic color print, overlaid with text sandblasted in glass; image: diam. 45.7 cm (18¾ in.); overall: 59.7 x 49.4 cm (23½ x 19½ in.); framed: 68 x 58 cm (26¾ x 22⅞ in.). The Art Institute of Chicago, Horace W. Goldsmith Fund (1996.423).

tree, evokes powerful images of violence against African Americans.[23] The indirectly indicated, but clear, nature of the narrative to which this work alludes acts insidiously, getting under one's skin, as the saying goes.

The text also links past and present experiences of African Americans. Weems's combination of a nineteenth-century image and references to musical artists from the not-so-distant past collapses time and space, illustrating the deep ancestral legacy of African Americans today. Furthermore, the work suggests that the pain experienced by slaves emerged "smack in . . . the middle of [Duke] Ellington's orchestra" and "Billie [Holiday] heard it too and cried." An exploration of how historic persecution and contemporary prejudice function in the collective psyche of African Americans, this work also provided Weems herself with a way, as she put it, to "rise above the depiction of blacks always as the victim of the gaze."[24] Acknowledging and commemorating the rocky experience of African Americans, the series *From Here I Saw What Happened and I Cried* captures the spirit of

the line from an old African American hymn, "Wouldn't take nothing for my journey now": what does not kill makes one stronger.[25] In her work, Weems taps into the pain her models experienced and survived, embracing it as fodder for creative energy.

Willie Robert Middlebrook

Like Simpson and Weems, Willie Robert Middlebrook explores the subjectivity of African Americans, but he does so in mixed-media works —often in large-scale—in which he has clearly taken pains to portray his subjects with a sensitivity that conveys familiarity and attachment.[26] For this reason, Middlebrook often photographs models with whom he feels particularly connected, especially his family and friends.

After working in the field of documentary photography for several years, Middlebrook began to be troubled by the genre on a number of scores. He realized that, because a photographer chooses what to portray and in which manner, a complex negotiation of power is inherent to the medium. He perceived that certain photographers, because they feel intimidated by their subjects, use their cameras to mediate between themselves and what they photograph. In addition, he was uncomfortable with what he sensed to be the pleasure that some documentary photographers clearly derive by watching people from behind the camera and the voyeurism this implies. He also detected a readiness on the part of art institutions to classify African American artists as documentarians. For all these reasons, Middlebrook turned away from the "objectivity" of documentary photography toward the more subjective and expressive process of mixed media, incorporating techniques of painting into the photographic portraits he makes.[27] In fact the three works discussed below are all from his series *Portrait of My People.*

Believing that artists create images, whereas photographers capture them, Middlebrook opted for a more active role in image-making. The innovative, painterly manner he evolved in the process of rejecting the documentary mode prompted him to consider himself an artist rather than a photographer.[28] Middlebrook refuses to adhere to the pristine print aesthetic that results in the cool, smooth surfaces of works by Simpson and Weems; rather, his works are intentionally rough and unkempt. His manipulation of images by applying pigment and spraying photographic chemicals onto paper not only conveys his interest in spontaneity, but also allows him to communicate his response to his sitters in a personal and expressive way. Middlebrook uses the concept of synecdoche differently than do Simpson and Weems; he emphasizes his subjects' individuality by depicting them up close and enlarges their features to the point of abstraction, so that one individual comes to symbolize many.[29] Although the artist regularly photographs African Americans, he attempts to communicate not just to and about blacks, but universally, offering viewers an opportunity to identify with his models' humanity, as well as that of the larger group they represent.

Printed in varying shades of brown on photographic paper, *Untitled* (fig. 5) depicts the eyes, nose, and lips of an African American woman who looks past the camera, toward the right. She is framed on the left by a large, light-toned field pierced by lines of brown pigment, and on the right by striations of light-and-dark brown tones. The model's face is contained within the shape of an inverted triangle, whose apex marks her chin. As the lines of her chin open and extend upward toward her eyes, her face becomes increasingly visible. The model's expression is contemplative and calm; the slight squinting of her eyes suggests

inquisitiveness. The portion of her face that is featured in the center of the print appears relatively solid and defined. In other areas, however, especially above and below her eyes, her appearance seems sketchy and not quite fixed on the surface. The uneven rendering of the model's countenance may relate to the specific individual and the particular process by which she came to terms with herself; more generally it could symbolize the impermanence and fragility of human existence.

Untitled (fig. 6) features an extreme close-up of the artist's face as he looks to his right. Printed in deep-brown tones on photographic paper, the image is dark and haunting. The horizontal smearing of pigment at the right draws attention to the artist's eyes, while the vertical and diagonal drips below his eyes lead us to his mouth. Tension is created not only by the proximity of the face to the left edge of the image, but also by the manner in which the right side of the face is outlined by a stroke of light pigment. The tightness with which the artist closes his lips and the absent stare of his

FIGURE 6

Willie Robert Middlebrook. *Untitled,* from the series *Portrait of My People,* 1992. Gelatin silver print with chemical manipulations; 50.8 x 61 cm (20 x 24 in.). The Art Institute of Chicago, Henry Foundation Fund (1994.342).

FIGURE 7
Willie Robert
Middlebrook.
Untitled, from the
series *Portrait
of My People,* 1990
(negative), printed
1995. Gelatin silver
print with chemical
manipulations; 137.2 x
243.8 cm (54 x 96 in.).
The Art Institute of
Chicago, Mary L. and
Leigh B. Block
Endowment Fund
(1995.279).

eyes communicate a sense of resolve. The drips of thick, dark-brown pigment under his left eye evoke the color and viscosity of blood, and the lighter-toned drips under his right eye suggest the translucency of tears. The apparently quick application of photographic chemicals— evidenced in the spontaneous splashes and drips at the top right—together with the artist's expression, conveys a sense of rage. Yet we are not privy to information that might clarify our understanding. Rather, Middlebrook left it to us to question whether he was expressing his own anger, the anger of African Americans, or any emotions whatsoever.

Printed on an eight-foot-long sheet of mural paper, another untitled work (fig. 7) features an older African American woman. The hands of an otherwise unseen individual gently frame the model's head. The proper left side of her face is covered with a light, almost white, pigment and is surrounded by an expanse of alternating light and dark tones. The proper right side is covered with an ocher color and framed by a field shifting between shades of rust, brown, and yellow. The model's expression, one of sorrow and weariness, seems to extend over the entire work, carried by the spots of photographic chemicals that dot the surface. In contrast to the tearlike drops concentrated under the right eye of the artist in his self-portrait, the drips covering this image do not suggest that the woman is crying. In fact, Middlebrook seems to have carefully wiped away much of the photographic chemical so that the model's eyes are clearly discernible. In this way, he forged a direct link between model and viewer, allowing us to share in the sense of loss, grief, and compassion the work exudes. The subject is the photographer's mother, photographed shortly

after the death of her husband, Middlebrook's father; the hands that frame her face belong to Middlebrook's brother. Thus, Middlebrook here shared an intimate, emotional family moment. At the same time, he protected his subject's privacy by erecting a screen—symbolized by the dripped pigment—through which he mediated our experience.

Middlebrook's close-up and often large-scale portraits are not idealized. Instead, they depict people with singular appearances. The close-up focus of the works prompts us to look carefully at the faces of African American individuals, as if to dispel another stereotype: that all blacks look alike. Nonetheless, Middlebrook intentionally provides little information about his subjects' clothing, hairstyles, or skin color, so we cannot easily classify or stereotype them. Middlebrook presents us with the larger-than-life visages of African Americans, whose individuality he forces us to confront and accept.

Conclusion

Lorna Simpson, Carrie Mae Weems, and Willie Robert Middlebrook each struggle with how to represent her or his community. Although all were originally drawn to documentary photography, they eventually rejected it and employed mixed-media techniques instead. This change in direction enabled Simpson, Weems, and Middlebrook to demonstrate not only their criticisms of the documentary genre but also to focus attention on how it can pigeonhole and misrepresent individual identity. Their works interrogate our unquestioned acceptance of the stereotypical information encoded into documentary photographs by emphasizing the subjects' anonymity (Simpson and Weems) or singularity (Middlebrook). Further, the three use the concept of synecdoche to demonstrate the negative effects of stereotyping on the self-definition, or subjectivity, of African Americans.

Invoking the idea that one's subjectivity is shaped by information that is received from multiple and disparate sources and then pasted together, Simpson, Weems, and Middlebrook use mixed media to evoke the ways that the uneven and uneasy joining of traditions, assumptions, and prejudices have produced a collective and stereotypical identity for African Americans. The artists' interest in combining media demonstrates the collaged manner in which we absorb and attempt to integrate information. Moreover, the three employ mixed media to obfuscate the distinction between high art and low and between the aesthetic and functional. Finally, the works we have examined here by Simpson, Weems, and Middlebrook validate, commemorate, and honor African Americans and their expressive traditions.

Notes

ROSSEN, "Introduction," pp. 4–7.

1. For more on Blackshear, see Chicago, The School of The Art Institute of Chicago, *A Tribute to Kathleen Blackshear,* exh. cat. (1990).

2. Kymberly N. Pinder, Assistant Professor of art history at the School of the Art Institute, has initiated research on this topic.

3. For more information on this exhibition, see Lisa Meyerowitz, "*The Negro in Art Week:* Defining the 'New Negro' Through Art Exhibition," *African American Review* 31 (1996), pp. 75–89.

4. For more information on this exhibition, see Schulman essay (note 33).

5. A small sculpture by the nineteenth-century artist Edmonia Lewis was in the museum's collection for many years, displayed in the lobby of the Goodman Theatre; its present location is unknown. I am grateful to Daniel Schulman for informing me about the second Tanner painting and the Lewis sculpture. The Art Institute's interest in Tanner actually dates back to 1896, when his *Daniel in the Lions' Den* (1895; present location unknown) was included in that year's annual "American Exhibition," along with the portrait of the artist by his close friend Herman Dudley Murphy now in the Art Institute's collection. I am grateful to Andrew J. Walker for this information.

6. The Art Institute of Chicago, *Martin Puryear,* exh. cat. by Neal David Benezra with an essay by Robert Storr (1991). Puryear is represented in the Art Institute by five works.

WESTERBECK, "Frederick Douglass Chooses His Moment," pp. 8–25.

1. "In Their Own Right: Images of African Americans from The Art Institute of Chicago" was held from Sept. 27, 1997, through Jan. 11, 1998.

2. Frederick Douglass, *Narrative of the Life of Frederick Douglass, an American Slave, Written by Himself* (Boston, 1845; repr. New York, 1968); idem, *My Bondage and My Freedom* (New York/Auburn, N.Y., 1855; repr. New York, 1969); idem, *Life and Times of Frederick Douglass* (Hartford, Conn., 1881; repr. New York, 1983).

3. Douglass' weekly newspaper was published under two names, *North Star* (1847–51) and *Frederick Douglass' Paper* (1851–59). *Frederick Douglass' Monthly,* which had begun as a supplement to *Frederick Douglass' Paper,* became his sole publication from 1859 until 1863; and in 1870 he bought a part-interest in another journal, which he renamed *New National Era* and published until 1873.

4. The chief source of Frederick Douglass material—letters, manuscripts of speeches, etc.—is the Frederick Douglass Collection in the Library of Congress, Washington, D.C. The most important scholarship on Douglass is to be found in Philip S. Foner, *The Life and Writings of Frederick Douglass,* 5 vols. (New York, 1950–75); William S. McFeely, *Frederick Douglass* (New York, 1991); and Benjamin Quarles, *Frederick Douglass* (New York, 1948). Two earlier studies of note are Frederic May Holland, *Frederick Douglass: The Coloured Orator* (New York, 1891); and James M. Gregory, *Frederick Douglass: The Orator* (New York, 1893).

5. J. W. Hanson, D.D., ed., *The World's Congress of Religions: The Addresses and Papers Delivered before the Parliament and an Abstract of the Congresses Held in the Art Institute, Chicago, Illinois, U.S.A., August 25 to October 15, 1893, under the Auspices of the World's Columbian Exposition* (Chicago, 1894), p. 17.

6. Frederick Douglass, *The Reason Why the Colored Man is Not in the Columbian Exposition* (Chicago, 1892); repr. Foner (note 4), vol. 4: *Reconstruction and After* (1950), p. 475.

7. F. W. Putnam, *Oriental and Occidental Northern and Southern Portrait Types of the Midway Plaisance* (St. Louis, 1894). For a discussion of both Putnam's plan and his publications, see James Gilbert, *Perfect Cities: Chicago's Utopias of 1893* (Chicago, 1991), pp. 109–10.

8. Dr. Samuel Morton, *Crania Americana* (Philadelphia, 1839). Unknown for most of the twentieth century, these studies of slaves were rediscovered in 1975 at Harvard University's Peabody Museum, Cambridge, Mass. For a full discussion of them, see Brian Wallis, "Black Bodies, White Science: Louis Agassiz's Slave Daguerreotypes," *American Art* 9, 2 (summer 1995), pp. 39–61.

9. Although Wallis (note 8), p. 39, said that there were six thousand whites and one hundred thousand slaves in the vicinity of Columbia, South Carolina, this city, which was the most modern in the state and its commercial center, was a rare instance in which whites actually constituted the majority. Slaves did outnumber whites statewide, but the area of the highest ratio of blacks to whites was around Charleston, in the Tidewater parishes. Even there, the figures did not approach the fifteen or sixteen to one suggested by Wallis. I am indebted for guidance on this question to Professor Peter Woods of Duke University, Durham, N.C. For more on the issues involved, see George M. Frederickson, "Masters and Mudsills:

The Role of Race in the Planter Ideology of South Carolina," in idem, *The Arrogance of Race: Historical Perspectives on Slavery, Racism, and Social Inequality* (Middletown, Conn., 1988), pp. 15–17. Also enlightening are William W. Freehling, *Prelude to the Civil War: The Nullification Controversy in South Carolina* (New York, 1966); and Stephen A. Channing, *Crisis of Fear: Secession in South Carolina* (New York, 1970).

10. Frederick Douglass, *The Claims of the Negro Ethnologically Considered: An Address before the Literary Societies of Western Reserve College, at Commencement, July 12, 1854* (Rochester, N.Y., 1854); repr. John W. Blassingame, ed., *The Douglass Papers: Series One, Speeches, Debates, and Interviews, 1847-54*, vol. 2 (New Haven, 1982), pp. 497-525. While he may not have been aware of Agassiz's daguerrean study of slaves, Douglass did know about Agassiz's theories. Earlier, in his address at Western Reserve, Douglass referred to Agassiz in the same breath with *Crania Americana*'s author, Samuel Morton, and other anthropologists whom he considered racist; see ibid., p. 503; for Douglass on *Crania Americana*, see pp. 508-14.

11. There were other insults to the African American during the Columbian Exposition that must have rankled Douglass. The World's Parliament of Religions was sullied by the message and tone of papers dealing with race. In "Religious Duty to the Negro," for example, Chicagoan Fanny B. Williams found "negroes" noble in slavery, but problematic once they were free; see Hanson (note 5), pp. 893–97. In an event connected with the Parliament of Religions—the World Auxiliary Congress on Evolution—religious support was expressed for the view of the nineteenth-century English philosopher Herbert Spencer that evolution as a progression had left Africans behind. The fair also marked the introduction of "Aunt Jemima" pancake mix, establishing a stereotype of great longevity in American life; see Marilyn Kern-Foxworth, "Plantation Kitchen to American Icon: Aunt Jemima," *Public Relations Review* 16, 3 (fall 1990), p. 59.

12. *Herald of Freedom* (Concord, N.H.), Feb. 16, 1844.

13. Quoted in McFeely (note 4), p. 371.

14. The oil painting is now in the National Portrait Gallery, Washington, D.C. See Washington, D.C., National Portrait Gallery, *Majestic in His Wrath: A Pictorial Life of Frederick Douglass*, exh. cat. by Frederick S. Voss (1995), pp. 22–23. This catalogue for an exhibition at the National Portrait Gallery was published the year before the Art Institute's daguerreotype came to public attention.

15. Douglass to Richard D. Webb, Apr. 16 (?), 1846, in Foner (note 4), vol. 5: *Supplementary Volume, 1844–1860* (1975), p. 42.

16. For a detailed discussion of this daguerreotype and the events surrounding it, see Hugh C. Humphreys, "'Agitate! Agitate! Agitate!' The Great Slave Law Convention and its Rare Daguerreotype," *Madison County Heritage* 19 (1994), pp. 1–64. This journal is a publication of the Madison County Historical Society, Oneida, N.Y.

17. I am indebted to Mary Panzer of the National Portrait Gallery for sharing with me the hypothesis of Will Stapp, former Curator of Photographs at the Gallery, that the portrait may date as early as 1845.

18. Allison Davis, *Leadership, Love, and Aggression* (New York, 1983), p. 89. This essay appears as the second chapter, "Douglass, the Lion," in Davis's book on prominent African Americans. The others discussed are W. E. B. DuBois, Richard Wright, and Martin Luther King, Jr.

19. See Pittsburgh, Dargate Auction Galleries, *Estate of Hans Tauchnitz, Mrs. Standish, David Ferguson, Plus Other Select Consignments*, Apr. 27–28, 1996, lot 642, pp. 51–52.

20. Martin R. Delany to Douglass, in *North Star*, Apr. 28, 1848, p. 2.

21. *Beacon Journal* (Akron, Oh.), Mar. 5, 1888.

22. *Frederick Douglass' Paper* (Rochester, N.Y.), Apr. 28 and May 5, 1854.

23. The convention that all men's garments buttoned left over right seems to have been universal by Douglass' era. See John Peacock, *Men's Fashions: The Complete Sourcebook* (London, 1996), pp. 58–75, 203–204; and Penelope Byrde, *The Male Image: Men's Fashion in Britain 1300–1970* (London, 1979), pp. 71–124 *passim*.

24. Douglas Severson, photography conservator at the Art Institute, determined from the state of the preserver that he was the first person to open this assembly since the daguerreotype was made and fitted with its case. This accounts for the pristine condition of the plate, for efforts to repair or restore daguerreotypes have usually tended to damage them instead.

25. See Floyd Rinhart and Marion Rinhart, *The American Daguerreotype* (Athens, Ga., 1981), p. 402 (listed as S. S. Miller, not Samuel J. Miller); and John S. Craig, *Craig's Daguerreian Registry*, vol. 3: *Pioneers and Progress, MacDonald to Zulky* (Torrington, Conn., 1996), pp. 88, 395.

26. *Akron Summit Beacon*, Aug. 25, 1852, p. 3.

27. Samuel Alanson Lane, *Fifty Years and Over of Akron and Summit County* (Akron, Oh., 1892), p. 30.

28. For a discussion of the economic conditions under which the daguerreotype was introduced, see Robert Taft, *Photography and the American Scene: A Social History, 1839–1889* (New York, 1938), p. 39.

29. Edward Waldo Emerson and Waldo Emerson Forbes, eds., *The Journals of Ralph Waldo Emerson, 1841–1844* (Boston, 1911), pp. 110–11.

30. Ibid.

31. Frederick Douglass, "Self-Made Men," *The Papers of Frederick Douglass*, Library of Congress, Washington, D.C., reel 18. By citing, among the various complete texts and fragments of this talk to survive, the version published when Douglass delivered it at the Indian Industrial School in Carlisle, Penn., I have followed the example of Rafia Zakar, "Franklinian Douglass: The Afro-American as Representative Man," in Eric J. Sundquist, ed., *Frederick Douglass: New Literary and Historical Essays* (Cambridge, Eng., 1990), pp. 99–117.

32. The more elaborate story about Ball, which ran in *Frederick Douglass' Paper* on May 5, 1854, was a reprint from an Apr. 1, 1854, issue of the popular magazine *Gleason's Pictorial*.

33. Quoted in Foner (note 4), vol. 1: *Early Years, 1817–1849* (1950), pp. 379–80. Douglass was reviewing an 1849 book entitled *A Tribute for the Negro* by Wilson Armistead that was illustrated with engravings (repr. Miami, 1969). Whether some of these were based on daguerreotypes, which were by then commonly used as a basis for the lithographs and engravings published in books, is unclear. Douglass himself is one of the subjects profiled, and the accompanying portrait of him was poorly copied

from the engraving in his first autobiography. Douglass' use of the word "take" in his article suggests that he had a photographic process in mind, although at this stage of its history the medium was not generally considered capable of the amount of manipulation he was talking about here.

34. Albert Bushnell Hart, *Slavery and Abolition*, vol. 16 of *American Nation Series* (New York, 1910), p. 196; quoted in Quarles (note 4), p. 63.

35. Douglass to Sidney Howard Gay, Sept. 1847, in Foner (note 33), pp. 262–63.

36. I am thinking here not only of Douglass, but of Abraham Lincoln, who said that two things got him elected President: the speech he gave at New York's Cooper Union in 1860, and the widely distributed photograph Mathew Brady took of him that night; see James D. Horan, *Mathew Brady: Historian With a Camera* (New York, 1955), p. 32.

37. Caleb Bingham, comp., *The Columbian Orator: Containing a Variety of Original and Selected Pieces: Together with rules, calculated to improve youth and others in the ornamental and useful art of eloquence,* 18th ed. (New York, 1816).

38. Quoted in James W. Tuttleton, "Frederick Douglass," *The New Criterion* 12, 6 (Feb. 1994), p. 22.

39. James Russell Lowell, in *The Pennsylvania Freeman* (Philadelphia), Feb. 13, 1845; quoted in Quarles (note 4), p. 19.

40. Genesis 32:24–28. While Douglass, like Abraham Lincoln, did not subscribe to any of the organized religions of his day, he did feel himself to be a man of destiny, someone whom God had chosen to fulfill His will. This belief began in boyhood when a slave called Uncle Lawson told him he had a mission in life, and it ripened into a conviction that he had been born to be a prophet of his people. Recent scholars who concur in Douglass' own assessment of his importance include William B. Rogers, who has placed Douglass in a prophetic tradition going back to the Puritans; see William B. Rogers, *"We Are All Together Now": Frederick Douglass, William Garrison, and The Prophetic Tradition* (New York, 1995), pp. 21, 124. Douglass' prophetic role has also been noted by the author of his definitive modern biography, William S. McFeely (note 4); see note 51 below.

41. Douglass, *My Bondage and My Freedom* (note 2), p. 246.

42. Ibid., pp. 358–62. See also idem, *Life and Times . . .* (note 2), pp. 219–21.

43. Douglass, *My Bondage and My Freedom* (note 2), p. 360. See also idem, *Life and Times . . .* (note 2), p. 218.

44. Sundquist (note 31), p. 10.

45. Douglass to Maria (Weston) Chapman, Mar. 29, 1846, in Foner (note 33), p. 142.

46. Douglass, *My Bondage and My Freedom* (note 2), p. 364.

47. Quoted in Philip S. Foner, *Frederick Douglass, A Biography* (New York, 1964), p. 82.

48. Douglass, *Life and Times . . .* (note 2), p. 282.

49. Quoted in Washington, D.C. (note 14), n.p.

50. Douglass to William Lloyd Garrison, in *The Liberator* (Boston), Mar. 27, 1846.

51. McFeely (note 4), p. 173.

MOONEY, "Representing Race: Disjunctures in the Work of Archibald J. Motley, Jr.," pp. 26–43.

I would like to thank Archie Motley, the artist's son, for his continued support and insightful suggestions throughout the research of this article and my dissertation, "The Crisis of Crossing: Race and Identity in the Work of Archibald J. Motley, Jr." (Rutgers [N.J.] University). I appreciate the steadfast encouragement and critical comments of Wendy Greenhouse, Matthew Baigell, James Smalls, Joe Jacobs, and Martin Eidelberg. I also extend my gratitude to Andrea D. Barnwell, Kathleen Bickford Berzock, Kirsten P. Buick, Matthew Cook, Cynthia Matthews, Clara Ines Rojas Sebesta, and Cherise Smith; and finally I wish to acknowledge the love and support of my parents, Diane and Hugh Mooney, and my husband, Geof Bradfield.

1. "Interview with Archibald J. Motley, Jr.," conducted by Dennis Barrie, Jan. 23, 1978, Archives of American Art, Smithsonian Institution, Washington, D.C.

2. Archibald J. Motley, Jr., application for John Simon Guggenheim Memorial Foundation Fellowship, 1928, Chicago Historical Society, Archives and Manuscripts Collection.

3. "Motley Interview" (note 1).

4. According to the School's "Official Statement of Credits" (Office of Registration Records, The School of The Art Institute of Chicago), Motley received all "Gs" (good), "G+s" (very good), and "Es" (excellent). This transcript also lists an honorable mention for "Junior Composition" and a faculty honorable mention for composition in 1916. After graduating from the School of the Art Institute, Motley briefly returned in 1919 to take a class with the painter George Bellows. For a more complete biography of the artist, see Chicago Historical Society, *The Art of Archibald J. Motley, Jr.,* exh. cat. by Jontyle Theresa Robinson and Wendy Greenhouse (1991).

5. Dawson and Farrow were students at the same time as Motley; Scott graduated before Motley arrived, but they met later through mutual School contacts. On his memories of courteous treatment, see Elaine Woodall, "Looking Backward: Archibald J. Motley and the Art Institute of Chicago," *Chicago History* 8 (spring 1979), p. 53. On his harassment by students, see "Motley Interview" (note 1).

6. Wendy Greenhouse, "An Early Portrait by Archibald J. Motley, Jr.," *American Art Journal* 29 (1999), at press. I would like to thank Dr. Greenhouse for sharing early galleys of her article.

7. Archibald J. Motley, Jr., "The Negro in Art," *Chicago Defender,* July 6, 1918, editorial page.

8. The riot began with an altercation between blacks and whites over the boundaries of a segregated beach, which resulted in the death of an African American youth. Six days of violence caused further deaths and destruction of property. See St. Clair Drake and Horace R. Cayton, *Black Metropolis: A Study of Negro Life in a Northern City* (Chicago, 1993), pp. 65–69. According to Woodall (note 5), p. 54, the Motleys were

threatened by a mob until neighbors interceded to protect them. Interracial relationships were considered taboo, forcing Motley and Granzo to pursue their relationship with caution; see Jontyle Theresa Robinson, "The Life of Archibald J. Motley, Jr.," in Chicago (note 4), p. 3.

9. Motley also received an award from the National Conference of Artists in 1972. As part of the National Conference of Artists Exhibition at the Corcoran Gallery of Art in 1980, Motley was invited to the White House, where he was honored by President Jimmy Carter. Also in 1980, The School of The Art Institute of Chicago granted him an honorary doctorate.

10. On the seminal role of Chicago in the development of jazz, see for example Lawrence W. Levine, "Jazz and American Culture," in idem, *The Unpredictable Past* (New York, 1993), pp. 172–88; and Dempsey Travis, *An Autobiography of Black Jazz* (Chicago, 1983).

11. Bruce M. Tyler, *From Harlem to Hollywood: The Struggle for Racial and Cultural Democracy 1920–1943* (New York, 1992), p. 6. For DuBois on the use of art to promote African Americans, see idem, "Criteria of Negro Art," *The Crisis* (Oct. 1926); repr. *The Portable Harlem Renaissance Reader,* ed. David Levering Lewis (New York, 1994), pp. 100–105.

The role of the arts in this regard was further elaborated by Harlem Renaissance author James Weldon Johnson:

A people may become great through many means, but there is only one measure by which its greatness is recognized and acknowledged. The final measure of the greatness of all people is the amount and standard of the literature and art they have produced. . . . No people that has produced great literature and art has ever been looked upon by the world distinctly as inferior.

See James Weldon Johnson, "Preface," in idem, ed., *The Book of American Negro Poetry* (New York, 1922); repr. Nathan Irvin Huggins, ed., *Voices from the Harlem Renaissance* (New York/Oxford, 1995), p. 281.

12. Carl Van Vechten, "The Negro in Art: How Shall He Be Portrayed? A Symposium," *The Crisis* (Mar. 1926), p. 219.

13. Countee Cullen, response to "The Negro in Art . . ." (note 12), *The Crisis* (Aug. 1926), p. 194.

14. Archibald J. Motley, Jr., "How I Solve My Painting Problems," 1947, n.p., Chicago Historical Society, Archives and Manuscripts Collection. Motley had received a gold medal from the Harmon Foundation for his painting *Mending Socks* (1924; Chapel Hill, University of North Carolina, Ackland Art Museum), which toured with the foundation's 1929 "Exhibit of Fine Arts by American Negro Artists." In 1947 Mary Beattie Brady, the foundation's Executive Director, wrote to Motley to thank him for the "beautifully prepared statement," which, she said, the organization "will be able to use in a number of ways"; Beattie to Motley, July 1, 1947, in Chicago Historical Society, Archives and Manuscripts Collection.

15. Greenhouse (note 6).

16. L. Hamilton McCormick, *Characterology, An Exact Science* (Chicago, 1920), pp. 46–47. On this mass of publications, see Charles Colbert, in *A Measure of Perfection: Phrenology and the Fine Arts in America* (Chapel Hill, N.C., 1997), pp. 12–13.

17. By 1889 the Ryerson Library of The Art Institute of Chicago had acquired Dr. William Rimmer's *Art Anatomy* (Boston, 1877), an instructional drawing manual that relies upon phrenology and social Darwinism

and includes several plates in which African American physiognomies are compared to that of a chimpanzee (pp. 4–5). This kind of racist association is also seen in R. W. Shufeldt, *America's Greatest Problem: The Negro* (Philadelphia, 1915).

18. The National Academy of Design, New York, had introduced courses in phrenology into its curriculum beginning in 1826; see Colbert (note 16), pp. 12–13. The connection between countenance and character is present, although to a lesser degree, in the instructional drawing manual of the School of the Art Institute's influential teacher John Vanderpoel, which was published in numerous editions; see idem, *The Human Figure* (Chicago, 1907).

19. For these physiognomic interpretations, see McCormick (note 16), pp. 46–47, 139, 160–61, 197. In their study of Motley's career (Chicago [note 4], p. 72), Robinson and Greenhouse suggested that the stylization of the hands in the Art Institute's *Self-Portrait* was due to a lack of skill; however, Motley used the same convention in the hands of the subject of *The Octoroon Girl* (fig. 3), painted some five years later and widely recognized as one of his most accomplished portraits. In her review of Motley's 1928 New York debut (see note 28), Marya Mannes praised the artist's "amazing ability in painting hands," which she credited to his apparent "passionate delight in their fragility, complexity and movement"; see idem, "Gallery Notes," *Creative Art* 2, 4 (Apr. 10, 1928), p. xvi.

20. See Elaine Woodall, "Archibald J. Motley, Jr.: American Artist of the Afro-American People 1891–1928," M.A. thesis, Pennsylvania State University, State College, Penn. (1977), p. 7.

21. Wendy Greenhouse, "Motley's Chicago Context: 1890–1940," in Chicago (note 4), p. 43.

22. "Motley Interview" (note 1).

23. "Mulatto," from the Spanish, means "hybrid." Further classifications included a "sambo" or "griffe" (three-quarters black) and "mango" or "sacatra" (seven-eighths black). For the French and Spanish origins of the Creole classification system, see F. James Davis, *Who Is Black?* (University Park, Penn., 1991), pp. 36–37.

24. Ibid., p. 5.

25. Motley (note 14).

26. Ibid.

27. Although this work is known only from its reproduction on the cover of Motley's first New York exhibition (see note 28), it is described in a later exhibition catalogue as follows: "This picture of a red-gowned mulatress with her pearl necklace and coral earrings is the most famous painting of the best-known of American Negro artists. Excellent in arrangement and color treatment, it is even more so in characterization, and this mulatress, with her sensuality, her touch of sorrow, her suggestion of intelligence, and her determination, has an epic quality"; see New York, Anderson Galleries, *Notable Paintings and Drawings of George S. Hellman,* exh. cat. (1932), p. 63.

28. The exhibition ran from Feb. 25 to Mar. 10, 1928; see New York, The New Gallery, *Exhibition of Paintings by Archibald J. Motley, Jr.,* exh. cat. by George S. Hellman, n.p. The cover bore a disclaimer that Mr. Hellman, the gallery's director, had had no prior knowledge of the artist's racial identity. Since Motley's connection to the New Gallery was the result of the initiative of Robert Harshe, Director of The Art Institute of Chicago from

1921 to 1938, who took a personal interest in the painter's success, this professed ignorance on the part of the gallery of the artist's race is highly unlikely, especially in light of Hellman's request that Motley execute paintings with voodoo subjects; see p. 171 and note 35).

29. Motley (note 14).

30. The origins of the "tragic Mulatto" character are discussed in *The Culture of Sentiment: Race, Gender, and Sentimentality in Nineteenth Century America,* ed. Shirley Samuels (New York, 1992). For a consideration of visual depictions of the "tragic Mulatto," see Albert Boime, *Art of Exclusion* (Washington, D.C., 1990). For the proliferation of this character type in literature and its various interpretations, see the thorough treatment in James Kinney, *Amalgamation! Race, Sex, and Rhetoric in the Nineteenth-Century American Novel* (Westport, Conn., 1970). In a discussion of the "tragic Mulatto" type, Daniel J. Leab noted that the playwright Eugene Walter did not want a character to represent the "traditional mammy," since his "Mulatress" character "is cunning[,] crafty, heartless, sullen . . ."; see idem, *From Sambo to Superspade: The Black Experience in Motion Pictures* (Boston, 1975), p. 10. The real tragedy of this stereotype was the way it was used to deny and romanticize the raping of black slave women by their white owners.

31. For a physiognomic interpretation of the chin and mouth, see McCormick (note 16), p. 212. McCormick also believed that thick lips indicated "grossness, slothfulness, love of food, sensuality, lack of breeding, and unenterprising, indolent disposition"; ibid., p. 215.

32. Motley (note 14).

33. Although the trope of the "tragic Mulatto" is still current, contemporary critical theorists have exposed its use as a perpetuation of racist myths of deviant sexuality and of the objectification of black women. See for example bell hooks, *Ain't I a Woman: Black Women & Feminism* (Boston, 1981); and Deborah Gray White, *Too Heavy a Load: Black Women in Defense of Themselves, 1894–1994* (New York, 1998).

34. Motley titled the work *Mammy* for his 1928 exhibition (see note 28) and in both his Guggenheim applications (notes 2 and 51).

35. George Hellman to Motley, May 9, 1927, Chicago Historical Society, Archives and Manuscripts Collection.

36. In addition to the two works illustrated here (figs. 6–7), *Waganda [Uganda] Charm Makers* is known through a reproduction in *Opportunity* 6, 4 (Apr. 1928), pp. 114–15. Motley's own descriptions in "How I Solve My Painting Problems" (note 14) and contemporary reviews indicate that both *Devil-Devils* and *Spell of the Voodoo* similarly embodied a stereotypical approach to the exotic; see for example Mannes (note 19).

37. Edward Alden Jewell, "A Negro Artist Plumps the Negro Soul," *New York Times Magazine,* Mar. 25, 1928, p. 8.

38. New York (note 28).

39. Alain Locke, "The Legacy of the Ancestral Arts," in idem, ed., *The New Negro: Voices of the Harlem Renaissance* (New York, 1925; repr. New York, 1992), pp. 254–67. The term "Dark Continent" became a synonym for Africa after the publication of Joseph Conrad's *Heart of Darkness* (London, 1902). For a discussion of the impact of Conrad's writing, see Marianna Torgovnik, "Traveling with Conrad," in idem, *Gone Primitive: Savage Intellects, Modern Lives* (Chicago, 1990), pp. 141–58.

40. Alain Locke, *The Negro in Art: A Pictorial Record of the Negro Artist and of Negro Themes in Art* (Washington, D.C., 1940), p. 134.

41. Four paintings by Delacroix were available for study in the galleries of The Art Institute of Chicago during Motley's student years at the School. While in Paris, Motley went twice to the Musée du Louvre to see an exhibition of works by this artist; see Archibald J. Motley, Jr., "Diary" (1929–30), Chicago Historical Society, Collection of Archie Motley. He also mentioned the French artist throughout "How I Solve My Painting Problems" (note 14).

42. "The Art Galleries," *The New Yorker* (Mar. 10, 1928), p. 79.

43. Robinson (note 8), p. 12, stated that Motley's African compositions were "inspired by the many stories [his] grandmother Harriet Huff passed on to him about life in East Africa. . . ." Throughout the literature on Motley, Huff has been described as a Pygmy from East Africa. Motley cited an article by Martin Johnson entitled "Asia," in *The American Magazine of the Orient* (July 1921) at the bottom of his description of *Devil-Devils;* see George S. Hellman Archives, Collection of Archives and Manuscripts, New York Public Library. Woodall (note 20), p. 124, stated that Motley consulted a composite of *National Geographic* articles in a volume entitled "Africa" (1924) compiled by the Ryerson Library at The Art Institute of Chicago. Unfortunately, this and other, similar volumes are no longer extant, with the exception of one on Greece comprising articles published from 1913 to 1943. Motley also consulted *Women of All Nations,* ed. Otis T. Mason (New York, 1912), a book that claims to present the "habits, manners and customs of women in every part of the world" through its photographic illustrations and their captions. According to Jontyle Theresa Robinson, Motley had marked pages that discuss East Africa; see idem, "Archibald J. Motley, Jr.: Pioneer Artist of the Urban Scene," *American Visions: Afro American Art,* ed. Carroll Greene (Washington, D.C., 1987), p. 33.

44. I have explored this idea further in "The Crisis of Crossing: Memory or Amnesia in the Work of Archibald J. Motley, Jr.," presented at the annual meeting of the College Art Association, New York City, Feb. 13, 1997. Motley intended each "legend" to detail the cultural practices associated with the people and country depicted in the work. Assuming the authoritative tone of an amateur anthropologist, he wrote descriptions that read like photo captions from *National Geographic* and that in fact have little to do with his images. For example, his legend for *Kikuyu God of Fire* explains that, after the appearance of the deity, "a sheep and a she goat are sacrificed beneath a spreading sacred tree . . . [and] the skin is cut into strips and given to the women for luck. . . . Men, women, and children drink blood, or blood mixed with milk." In his narrative for *Waganda [Uganda] Woman's Dream,* the artist described the "superstitious" women of Waganda, who subscribed to the validity of their dreams and "believed that some demons are able to spirit away children and even grown up men and women." The complete texts Motley submitted are in the George S. Hellman Archives (note 43).

45. For an examination of Covarrubias's life in Harlem, see Adriana Williams, *Covarrubias* (Austin, Tex., 1994), pp. 37–40.

46. See for example Cedric Dover, *American Negro Art* (Greenwich, Conn., 1960), pp. 34–35; Samella S. Lewis, *Art: African American* (Los Angeles, 1990), p. 66; and Los Angeles County Museum of Art, *Two Centuries of Black American Art,* exh. cat. by David C. Driskel (1976), pp. 61–62.

47. This is certainly revealed in the material and tone of the artist's legends for the paintings. Perhaps his use of the word "legend" to explain

his research in a letter to the secretary of the Guggenheim Foundation suggests that he was fully aware of the exaggerated character of his interpretations. See Motley to Mr. Moe (Henry Allen Moe, Secretary, John Simon Guggenheim Memorial Foundation), Feb. 21, 1929, in Chicago Historical Society, Archives and Manuscripts Collection.

48. Franz Boas, "The Real Race Problem," *The Crisis* 10, 2 (Dec. 1910), pp. 22–25. Sociologist E. Franklin Frazier also argued that race is a social construction based on psychological attitudes derived from the cultural environment; therefore, he concluded, eugenics, or "selective mating" of only the best and brightest, would not resolve "the race problem"; see idem, "Eugenics and the Race Problem," *The Crisis* 31, 2 (Dec. 1925), pp. 91–92.

49. This historical debate is thoroughly discussed in Barbara J. Fields, "Ideology and Race in American History," in *Region, Race and Reconstruction: Essays in Honor of C. Vann Woodward,* eds. J. Morgan Kousser and James. M. McPherson (New York/Oxford, 1982), pp. 143–77.

50. Motley (note 2).

51. A copy of Motley's 1929 Guggenheim application can be found in Archibald J. Motley, Jr., Papers, Chicago Historical Society, Archives and Manuscripts Collection. It is interesting that those reviewing the applications and choosing the recipients were amenable to Motley's request when he dropped his ethnic goals to embrace purely formalist ones.

52. Zora Neale Hurston, "Characteristics of Negro Expression," in *Negro: An Anthology,* eds. Nancy Cunard and Hugh Ford (New York, 1935), pp. 29–30; repr. Huggins (note 11), pp. 232–33. I want to thank Kirsten P. Buick for sharing the varied meanings of "jook" and her interpretation of *Nightlife*. Another important meaning of the word is to "fake out," perhaps referring to the temporary pleasures sought in the "juke" during the trying years of World War II. See Clarence Major, ed., *Juba to Jive: A Dictionary of African American Slang* (New York, 1994), pp. 262, 264, where "juke" is defined as a term, used from the 1800s to 1940, "of African Gullah origin, [meaning] to be unruly; loud, boisterous, to have a good time dancing; to dance in a whorehouse; to get drunk; to dance to the music of a juke box."

53. Sharon F. Patton, *African-American Art* (New York/Oxford, 1998), p. 139.

54. For a thorough examination of the proliferation of these images, see Jan Nederveen Pieterse, *White on Black: Images of Africa and Blacks in Western Popular Culture* (New Haven/London, 1992).

55. "Motley Interview" (note 1).

56. Levine (note 10), pp. 181–82. Surprisingly, given jazz's powerful, popular appeal, it was still considered threatening in the 1940s. According to Tyler (note 11), p. 219, "By 1943, federal and local authorities started closing clubs and repressing musicians because it was feared that they were corrupting and exploiting soldiers and civilians by playing jazz and selling them booze, drugs, and sex that dissipated their health and morals." In New York, club owners were required to hire only those musicians who were deemed "clean"; authorities also issued "cabaret cards" to musicians as a way to police illicit activities. The renowned alto saxophonist Charlie Parker repeatedly lost his card because of his drug use. On the jazz scene in the United States in the 1940s, see *Bird: The Legend of Charlie Parker,* ed. Robert Reisner (New York, 1962).

57. Nathan Irvin Huggins, *Harlem Renaissance* (New York, 1997), p. 91.

BARNWELL AND BUICK, "Continuing the Dialogue: A Work in Progress," pp. 44–51.

We would like to thank Okwui Enwezor, Ronne Hartfield, Daniel Schulman, and Jeremy Strick for their critical commentary and thoughtful suggestions.

1. Quoted in Tony Kornheiser, "The Problem with Art That's Only Skin Deep," *The Washington Post,* Dec. 3, 1989, sec. F, p. 1.

2. Quoted in Roxanne Roberts, "Jackson: Not Insulted by Painting, Says Destruction of Portrait Reflects Hidden Anger," *The Washington Post,* Dec. 4, 1989, sec. B, p. 1.

3. Quoted in Barbara Gamarekian, "Portrait of Jackson as White is Attacked," *New York Times,* Dec. 1, 1989.

4. Closer to home can be cited two incidents at The School of The Art Institute of Chicago that also attest to the power of art to anger and provoke fear. When *Mirth and Girth* (1988), by David Nelson, an acrylic painting of the late Chicago African American mayor Harold Washington in ladies' lingerie, was exhibited in the School's 1988 "3-D Exhibition of Graduate Students," a number of the city's aldermen and women became incensed and had the work removed. See Bill Stamets, "Theater of Power, Theater of the Absurd," *New Art Examiner* (summer 1988), pp. 29–31. The following year, *What Is the Proper Way to Display a US Flag?*, a mixed-media piece by Scott Tyler in which an American flag was placed on the gallery floor and visitors were invited to walk over it, was included in a School exhibition entitled "A/Part of the Whole." It too became the subject of intense controversy. See K. O. Dawes, "Flag Artwork to be Shown Despite Suit," *Chicago Sun-Times,* Mar. 2, 1989; and Jean Fulton and Benjamin Seaman, "The Flag Fracas," *New Art Examiner* (May 1989), pp. 30–32.

5. Raymond Williams, *Keywords: A Vocabulary of Culture and Society* (London, 1976; repr. London, 1983), p. 248.

6. Barbara J. Fields, "Ideology and Race in American History," in *Region, Race, and Reconstruction: Essays in Honor of C. Vann Woodward,* eds. J. Morgan Kousser and James M. McPherson (New York/Oxford, 1982), p. 152.

7. Elsa Barkley Brown, "Polyrhythms and Improvisation: Lessons for Women's History," *History Workshop Journal* 31 (spring 1991), p. 86. Brown's analysis is concerned with women's history, but, as a model for historical inquiry, is certainly applicable here.

8. Alain Locke, "The Legacy of the Ancestral Arts," in idem, ed., *The New Negro, Voices of the Harlem Renaissance* (New York, 1925; repr. New York, 1992), pp. 254–67.

9. W. E. B. DuBois, "Conservation of Races," in *W. E. B. DuBois Speaks: Speeches and Addresses, 1890–1919,* ed. Philip S. Foner (New York, 1970), pp. 73–76; repr. David Levering Lewis, *W. E. B. DuBois: A Reader* (New York, 1995), pp. 20–27. For additional discussion of the shortcomings of Locke's views, see Jeffrey Stewart, *The Critical Temper of Alain Locke: A Selection of His Essays on Art and Culture* (New York, 1982); idem, "(Un)Locke(ing) Jacob Lawrence's Migration Series," in Washington, D.C., The Phillips Collection, *Jacob Lawrence: The Migration Series,* exh. cat. (1993), pp. 41–51; and Lisa Meyerowitz, "The *Negro in Art Week:* Defining the 'New Negro' Through Art Exhibition," *African American Review* 31 (1996), pp. 75–89.

10. Another leading artist who focused on images of Africa was Palmer Hayden (1890–1973).

11. Newark Museum, *Against the Odds: African-American Artists and the Harmon Foundation*, exh. cat. by Gary Reynolds and Beryl J. Wright (1989); Winifred Stoelting, "The Atlanta Years: A Biographical Sketch," in New York, Studio Museum of Harlem, *Hale Woodruff: Fifty Years of His Art*, exh. cat. (1979), pp. 20–25; and Chicago, American Negro Exposition, *Exhibition of the Art of the American Negro (1851 to 1940)*, exh. cat. (1940).

12. Elizabeth Johns, *American Genre Painting: The Politics of Everyday Life* (New Haven/London, 1991), p. 2.

13. New York, Whitney Museum of American Art, *Bob Thompson*, exh. cat. by Thelma Golden (1998), p. 22.

14. Charles Alston, Edward Clark, and Hale Woodruff are others who have been excluded from surveys on American abstraction. Black artists have either been entirely ignored or only minimally referenced in a number of standard texts, including the following: Irving Sandler, *Triumph of American Painting* (New York, 1970); New York, Whitney Museum of American Art, *Abstract Expressionism: The Formative Years,* exh. cat. by Robert Hobbs and Gail Levin (1978); and H. Arnason, *History of Modern Art: Painting, Sculpture, Architecture*, rev. and updated by Daniel Wheeler (New York, 1986). An important revisionist study is Ann Eden Gibson, *Abstract Expressionism: Other Politics* (New Haven/London, 1997).

15. Alain Locke, "Enter the New Negro," *Survey Graphic* 53, 11 (Mar. 1, 1925), pp. 631–35.

"Portfolio," pp. 52–83.

1. Clara T. MacChesney, "A Poet-Painter of Palestine," *International Studio* 50, 1 (July 1913), p. xi.

2. Quoted in Kansas City, Mo., Nelson-Atkins Museum of Art, *Across Continents and Cultures: The Art and Life of Henry Ossawa Tanner*, exh. cat. by Dewey F. Mosby (1995), p. 40.

3. Quoted in Kathleen James and Sylvia Yount, "Chronology," in Philadelphia Museum of Art, *Henry Ossawa Tanner*, exh. cat. by Dewey F. Mosby, Darrel Sewell, and Rae-Alexander Minter (1991), p. 45.

4. Sharon F. Patton, *African-American Art* (Oxford/New York, 1998), pp. 115–16.

5. Amy Helene Kirschke, "The Depression Murals of Aaron Douglas: Radical Politics and African American Art," *International Review of African American Art* 12, 4 (1995), pp. 18–30.

6. Blacks began frequenting Oak Bluffs around 1890. For a discussion of African Americans' history at Martha's Vineyard, see Jill Nelson, *Volunteer Slavery* (New York, 1993); Robert Stepto, *Blue as the Lake: A Personal Geography* (Boston, 1998); and Dorothy West, *The Wedding* (New York, 1995).

7. Richard J. Powell, *Homecoming: The Art and Life of William H. Johnson* (Washington, D.C., 1991), p. 170.

8. Richmond Barthé to Courtney Donnell, Dec. 19, 1978, Department of Twentieth-Century Painting and Sculpture files, The Art Institute of Chicago.

9. David Leeming, *Amazing Grace: A Life of Beauford Delaney* (New York, 1998), p. 50.

10. As Leeming stated (note 9), p. 27, "Beauford knew he was in emotional trouble, that he was presenting too many faces to the world and to himself. The faces were beginning to fight with each other and they were already becoming the voices that would later haunt him."

11. Langston Hughes, "Graduation," in idem, *One-Way Ticket* (New York, 1949), p. 128.

12. For more on Lewis, see New York, Studio Museum of Harlem, *Norman Lewis: Black Paintings 1946–1977*, exh. cat. by Ann Eden Gibson and Jorgé Daniel Veneciano (1998).

13. Romare Bearden and Harry Henderson, *A History of African-American Artists: From 1792 to the Present* (New York, 1993), p. 315.

14. Samella S. Lewis, ed., *Black Artists on Art* (Los Angeles, 1969), vol. 2, p. 57.

15. New York, The Museum of Modern Art, *Roy DeCarava: A Retrospective*, exh. cat. by Peter Galassi (1996), pp. 14–19.

16. Ibid., p. 19.

17. Quoted in Claudine Ise, "A Conversation with Roy DeCarava, Photographer," *Artweek* 28, 1 (Jan. 1997), pp. 23–24.

18. Samella S. Lewis, *The Art of Elizabeth Catlett* (Claremont, Ca., 1984), p. 97.

19. Interview between Richard Hunt and Kymberly N. Pinder, Chicago, Aug. 2, 1998.

20. Quoted in New York, The Museum of Modern Art, *The Sculpture of Richard Hunt*, exh. cat. (1971), p. 14.

21. Michael Brenson, "Lynch Fragments," in Purchase, New York, Neuberger Museum of Art, *Melvin Edwards Sculpture: A Thirty-Year Retrospective 1963–1993*, exh. cat. org. by Lucinda H. Gedeon (1993), p. 21.

22. New York, Studio Museum of Harlem, *Vincent Smith: Painting and Drawing*, exh. cat. (1969), n.p.

23. Derryl DePasse, "Joseph Yoakum," in New York, Museum of American Folk Art, *Self-Taught Artists of the Twentieth Century: An American Anthology*, exh. cat. (1998), p. 110.

24. See Floyd Coleman, "The Changing Same: Spiral, the Sixties, and African-American Art," in Indianapolis Institute of Art, *A Shared Heritage: Art by Four African Americans*, exh. cat. ed. by William E. Taylor and Harriet G. Warkel (1996), pp. 147–58.

25. Ralph Ellison, *Romare Bearden, Paintings and Projects*, exh. cat. (Albany, 1968), n.p.

26. Romare Bearden, "Rectangular Structure in My Montage Paintings," *Leonardo* 2 (1969), p. 14.

27. Quoted in *Contemporary American Women Artists* (San Rafael, Ca., 1991), p. 62.

28. Lucy R. Lippard, *Mixed Blessings: New Art in a Multicultural America* (New York, 1989), p. 236.

29. Quoted in Anne Keegan, "An Artist's Vision," *Chicago Tribune*, Nov. 28, 1995, sec. 5, p. 2.

30. Quoted in David Colman, "Pretty on the Outside," *George* (June/July 1996), p. 118.

31. "Extreme Times Call For Extreme Heroes," *The International Review of African American Art* 14, 3 (1997), pp. 2–15.

32. Quoted in Lynn Gumpert, "Kara Walker: Anything but Black and White," *Art News* 96, 1 (Jan. 1997), p. 136.

SCHULMAN, "Marion Perkins: A Chicago Sculptor Rediscovered," pp. 84–107.

I am deeply grateful to Marion Perkins's family, particularly his sons Toussaint and Useni Eugene Perkins, for graciously allowing me access to materials still held by the family. This study of Perkins's work would not have been possible without the enthusiasm and assistance of Julia Perkins, an Art Institute colleague, and the artist's granddaughter. For agreeing to be interviewed and for facilitating my research on Perkins, I wish to thank the following individuals: Barbara Adler, William and Glenda Ashley, Genevieve Baim, Andrea D. Barnwell, Dick Berglund, Margaret T. Burroughs, Jean Callahan, Theresa Christopher, Eldzier Cortor, Alan and Lois Dobry, Walter O. Evans, Peter Gourfain, Steven L. Jones, Belle and Hal Kerman, Bea Kraus, Linda Lewis, John Loengard, Gail London, William London, Roslyn Lund, Muriel Kallis Newman, Herb Nipson, David Norman, James Parker, Andrew Patner, Creilly Pollack, Ramon Price, Helen Roberson, Michael Rosenfeld, Irwin Salk, Elizabeth G. Seaton, Dorothy Seiberling, Virginia Shore, Kent Smith, Esther Sparks, Ellen Steinberg, Glen Steinberg, Jeannette Stieve, Studs Terkel, Anna Tyler, Carol Ware, Sherry Goodman Watt, Susan Woodson, and Quentin and Ruth Young. I am also grateful to Beth Howse, Fisk University Library; Mary Ann Bamberger and Patricia Bakunas, University of Illinois at Chicago, The University Library, Department of Special Collections; Laura Giammarco, Time-Life Syndication; and Katherine Hamilton-Smith, Lake County Museum. For permission to reproduce photographs from *Ebony* magazine, I am deeply grateful to John H. Johnson, Lerone Bennett, and Basil O. Phillips.

1. Since 1961 there has been only one solo exhibition—at the Chicago Public Library in 1979—devoted to the work of Perkins; however, neither a checklist nor a catalogue was published. The following, recent exhibition catalogues include his work in a larger context: Chicago, Illinois Art Gallery, *The Flowering: African-American Artists and Friends in 1940s Chicago: A Look at the South Side Community Art Center,* exh. cat. by Judith Burson Lloyd and Anna Tyler (1993); Ramon B. Price, *Two Black Artists of the FDR Era: Marion Perkins, Frederick D. Jones* (Chicago, 1990); Washington, D.C., Evans-Tibbs Collection, *Margaret Burroughs and Marion Perkins,* exh. cat. (1982); and Chicago, Council on Fine Arts and Chicago Public Library, *WPA and the Black Artist: Chicago and New York,* exh. cat. by Ruth Ann Stewart (1978). For excellent background material, see Wendy Greenhouse, "Motley's Chicago Context: 1890–1940," in Chicago Historical Society, *The Art of Archibald J. Motley, Jr.,*

exh. cat. by Jontyle Theresa Robinson and Wendy Greenhouse (1991), pp. 33–63.

2. Perkins once estimated that he had carved or modeled over two hundred works; see Wesley South, "Loader by Day, Sculptor by Night," *Chicago-American,* May 3, 1957. To date I have been able to identify and locate only about half that number.

3. According to his family and friends, Perkins was at one time a member of the Communist Party. His writings leave no doubt that he was an advocate of revolutionary Marxist doctrine. In fact his activism and associations made him a target of government surveillance. Material was requested from his FBI files under the Freedom of Information/Privacy Act, but was not received by the time this article went to press.

4. Information about Perkins's youth is based on newspaper interviews conducted with the artist in the 1940s and 1950s, and on family lore. The Arkansas Department of Health, Division of Vital Records, was unable to locate a birth certificate for Perkins; nor have Perkins's children succeeded in locating any of their father's relatives. It is not known how, or even if, Padrone was actually related to Perkins.

5. Allan H. Spear, *Black Chicago: The Making of a Negro Ghetto, 1900–1920* (Chicago, 1967), p. 12.

6. The best history of Bronzeville can be found in St. Clair Drake and Horace R. Cayton, *Black Metropolis: A Study of Negro Life in a Northern City* (Chicago, 1945; repr. 1993).

7. Eva Perkins is remembered by family and friends as affectionately as is her husband. For the most part, she devoted herself to raising her children, but, in the 1930s and 1940s, she worked as a seamstress. In the 1950s, when her children were grown, she was employed as a housekeeper at a University of Chicago dormitory.

8. Gwendolyn Brooks, "They Call It Bronzeville," *Holiday* 10, 4 (Oct. 1951), p. 64. The full article, which runs from p. 61 to p. 67 and p. 112 to p. 116, was located as a clipping in the Eldzier Cortor Papers, Archives of American Art, Smithsonian Institution, Washington, D.C. (reel N70–47).

9. The DuSable Museum has ten works by Perkins.

10. Perkins's application for a grant from the Julius Rosenwald Fund is preserved at the Fisk University Library, Nashville. Of the dozens of articles that cite Perkins, those with biographical information are: "Present Hall Branch with Distinctive John Henry Sculpture Creation," *Chicago Criterion* (Mar. 1943); "Postal Employe [*sic*] Becomes One of Chi's Foremost Sculptors," *The Pittsburgh Courier,* Aug. 23, 1947; Janet Peck, "'Relax' is Word of Action for Artist Perkins," *Chicago Tribune,* Aug. 24, 1947; "Self Taught Week-End Sculptor Seeks Chance for Full Time Art," unsigned, undated clipping [1947–48], Fisk University archives; "His Soap Chipping Rewarded," *Chicago Sun-Times,* May 8, 1948; "'Sorrows' Head Gives Sculptor Joy—$750 of It," *Fort Wayne* [Ind.] *News-Sentinel* [1951]; "Sculpture Prize to Self-Taught Chicago Artist," *Chicago Sun-Times,* May 30, 1951; C. J. Bulliet, "Student Takes Highest Chicago Honors," *Art Digest* 25, 17 (June 1, 1951), ill.; Hertha Stein Duemling, "19 Prizes Awarded in Area Show," *Fort Wayne* [Ind.] *News-Sentinel,* June 2, 1951, ill.; Frank Holland, "Chicagoans' Exhibit Mainly Bunch of Junk," *Chicago Sun-Times,* June 3, 1951, ill.; "Chicago Art," *Where Magazine* (June 9, 1951), ill.; "Realistic Artist Slants Sculpture Toward Negro," *Chicago Defender,* Sept. 29, 1956; South (note 2); George McCue, "Fame, but Not Much Money, Comes to Marion Perkins," *St. Louis Post-Dispatch,* Oct. 20, 1957.

11. Marion Perkins File, National Personnel Records Center, St. Louis, Mo. The most authoritative source on the Illinois Art Project lists Perkins as a participant in the sculpture division of the Federal Art Project in Illinois, but bases this finding on secondary source material; see George J. Mavigliano and Richard A. Lawson, *The Federal Art Project in Illinois, 1935–1943* (Carbondale/Edwardsville, Ill., 1990), p. 130. Had Perkins participated in the prestigious sculpture division, surely he would have stated this in his Rosenwald application. Since Perkins's position in 1936 at Garfield Park was classified as a "recreational instructor" rather than as a "teacher/adult education," he probably did not teach art or handicrafts. This position may have involved sports, as an unsigned, undated newspaper clipping in Perkins's file at Fisk ("Self Taught . . . Sculptor . . ." [note 10]) states that one of his WPA assignments was to teach boxing.

One interesting document from Perkins's file at the National Personnel Records Center may provide early evidence of his outspokenness and the radical political convictions that emerged later in his life. A "Change in Work Status" form, dated Nov. 30, 1935, records Perkins's dismissal for being a troublemaker, after only two weeks on a construction job. The document states that, after having been "warned several times," he was fired for "failing to work, leaving the job without permission"; it describes him as an "instigator of trouble," who "keeps other men from their work."

12. For more discussion of the SSCAC, see note 27.

13. See for example two infrequently cited articles: Bernard Goss, "Ten Negro Artists on Chicago's South Side," *Midwest—A Review* (Dec. 1936), pp. 17–19; and Willard F. Motley, "Negro Artists of Chicago," *Opportunity* 18, 1 (Jan. 1940), pp. 19–31. Motley's article was triggered by a 1939 exhibition at Hull House, the well-known Chicago settlement organization founded by Jane Addams. The much younger relative of painter Archibald J. Motley, Jr. (see Mooney essay), Willard Motley wrote some of his finest early pieces while on the editorial staff at Hull House. This center was one of several on the South Side that, from 1939 at least, ran ambitious WPA-supported art-training programs. For further information on Motley, see Robert E. Fleming, *Willard Motley* (Boston, [c. 1978]).

14. The author of a 1951 profile on Perkins in *Ebony* magazine, Herb Nipson, referred to Perkins's sensitivity to this issue: "Today Perkins is hailed by some critics as a self-taught artist and others imply that the laborer-sculptor is a primitive. Perkins pooh-poohs such talk and points to his WPA study under Gordon, an established sculptor and teacher now travelling in Europe, as a part of his training"; see [Herb Nipson], "Marion Perkins," *Ebony* 6, 12 (Oct. 1951), p. 110.

15. "Postal Employe [*sic*] . . ." (note 10).

16. Theodore Ward's plays have been examined by Rena Fraden, *Blueprints for a Black Federal Theater, 1935–1939* (Cambridge/New York, 1994), pp. 111–35; and Helene Keyssar, *The Curtain and the Veil: Strategies in Black Drama* (New York, 1981), pp. 77–112.

17. For information on Wright in Chicago, see Margaret Walker, *Richard Wright, Daemonic Genius: A Portrait of the Man, a Critical Look at His Work* (New York, [c. 1988]), pp. 53–104. Wright lived only doors away from the Perkinses in the mid-1930s.

18. According to Perkins's Rosenwald Fund application, he bought the newsstand in 1939; however, both Burroughs and Pollack reported meeting Perkins there earlier. See "Margaret Taylor Goss Burroughs Interview," Archives of American Art, Smithsonian Institution, Washington, D.C., pp. 26–27.

19. Peter Pollack, quoted in "Chicago Art" (note 10). The sculpture of Lincoln has not been located.

After serving as director of the SSCAC from 1939 to 1943, Pollack (1909–1978) worked at The Art Institute of Chicago from 1945 to 1957, where he began as public-relations counsel and eventually founded the museum's Department of Photography. He wrote *The Picture History of Photography* (New York, 1959). Pollack's papers are housed at the J. Paul Getty Research Institute for the History of Art and the Humanities, Los Angeles (acc. no. 900283).

20. South (note 2).

21. According to a pamphlet for a WPA program, "National Art Week," Nov. 25–Dec. 1, 1940, Gordon shared a studio at 3567 Cottage Grove Avenue with Mischa Kohn and Esther Zolott. (My thanks to Susan Woodson for bringing this source to my attention.) Other artists in Gordon's circle included Julio de Diego, Leon Garland, Todros Geller, Henry Simon, and Morris and Alex Topchevsky.

Information on Gordon is very scarce. For example, he is not included in Esther Sparks's useful compendium of Illinois artists, "A Biographical Dictionary of Painters and Sculptors in Illinois, 1808–1945," Ph.D. thesis, Northwestern University, Evanston, Ill., 1971. The only published biographical information located to date is Harold Haydon, "Galleries: Si Gordon—A Sculptor with a Heart," *Chicago Sun-Times*, Sept. 29, 1972, sec. 2, p. 4; and a section devoted to him in a pamphlet by Barbara Bernstein, *Sculpture of the 1930's Federal Art Project* (Chicago, n.d.), pp. 12–13, which appears to rely heavily on Haydon's article and is occasionally erroneous. The generosity of spirit to which the title of Haydon's article refers is revealed in a story told by Margaret Burroughs. She recalled that, on one visit to Gordon's studio, he offered to lend her books on African American heroes such as Harriet Tubman. This was her first exposure to African American history. See "Burroughs Interview" (note 18), pp. 44–45.

On Gordon's work under the WPA, see Si Gordon File, National Personnel Records Center (note 11).

22. See "Adult Sculpture Class Exhibit at Wabash Y," *Chicago Defender*, Oct. 8, 1938, p. 7; and "Blind Girl's Work Feature of Art Show," idem, Sept. 24, 1938, p. 3. These articles are preserved in scrapbooks of the 38th Street YMCA, Special Collections, University of Illinois at Chicago Library. These archives provide major primary and secondary source material on the art-related activites sponsored by Chicago's Hull House.

23. Gordon's work might have been completely forgotten had it not been for the determination of Louis Cheskin, the former head of adult education of the Illinois Art Project. Cheskin acquired many WPA sculptures, including some by Gordon, from warehouse surplus after World War II, and donated them to the Illinois State Museum, Springfield.

24. The Biltmore Hotel commission is mentioned in interviews with Perkins (see note 10), but no details are disclosed. The date usually given for the commission is 1938, but the Steubens did not buy the hotel until 1940; see "It's No Cinch Fitting Hotel For Summer," *South Haven Daily Tribune,* June 12, 1943. I wish to thank Bea Kraus, Gail London, and Mrs. Jeanette Stieve for providing key information on South Haven and the Biltmore. I would also like to thank Genevieve Baim for sharing her time with me; interview with Genevieve Baim, Jan. 1998.

Perkins's sons worked at the Biltmore when they were children; Toussaint helped in the kitchen, and Eugene shined shoes. However, neither has detailed recollections of the owners of the hotel or of the sculptures. Why the Steubens approached Perkins remains unknown.

25. Chicago, American Negro Exposition, *Exhibition of the Art of the American Negro (1851 to 1940),* exh. cat. (1940), nos. 245–46. The exhibition was held from July 4 to Sept. 2. Members of the juries of selection and awards included Pollack and Art Institute Director Daniel Catton Rich. The survey of African American art in the catalogue of the exhibition is similar in content to Alain Locke's major publication *The Negro in Art: A Pictorial Record of the Negro Artist and of Negro Themes in Art* (Washington, D.C., 1940).

26. "Burroughs Interview" (note 18), pp. 29–30; Samella S. Lewis, *The Art of Elizabeth Catlett* (Claremont, Ca., 1984), pp. 13, 158–61. For photographs of the now-lost sculpture by Catlett, see A. Elizabeth Catlett, "Sculpture in Stone: Negro Mother and Child," MFA thesis, University of Iowa, Iowa City, 1940, pl. 5.

27. The South Side Community Center (SSCAC) was among approximately one hundred such neighborhood organizations founded in the late 1930s under the auspices of the WPA. It is the only one still in operation today. Although the SSCAC's archives have not been inventoried, there are several good sources on its activities: Chicago, Illinois Art Gallery (note 1); Chicago Council on Fine Arts . . . (note 1); Commission on Chicago Landmarks, *South Side Community Art Center, 3831 South Michigan Avenue* (Chicago, 1993); Mavigliano and Lawson (note 11), pp. 66–71; Margaret Goss Burroughs, "Chicago's Community Art Center: A Personal Recollection," in *Art in Action: American Art Centers and The New Deal,* ed. John Franklin White (Metuchen, N.J./London, 1987), pp. 131–44; and the Scrapbooks maintained by The Art Institute of Chicago, Ryerson and Burnham Libraries (hereinafter referred to as AIC Scrapbooks). The papers of William McBride, one of the founding members of the SSCAC, were donated to the Vivian Harsh Collection, Carter Woodson Branch, Chicago Public Library. Although these papers are not yet available to scholars, they will undoubtedly prove to be a major repository on the activities of African American artists in Chicago from the 1920s to the 1950s. For the development of WPA-supported art centers in general, see William F. McDonald, *Federal Relief Administration and the Arts* (Columbus, 1967), pp. 464–74.

28. For the opening of the center, see Alain Locke, "Chicago's New Southside Art Center," *Magazine of Art* 34, 7 (Aug.–Sept. 1941), pp. 370–74. The extensive local newspaper coverage can be seen in AIC Scrapbooks (note 27). A small scandal enlivened the opening, when people learned that a few notorious "policy kings" served on the board, along with reform alderman Paul Douglas and other important local politicians and socialites. ("Policy" is a term that referred to the ubiquitous form of illegal numbers—often protected by the police—that flourished in Bronzeville in these years.) See "Policy Racket Bared as Patron of S. Side Arts," *Chicago Tribune,* May 11, 1941, AIC Scrapbooks (note 27); see also Burroughs (note 27), p. 136.

Perkins showed at SSCAC exhibitions in 1943, 1945, 1946, and 1947, according to his Julius Rosenwald Fund grant questionnaire (note 10). I have been unable to locate catalogues for these exhibitions.

29. The Art Institute of Chicago, *53rd Annual Exhibition of American Paintings and Sculpture,* exh. cat. (1942), no. 263. The exhibition was on view from Oct. 29 to Dec. 10. For a brief history of the "American Exhibition," as well as the "Chicago and Vicinity" exhibition, which was also held annually at the museum, see David Falk, ed., *The Annual Exhibition Record of The Art Institute of Chicago, 1888–1950* (Madison, Conn., 1990).

30. Roark Bradford's novel *Ol' Man Adam an' His Chillun* (New York/London, 1928), based on black folktales, had been adapted by Marc Connelley for the successful stage musical "Green Pastures," which opened in New York in 1939. Bradford's own dramatic adaptation of his popular book *John Henry* (New York, 1931) proved to be a critical and commercial failure, despite its star and the publicity it engendered. For an overview of the literature on John Henry, see Brett Williams, *John Henry: A Bio-Bibliography* (Westport, Conn., 1983). See also Archie Green, "John Henry Depicted" and "John Henry Revisited," *John Edwards Memorial Foundation Quarterly* 14, 46 (fall 1978), pp. 126–43; and 19, 69 (spring 1983), pp. 12–31.

31. "Present Hall Branch with Distinctive John Henry Sculpture Creation," *Chicago Criterion* (Mar. 1943), n.p., in AIC Scrapbooks (note 27).

Another early work by Perkins with strong similarities to *John Henry* is *Figure Sitting,* reproduced in Savannah, Ga., Beach Institute, King-Tisdell Museum, *Walter O. Evans Collection of African American Art,* exh. cat. by Shirley Woodson (1991), no. 51, p. 86, fig. 20, where it is dated c. 1939, described as stone, and listed with the measurements 11 x 6 x 10 in.

32. "Present Hall Branch . . ." (note 31).

33. "Negro Artists of Chicago" was held at The Art Institute of Chicago between June 17 and Aug. 8, 1943. A typed exhibition list is found in the Art Institute's Ryerson and Burnham Libraries. A press release (AIC Archives) notes that Perkins was the only sculptor included in the show. Among the other artists featured were Henry Avery, William Carter, Eldzier Cortor, Charles Davis, Ramon Gabiel, Margaret Taylor Goss, Archibald J. Motley, Jr., William Edouard Scott, Charles Sebree, and Charles White.

While press coverage of "Negro Artists of Chicago" was extensive, only one writer, Frank Holland, singled out Perkins, and his comments were critical: "Marion Perkins, the only one of the group showing sculpture, is represented by two works, 'Woman with a Shawl' and 'O! Israel,' which are not up to the paintings in the exhibition"; see idem, "Negro Artists' Work an Exhibition of Talent," *Chicago Sun,* June 27, 1943, in AIC Scrapbooks (note 27). The dean of Chicago critics, C. J. Bulliet, used the occasion to pen a long-winded and somewhat condescending tract on the lack of a true Negro art. He concluded in "Groping for a Real Negro Art," *Daily News* (Chicago), July 10, 1943, in AIC Scrapbooks (note 27): "Nothing is evident, as yet, in the creations of American Negro artists that show any kinship with the impulses that developed and were perfected in the jungles along the Congo." Bulliet was generally very supportive of black artists, but was incapable of looking at works by them without applying this kind of exotic criterion.

34. *Moses* was certainly an important work for Perkins, since it was chosen to represent him in another survey of Negro art, on view in Albany, New York, between Jan. 3 and Feb. 11, 1945; see Albany Institute of History and Art, *The Negro Artist Comes of Age: A National Survey of Contemporary American Artists,* exh. cat. (1945), no. 52. The sculpture was illustrated in the catalogue and in a four-page spread in *Life* magazine: *Life* 21 (July 22, 1946), pp. 62–65 (ill. p. 62, where it is dated c. 1943). In 1947 it was shown again, in an exhibition sponsored by the Society for Contemporary American Art at The Art Institute of Chicago (checklist).

35. According to his Julius Rosenwald Fund application (note 10), Perkins exhibited at Hull House, but records of these exhibitions cannot be found. On Hull House, see notes 13 and 22. Two extraordinary heads of children in terracotta, now at the DuSable Museum, Chicago, may well be products of his Hull House training in ceramics.

36. The present whereabouts of *Figure at Rest* is unknown. IBM sold the piece, along with a large number of works from its collection, in 1960; see

New York, Parke-Bernet Galleries, *American and Other Modern Art* (Feb. 18, 1960), lot 88. IBM was one of the first American corporations to recognize the value of collecting art; Perkins's piece was apparently purchased as part of an initiative, in the 1940s, to acquire works by African American artists.

Among the books in Perkins's extensive art library were Jules Compos, *The Sculpture of José de Creeft* (Scarsdale, N.Y., 1945); and C. Ludwig Brummé, *Contemporary American Sculpture*, foreword by William Zorach (New York, 1948). Composed primarily of reproductions, Brummé's book is a balanced presentation of the techniques of direct carving, modeling, welding, and construction.

37. New York, Museum of Modern Art, et al., *Henry Moore*, exh. cat. by James Johnson Sweeney (1946); see also The Art Institute of Chicago, *Henry Moore, Drawings and Sculpture*, exh. cat. (1947). The artist's interest in abstraction is also demonstrated in several sketchbooks in the possession of his family. These appear to date from about 1948 to 1952, during the period of Perkins's most intense activity. Most pages are filled with rapid sketches of people. There are also studies for and after sculptural works from around 1950. The notebooks are primarily utilitiarian and indicate that for Perkins drawing was not an independent activity upon which he lavished a great deal of time.

38. The Art Institute of Chicago, *51st Annual Exhibition by Artists of Chicago and Vicinity*, exh. cat. (1947), no. 118 ("Negro Woman"). Ivan Le Lorraine Albright, "Chicago Art Exhibition Shakes Provincialism," *Chicago Herald-American*, June 4, 1947, p. 14, in AIC Scrapbooks (note 27). The dimensions and present location of Sylvia Shaw Judson's granite *Lambs* are unknown. A negative of this work is located in the Department of Imaging, The Art Institute of Chicago.

39. *Negro Woman* was referred to by Frank Holland as a portrait of Perkins's wife; see *Chicago Sun-Times*, May 7, 1947, p. 44. According to Susan Woodson, the 1947 portrait of Eva was at one time in the Gourfain collection.

40. Peck (note 10).

41. Established by Sears, Roebuck, and Company chairman Julius Rosenwald (1862–1932), the fund was designed to exhaust its resources and cease operations by 1948; thus Perkins's grant was among the last to be awarded. See Edwin R. Embree and Julia Waxman, *Investment in People, The Story of the Julius Rosenwald Fund* (New York, 1949). General records of the fund's activities, such as board-meeting minutes, are in the Special Collections of the Regenstein Library, The University of Chicago. The Fisk University Library, Nashville, has materials related to individual grant applications.

42. Quotation used by permission of Fisk University Library, Nashville; and Harold Ober Associates. Hughes's admiration for Perkins is indicated by the photographic portrait used to illustrate the back flap of his book of poems *One-Way Ticket* (New York, 1949). Taken by Gordon Parks, the photograph shows Hughes embracing Perkins's early limestone sculpture *Figure Sitting* (see Savannah [note 31]). I am grateful to Dr. Walter O. Evans for bringing this photograph to my attention.

43. See Harvey Klehr and John Earl Haynes, *The American Communist Movement: Storming Heaven Itself* (New York, 1992), pp. 129–30. As I stated above (note 3), I have not been able to study Perkins's FBI files, which might shed light on his activities at the time; but his circle of friends and supporters were outspoken opponents of the nation's Cold War policy.

44. The Art Institute of Chicago, *52nd Annual Exhibition by Artists of Chicago and Vicinity*, exh. cat. (1948), no. 142, fig. 6. Interestingly, the jury included Sylvia Shaw Judson, the sculptor whose *Lambs* Ivan Albright had compared unfavorably to Perkins's *Negro Woman* the previous year (see note 38).

45. Fuller's *Ethiopia Awakening* was reproduced in Alain Locke's *Negro in Art* (note 25), p. 31. For recent discussions of the date and significance of Fuller's sculpture, see Judith Wilson, "Hagar's Daughters: Social History, Cultural Heritage, and Afro-U.S. Women's Art," in Jontyle Theresa Robinson, *Bearing Witness: Contemporary Works by African American Women Artists* (New York, 1996), pp. 104–107, 110, n. 51; and Tritobia Hayes Benjamin, "May Howard Jackson & Meta Warrick Fuller: Philadelphia Trailblazers," in Philadelphia, Afro-American Historical and Cultural Museum, *Three Generations of African American Women Sculptors: A Study in Paradox*, exh. cat. by Leslie King-Hammond and Tritobia Hayes Benjamin (1996), p. 21. My thanks to Andrea D. Barnwell for these references.

46. Perkins's interest in Greek mythology and in classical sculpture is evidenced by a work of similar pose and expression entitled *Cassandra* (c. 1950; collection of Belle and Hal Kerman, Chicago). Perkins had earlier demonstrated familiarity with medieval art; his 1943 *Moses* (fig. 10) had the stripped-down immediacy and schematic directness of Romanesque architectural sculpture.

47. *Seated Figure* (fig. 12) was exhibited in the "53rd Annual Exhibition of Artists of Chicago and Vicinity" (1949), no. 202; and *Dispossessed* (present location unknown) was in the "60th Annual American Exhibition of Painting and Sculpture" (1951), no. 129. The Art Institute of Chicago, *55th Annual Exhibition by Artists of Chicago and Vicinity*, exh. cat. (1951), no. 130, ill. The only works by African American artists in the Painting and Sculpture Department's collection prior to 1951 were those by Henry Ossawa Tanner (Portfolio, no. 2; and see Rossen, note 5) and Richmond Barthé (Portfolio, no. 11).

48. [Nipson] (note 14). The article, which runs from p. 107 to p. 113, includes photographs by Mike Shay.

49. No captions were located with the negatives in the Time-Life archives. According to Dorothy Seiberling, a photo editor at *Life* in the 1950s, competition for space in the magazine was fierce, and it was not unusual for a story to be killed or to languish; see Seiberling to author, Dec. 29, 1997.

50. Eleanor Jewett, "Art Exhibition Prize Awards Called Absurd," *Chicago Tribune*, May 30, 1951; Frank Holland, "Chicagoans' Exhibit . . ." (note 10): both in AIC Scrapbooks (note 27). In his column for the national magazine *Art Digest*, Bulliet wrote about Perkins's work: "Negroid as the Congo, it is suffused with the spirit of devotion to Christ, sensed in a spiritual sung by a Marion Anderson or an Ethel Waters"; see Bulliet (note 10).

51. Besides works by Douglas and Johnson, there is an interesting carving in marble by Earl J. Hooks also titled *Man of Sorrows* and dated 1950; see Los Angeles County Museum of Art, *Two Centuries of Black American Art*, exh. cat. by David C. Driskell (1976), no. 200, p. 202, ill. Hooks, a professor of art at Fisk University, was acquainted with Perkins in the later 1950s and owns a version of Perkins's *Musician* (c. 1940); see ibid, no. 130, p. 170.

52. Quoted in [Nipson] (note 14), p. 109.

53. The Art Institute of Chicago, *56th Annual Exhibition: Artists of Chicago and Vicinity*, exh. cat. (1952), no. 146.

54. The Art Institute of Chicago, *LXII American Exhibition: Paintings and Sculpture*, exh. cat. (1957), no. 100.

55. Marion Perkins, "Hiroshima in Sculpture," *Masses & Mainstream* 5, 8 (Aug. 1952), pp. 19–21. Perkins's piece is prefaced by a brief profile by Victoria Steele, "Marion Perkins: Worker-Artist," pp. 17–18.

56. Perkins wrote, "Obviously, for me to attempt to express the idea of Hiroshima in such as fashion would have been the height of folly, since no American community would today be interested in such a public memorial. This act must be reserved for the future, when we have repudiated the crimes which at present make us the most feared and hated nation"; Perkins (note 55), pp. 19–20.

57. Ibid., p. 20.

58. Art-historical precedents for Perkins's skyward-looking figures are plentiful. Pablo Picasso's *Guernica* (1937; Madrid, Reina Sofia) includes several images of helpless figures looking up at war planes. Two further, noteworthy examples are Rockwell Kent's 1942 *Bombs Away* (Chicago, Philip and Suzanne Schiller Collection) and Grant Wood's poster *Bundles for Britain* (1940). Closer to home, the important Chicago printmaker Max Kahn created a woodblock print of the subject for a Hull House calendar in 1942 (Special Collections, University of Illinois at Chicago Library), which closely resembles Perkins's *Skywatchers*.

59. [Nipson] (note 14), p. 112.

60. Although the portrait of Bessie Smith was exhibited as recently as 1982 (Washington, D.C. [note 1], no. 14, ill. p. 15), it could not be found for this study. Perkins's *Head of Buddha* is recorded in a snapshot owned by the Perkins family. The location of this work and the identity of the patron remain unknown. One sculpture, executed in baling wire that Perkins appropriated from his son's newspaper-distribution business, resembles a Songye mask from central Congo; see Price (note 1), no. 25, p. xix.

61. Perkins showed with the Artists League of the Midwest, a kind of successor organization to the Artists Union of the 1930s; at Gallery 1020, a nonprofit space in a mansion at 1020 N. Michigan Avenue; and at the 1958 "Artists of Chicago" exhibition held at Navy Pier. An unjuried variation of the Art Institute's "Chicago and Vicinity" exhibitions, this event, dedicated to local art, had over two thousand exhibitors.

62. The North Shore Art League, which organized the Old Orchard Art Fair, confirms that Perkins's name does not appear on official exhibitor rolls; see Helen Roberson, Chairperson, North Shore Art League, to author, Jan. 29, 1998.

63. Perkins is remembered warmly by fellow artists for his extraordinary unselfishness and for his refusal to engage in petty, factional disputes. Interview between Eldzier Cortor and author, New York, Jan. 23, 1998; and "Burroughs Interview" (note 18), p. 26.

64. The text of Perkins's address was published by Toussaint and Eugene Perkins in 1971 as a booklet: Marion Perkins, *Problems of the Black Artist* (Chicago, 1971), intro. by Eugene Perkins.

SMITH, "Fragmented Documents: Works by Lorna Simpson, Carrie Mae Weems, and Willie Robert Middlebrook at The Art Institute of Chicago," pp. 108–123.

I wish to thank Michael Sittenfeld, former editor of *The Art Institute of Chicago Museum Studies,* and Kathleen Bickford Berzock, Associate Curator in the Department of Africa and the Americas, at The Art Institute of Chicago, for encouraging me to find my voice. I would also like to thank Professor Alex Nemerov, Lela Graybill, and Tirza Latimer at Stanford University; Andrea D. Barnwell, Kirsten P. Buick, and Amy M. Mooney at the Art Institute; and Professor Kate Ezra at Columbia College, Chicago, for reading drafts of this essay. In addition, I thank Professor Leah Dickerman for her constructive criticism. I also appreciate Professor Suzanne Lewis's sage advice and Ruben Ramirez's patience and confidence.

1. For more discussion of this phenomenon, see Louis Althusser, "Ideology and Ideological State Apparatus (Notes Toward an Investigation)," in *Video Culture,* ed. John G. Hanhardt (Layton, Ut., 1986), pp. 56–95.

2. Allan Sekula, "Dismantling Modernism, Reinventing Documentary (Notes on the Politics of Representation)," in idem, *Photography Against the Grain* (Halifax, 1984), p. 56.

3. Richard Dyer, "The Role of Stereotypes," in idem, *The Matter of Images* (London, 1993), p. 12. For more discussion of stereotypes, see Homi Bhabha, "The Other Question: Stereotype, Discrimination, and the Discourse of Colonialism," in *Out There: Marginalization and Contemporary Culture,* eds. Russell Ferguson, Martha Gever, Trinh T. Minh-Ha, and Cornel West (New York, 1990), pp. 71–87.

4. Brian Wallis, "Black Bodies, White Science: Louis Agassiz's Slave Daguerreotypes," *American Art* 9, 2 (summer 1995), pp. 39–61.

5. Shortly after the invention of photography, nearly 160 years ago, social scientists turned to the medium to record and categorize criminals and the mentally ill for future reference and research (up until that time, graphic techniques such as engraving and lithography had been employed for such purposes). Photography was also used by colonists to "capture" the "exotic" individuals they encountered during their travels, not only to document their experiences but also to reinforce their belief in European superiority.

6. Wallis (note 4), p. 42.

7. Alan Trachtenberg, *Reading American Photographs* (New York, 1989), pp. 54–60; and Westerbeck essay, p. 155.

8. W. E. B. DuBois, "Criteria of Negro Art," *The Crisis* (Oct. 1926); repr. in *The Portable Harlem Renaissance Reader,* ed. David Levering Lewis (New York, 1994), p. 103.

9. Langston Hughes, "The Negro Artist and the Racial Mountain," *The Nation* (June 23, 1926); repr. *The Portable Harlem Renaissance Reader* (note 8), p. 95.

10. Romare Bearden, "The Negro Artist and Modern Art," *Opportunity* (Dec. 1934); repr. *The Portable Harlem Renaissance Reader* (note 8), p. 141.

11. Regina Joseph, "Lorna Simpson Interview," *Balcon* 5, 6 (1990), pp. 35–39.

12. Quoted in ibid., p. 35.

13. See Lowery Stokes Sims, "The Mirror the Other," *Art Forum* 28, 7 (Mar. 1990), pp. 111–15, in which the author discussed Simpson's work, especially the anonymity of her sitters.

14. On the synedochal effect of Simpson's work, see Kellie Jones, "In Their Own Image," *Art Forum* 29, 3 (Nov. 1990), p. 135.

15. I wish to thank Pamela M. Lee, Professor of Art History at Stanford University, for suggesting that the text be read backward.

16. Judith Wilson, "Beauty Rites: Toward an Anatomy of Culture in African American Women's Art," *The International Review of African American Art* 11, 3 (fall 1994), pp. 11–55.

17. For another discussion of hair, see Kobena Mercer, *Welcome to the Jungle* (New York, 1994), pp. 97–128.

18. I wish to thank Carrie Mae Weems for her generosity in speaking with me. Our conversation took place in Sept. 1998.

19. Quoted in Susan Benner, "A Conversation with Carrie Mae Weems," *Art Week* 23 (May 7, 1992), p. 5.

20. On "signifyin'," see Henry Louis Gates, *The Signifying Monkey* (New York, 1988), pp. xix–xxviii.

21. Ibid., p. 51.

22. Weems's print appears to be a reproduction of a photograph entitled *The Scourged Back*. Taken by McPherson and Oliver of New Orleans in 1863, the photograph pictures the back of Gordon, an escaped slave, at the time of a medical examination. The image was later reproduced by McAllister & Brothers of Philadelphia and distributed internationally as Abolitionist propaganda. For more information and an illustration, see Kathleen Collins, "The Scourged Back," *History of Photography* 9, 1 (Jan. 1985), pp. 43–45.

23. The song "Strange Fruit," originally a poem, was written by Abel Meeropol, a.k.a. Lewis Allan, in the mid-1930s as a protest against lynching and was performed by Billie Holiday after 1938. For more information, see David Margolick, "Strange Fruit," *Vanity Fair* 457 (Sept. 1998), pp. 310–20.

24. Quoted in Benner (note 19).

25. This line, from the hymn "On Mah Journey Now," is quoted in bell hooks, "Diasporic Landscapes of Longing," in idem, *Art on My Mind* (New York, 1995), p. 65.

26. Interview with Willie Robert Middlebrook, Sept. 1997. I wish to thank Mr. Middlebrook for generously sharing his time with me, as well as Martha Schneider for the information she graciously provided me on the artist.

27. Middlebrook (note 26).

28. Ibid.

29. Ibid.